UNDERSTANDING

Portrait Photography

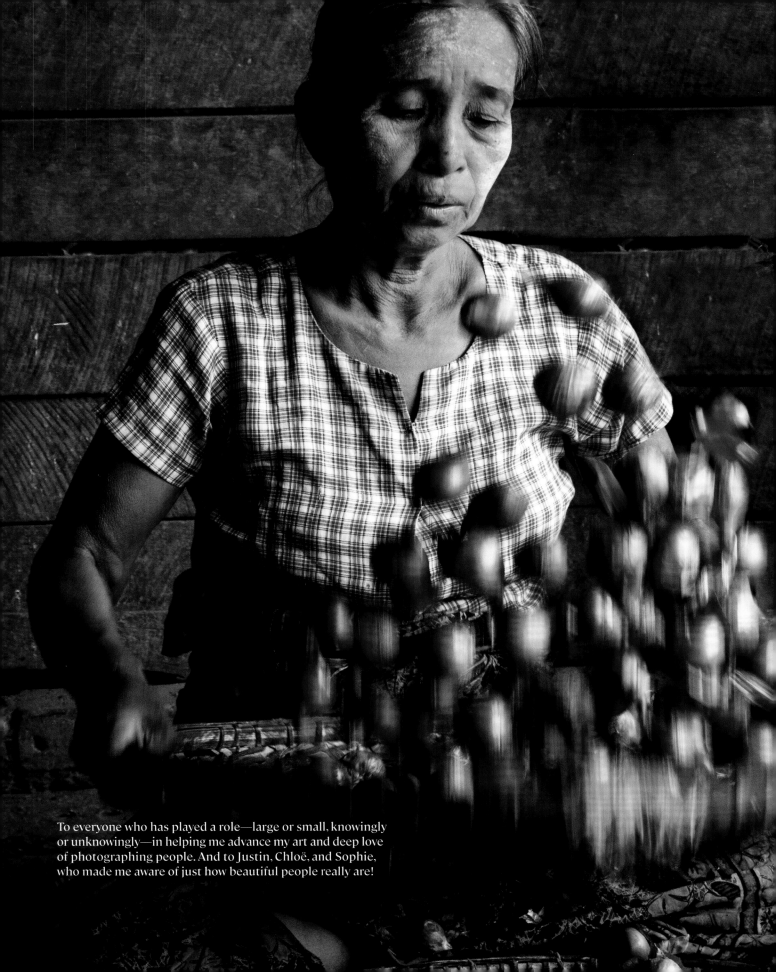

To everyone who has played a role—large or small, knowingly or unknowingly—in helping me advance my art and deep love of photographing people. And to Justin, Chloë, and Sophie, who made me aware of just how beautiful people really are!

New & Revised Edition of *Beyond Portraiture*

UNDERSTANDING

Portrait Photography

How to Shoot Great Pictures of People Anywhere

Bryan Peterson

author of *Understanding Exposure*

WATSON·GUPTILL

CALIFORNIA | NEW YORK

CONTENTS

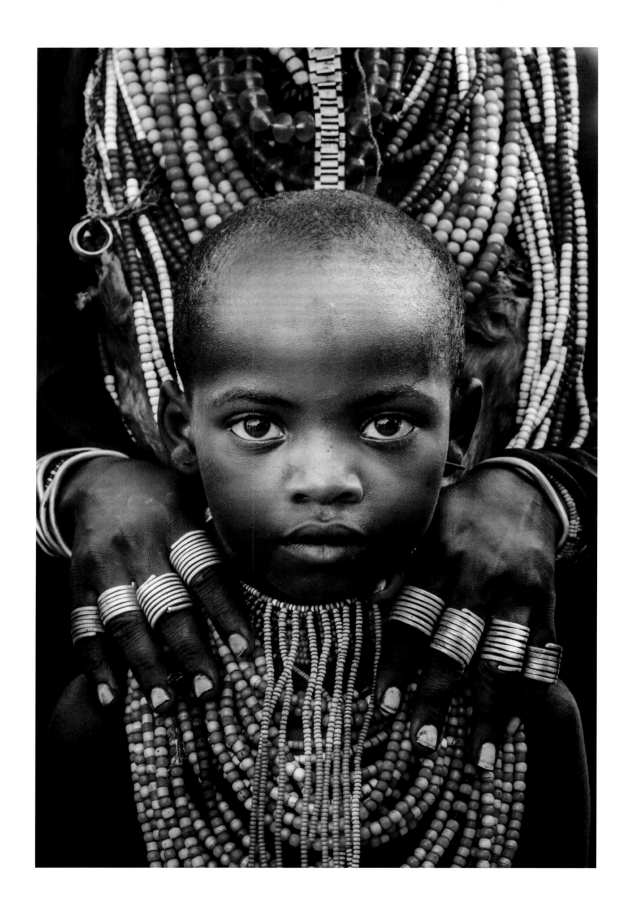

Introduction

In the background, in another room, I can hear a familiar television commercial. My daughter Sophie is watching "old" television commercials on YouTube and just as I sit down to write this introduction to yet another book on photography—a book about photographing people, a subject I've grown to love more than any other—I hear the classic commercial for Timex watches and their tagline, "It takes a licking and keeps on ticking." No doubt this tagline also describes me and my continued passion for image-making. Yes, my passion has taken a licking, but it's still here and it does keep on ticking!

My first book on photographing people, *People in Focus*, was a scary proposition for me—not "scary" in the sense that I was afraid to photograph people (although there was some of that), but in the sense that I was being asked to write an entire book about a single subject, and I, of course, felt that photography could not and should not be limited to a single subject, especially people. Was there really that much to say, that much to show, that much to share, that much to shoot on the subject of people?

Needless to say, my own maturation process has changed this way of thinking. Now when I'm asked whether I'll ever run out of ideas or subjects, I always respond with the same emphatic "*Not in this life!*" In fact, despite being told by my publisher, repeatedly, that I have more than enough material for this new book (along with nine more books on the subject), I still wish I had more time to gather additional examples of why people are such an inexhaustible photographic subject.

Obviously, you, too, share my interest in photographing people—otherwise, why are you holding this book in your hand? Whether your interest is in photographing family, friends, yourself, strangers, young or old subjects, people at play, people at work, people under strife, people celebrating, people in foreign lands, or people in your own neighborhood, I get it! Pictures of people tug at our hearts; they are, in many ways, pictures of ourselves. A photograph of a sad and teary-eyed six-year-old with a melting ice cream cone at her feet will touch most of us. We can feel her pain. Similarly, an image of three elderly people sitting on a front porch laughing hysterically may generate a number of interpretations, but one thing is certain: everyone can understand and appreciate the meaning of laughter. In addition, most of us have someone to thank—a mother, father, relative, or friend who had a camera in hand—for forever preserving small yet revealing vignettes of our personal histories.

Without realizing it, we are adding to one another's histories with each press of the shutter. Even if you have been photographing family and friends for only a few years, those memories are capable of triggering a host of emotions that will only get deeper as the years go by. Many people are reminded of their youth as they look back on images of yesterday; that a photo reminds people of an "easier" time is the most often-heard response from viewers. Your children, just as you were with your parents, are amused by pictures of you with your old-fashioned hairstyle and "vintage" outfit, or your shoulder-length hair and beard, in sharp contrast to that shiny dome the grandkids love to rub. You tell your

children that "you had to be there" when explaining your appearance back then and are quick to remind them that they, too, will look back with nostalgia and perhaps even embarrassment at the pictures you took of them just last week. "Whatever possessed me to wear baggy jeans around my knees and have orange hair?" your son or daughter might say.

At other times, photographs of people taken last year—or even today— give pause for reflection. You sigh and wonder where the time goes as you look at ten-year-old photographs of yourself and those you love. You are moved to tears and laughter as you stare at photos of your toddler daughter, who's now eighteen and about to leave for college halfway across the country.

How you photograph your loved ones, friends, and even strangers can reveal something about you. Surprised to learn this? I'm not a psychiatrist, but I've done enough reading—and, more important, student critiques—over the past forty years to conclude that how we compose photographs of friends and strangers reveals some of our inner selves. Do your favorite pictures show people in a vast landscape, causing them to appear small and diminished? Perhaps compositions of this type reflect your own feelings of being overwhelmed at times, or of just how lonely life can be, or even, still, of how "small" you feel. On the other hand, do you find that you most often fill the frame with just the face of your subjects? Such compositions might reflect the great compassion you feel toward people, as well as your ability to feel free enough to interact with most anyone. The reasons why you do what you do are numerous, and in part, they define who you are; but photography—unlike any other medium—can say volumes about you (by how you shoot your subjects) in a single stroke.

My photography career didn't begin with people as my main interest. Waterfalls and forests, flowers and bees, lighthouses and barns, and sunrises and sunsets drew 99 percent of my attention. This continued for more than ten years until one day I found myself composing yet another snowcapped peak reflected in a still foreground lake. That day proved to be a turning point as I began to reflect on the absence of people not only in my private life but equally so in my pictures. Spending countless days and weeks in nature was making me lonely.

For the next five years, I found myself making a slow but deliberate transition: I spent less and less time shooting compositions without people. I felt a new passion as I realized that the most vast and varied photographic subject was people. I felt lucky! As the song goes, "People who need people are the luckiest people in the world." And, I was quick to discover that my camera could be a bridge in introducing myself to people—but I still had one hurdle to overcome.

Since I'm normally an outgoing person, I was amazed to discover just how shy I really was. On more than one occasion, I resolved to abandon my interest in photographing people. After all, my landscape and close-up photography was already well received by magazine, greeting card, and calendar publishers. And, of course, there was one big distinction between nature subjects and people: mountains didn't move, flowers didn't stiffen up (or throw nectar in your face!), and butterflies never once asked for payment.

But try as I might, I couldn't silence the steady voice inside me that kept pushing me to return to people as subjects. The voice would grow louder when I saw particularly striking subjects, such as a lone ice cream vendor in a city square surrounded by hundreds of pigeons, a woman dressed in red walking parallel to a blue wall with her white poodle leading the way, or a white-bearded man of eighty-plus years sitting on a park bench and chuckling as he read an

Archie comic book. But even during those obviously great picture-taking opportunities, I seldom was courageous enough to raise my camera to my eye and take the picture. A wave of photographic shyness would come over me. Any thought of approaching strangers, especially, would find me panicking, overreacting, convinced that, with each closing step, anything I was going to say or do would be an unwelcome waste of their time, no matter how brief my request.

Unlike the landscapes with which I was so familiar, people can, and oftentimes do, talk back, and they do have something to say. People require interaction: I had to get involved with my subjects if I had any hope for spontaneity as well as cooperation. Otherwise, if I just simply raised the camera to my eye and took the picture, my subjects would immediately become self-conscious. It was as if I were a doctor with a huge hypodermic needle, about to administer the shot of their life.

As the weeks turned into months and I experimented more and more with my feeble attempts at photographing people, it slowly became evident what was behind this new "love" developing inside of me, this love of photographing people. Surprisingly, it had little to do with the settings in which I viewed them. It wasn't the surroundings, the colors of their wardrobe, or the amazing light that caused my emotions to stir, but rather the *person* in that scene. Remove the main subject and the "sentence" would lose its impact; the person was the exclamation point! Funny how only a few months prior, I'd been cursing people for getting in my shot and now I was afraid they would leave—unless, of course, I approached them and explained their importance to the overall composition, and with any luck they agreed to stick around for "1/60 of a second."

I was soon approaching both friends and total strangers with the "truth." I would often say, "I don't know if you're aware of it, but right now you are at the heart of a truly wonderful picture!" or, "I don't know if you're aware of it, but there are some really wonderful things going on just over there, and all that's missing is a person in the scene—and you are the person who can make that scene a truly compelling composition!" Today, this simple approach often continues to get me the permission I seek, though some situations require more diplomacy than others. Above all, the most important thing is to show a genuine interest in the people you are photographing. You will achieve a greater degree of cooperation and spontaneity when your tone and intent are sincere.

Having said that, I must stress that being a master at public relations is only half the battle. I've witnessed countless instances when a photographer has been given permission to photograph but then begins to fumble with the camera and lens, uncertain about the settings and/or the overall composition—and of course, it isn't long before the person they wish to photograph begins to fidget and, sure enough, the light is now gone or the subject's time was limited and they have to go, and so on.

No one will argue that every successful landscape shot or close-up relies in large measure on its ability to evoke both mood and emotion, and that quite often a bit of luck and opportune timing played major roles. But I've learned that luck is seldom a factor when you try to shoot good images of people. Every successful photographer possesses a combination of creative and technical skills, as well as the ability to anticipate the often-decisive moment. If your knowledge of *f*-stops, shutter speeds, great light, the right lens, the right environment, and the right subject are limited, you will find, in this book, page after page of valuable material that will close the gap between what you do not know and what you do know, so much so that you will be enthusiastically sharing your results with the

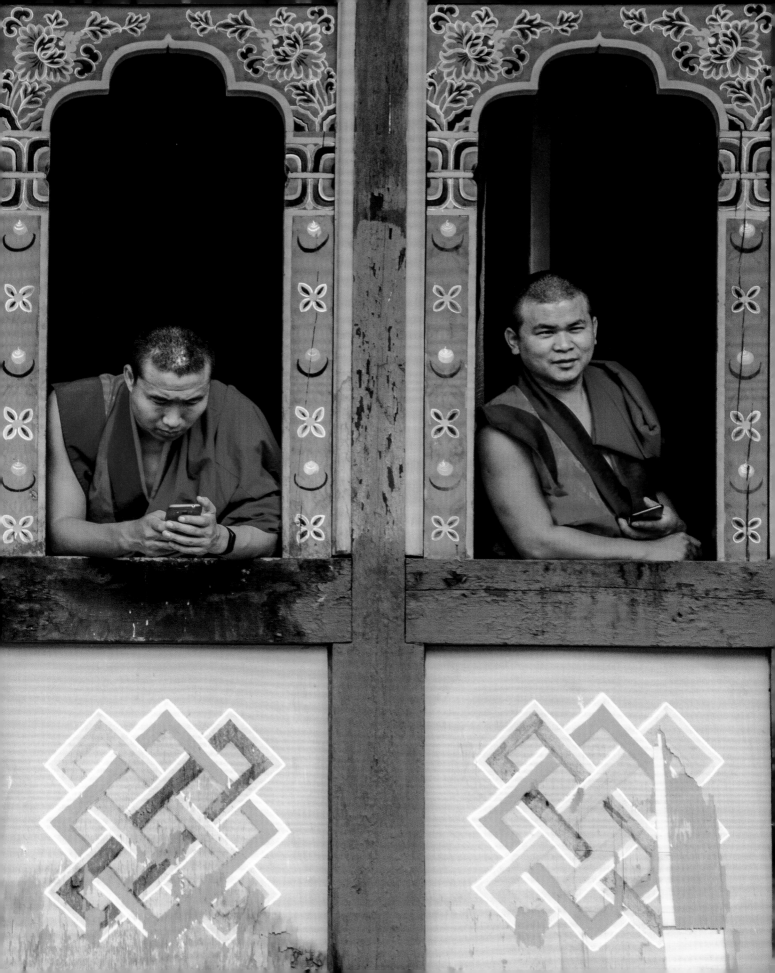

person or people you photograph *immediately* after taking their picture using one of the greatest public relations tools ever developed in the world of photography: the LCD screen on the back of your digital camera, a screen that says, "Wow, look at you and how amazing you look!" My subjects and I both enjoy the instant gratification of seeing an image within seconds of taking it. This adds to people's willingness and enjoyment of posing. (To be sure, there is some small resurgence of photographers shooting film; film-users might consider shooting a quick smartphone snap to show the person what you just did and serve as a substitute photo until you can scan and send them a copy of the film print via email.)

Whether you're shooting digital or film, sometimes you'll need to be able to pose, direct, and ask your subjects to dress or look a certain way. These tasks may seem relatively easy to accomplish with family and friends, but they can prove quite challenging when you need the cooperation of someone you met only ten minutes ago. Throughout this book, I address many different situations, locations, and cultures with people (of course) as the central theme. I also start off by discussing the psychology of people—not just your subjects but yourself, as well—in great depth. For example, when I photograph people, it is never my intention to embarrass them or call attention to a particular flaw in their physical appearance. Unfortunately, the temptation to exploit or embarrass a subject is, at times, so great that some photographers succumb to it, and rather than gaining a subject's trust, they turn the camera into an enemy. I'm also not a big fan of shooting from the hip or using a wide-angle lens to distort faces. Perhaps these are necessary photographs, but they're not the theme of this book.

As you'll discover, *Understanding Portrait Photography* goes far beyond simple portraits to discuss street photography, posed versus candid images, tips for shooting selfies, using artificial light, and an extensive section dedicated to the art of composition and the role the elements of design play in the overall success of a photograph.

I firmly believe that taking photographs of people is the most challenging and rewarding of all the photographic opportunities available today. No other subject is as vast and varied. "People" can range from babies to great-grandparents. Youthful skin or weathered skin, dark skin and deep brown eyes or blue-eyed and blond, short or tall, fat or thin, big hair or no hair, clothed or nude, male or female—when you combine these physical characteristics with the seemingly infinite choices for surroundings (urban or rural, forest or desert, international locale or your own backyard), the possibilities are truly enormous. And because people are the subjects, it is paramount that you embrace what is, perhaps, the greatest rule governing the human condition: You rarely, if ever, get a second chance to make a first impression.

Understanding People

Psychology 101

As you think about some of your best images of people—whether posed or candid, family, friends, or strangers—what do you feel was the single most important factor in the images' success? Was it your subject's clothing, their smile, their activity, their hair, their environment, the light that surrounded them, your lens choice, your composition, your point of view? The answer could be all of the above, but I'll go so far as to say that at the root of most successful people photographs is a spoken or unspoken "cooperation" between the subject and the photographer.

Lucky is the photographer who has a sound understanding of human psychology and the patterns of human behavior. If you're going to be able to motivate anybody to be a subject (family members included), you had better be prepared to answer the biggest and most immediate question that's either spoken or thought by your subject(s): *What's in it for me?* It is a fundamental "law" of human psychology that self-interest governs most of what people do.

To date I have flown more than three million air miles and photographed in just over one hundred countries, and without fail, I have repeated this same ice-breaker over and over: "Hello, my name is Bryan and I'm a photographer who loves to photograph people. You may not be aware of it, but right now at this time and this very place, you are part of an incredible photo that in fact would not be incredible at all if you were not here. Seriously! Can I take a quick snap of you and show you what I mean? I am sure you will agree! And of course, I would be happy to email you, almost instantly, a copy of this moment that you were such a huge part of. And to be really clear, this will cost you nothing."

Almost without fail, this "truth" produces the desired result—and truth it should be! When you analyze the reason(s) why you feel compelled to take someone's photograph, you will find it is often because at that moment the person or people really are part of something compelling.

Likewise, if you are of the ilk to "choreograph" images, you will, again, be enlisting the aid of family members, friends, even strangers. How can you motivate them? More often than not, the answer in today's world is to suggest that they will probably receive a high number of "likes" on Facebook or Instagram, assuming the ideas you have in mind are executed perfectly. Again, cooperation between the photographer and subject is key. And in today's fast-paced, instant-gratification world of digital photography, both of you can be immediately immersed in the joy of this cooperation as the images are quickly viewed and hopefully celebrated.

This simple law—"What's in it for me?"—is at the root of most, if not all, of your motivation to do anything. Most of us form relationships and make both small and life-changing decisions based on the what's-in-it-for-me question. In today's world, this might mean more likes on social media, more clients because of a stronger portfolio, or simply the desire to bring an idea to fruition. And like it or not, your subjects share the same thought process in response to your request. When your subjects don't feel that there is anything in it for them, they'll say no, more often than not, to being photographed. And yes, as many of you already know, this even applies to family members.

To be clear, I very rarely pay my subjects, because quite simply, it's not necessary, unless of course you're working with hired models, or you're

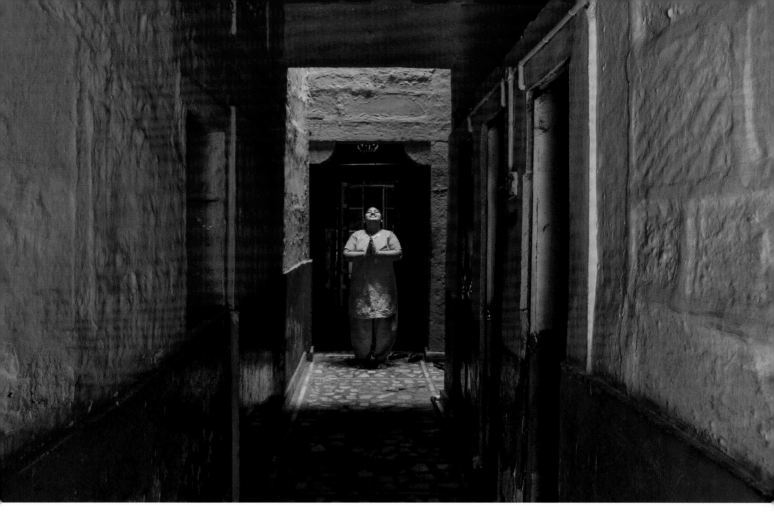

↑

Three cheers for travel without expectations! I was traveling with Nattakun, a model and makeup artist I've known for several years. We were in Jodhpur, India, and Natt wanted to get her hands painted with henna. Neither of us knew where the henna shops were, yet we were both too stubborn to ask for help. So, with a healthy dose of wanderlust, we hit the streets of Jodhpur and, twenty minutes later, saw a big red sign advertising henna along with sample photos of beautifully painted hands.

As we entered the establishment, we were greeted by a long, colorful hallway of green and blue. I made a note to myself: shoot this hallway with a wide-angle lens and a lone person standing in the one area of brightness, looking up to the heavens with folded hands. Once we arrived in the actual shop, I knew I had found my model. Dressed in green pants and an orange dress (orange, fortuitously, being the color complement of blue!), she was the owner of the shop. After she and her sister finished painting Natt's hands, she agreed to be my model for the shot you see here. I believe my exact words were, "You may not be aware of this, but your long and colorful hallway is a photographer's dream and, considering the bright orange clothing you are wearing, you would be the perfect addition to make that hallway truly come alive. Of course, I will happily share a copy of the result with you, and heck, you might want to even consider putting it on your website promoting yourself as the henna artist that you are!"

NIKON D500, NIKKOR 18–300MM LENS, *F*/16 FOR 1/100 SEC., ISO 1600, DAYLIGHT/SUNNY WB

photographing people with the intention of placing the images with a stock photo agency. In those cases, you'll need a signed model release, in which one of the provisions clearly states "for valuable consideration." More often than not, that valuable consideration is money, though it can also mean "x number of photos from the photo shoot" or "a ten-speed bicycle" or anything else deemed a fair trade of "valuable consideration."

But again, most subjects are not holding out for some enormous fee. There are only fourteen pictures in this book for which the subjects were actually paid money; in three of them, the subjects were professional models who I gladly paid a fee, and the other eleven expected payment as part of the "tourism culture" for the native tribes of Ethiopia's Omo Valley (and I can't stress enough that if you struggle with paying them their standard fee of 20 cents for ten minutes of their time, then please consider digging them a much-needed freshwater well instead!).

What I've found throughout the 111 countries to which I've traveled is that most people are willing subjects if your tone and intent are sincere. Lately I've been traveling with a portable HP printer called the Sprocket. Using an app on my iPhone, I'm able to print out a 2 x 3-inch color print—either a photo taken by my phone or a photo processed in Photoshop and then sent to my phone via email. Alternatively, I'll send a photo via email if the subject has an email account. Though at times there are language barriers, today's language translation apps have made this gap increasingly narrow.

Assuming you are presenting yourself as an aspiring photographer, and even if your experience is truly limited, people are more apt to hear the enthusiasm and passion in your voice and respond to that than they will to a somewhat reserved, shy, insecure voice. It's just another side of our human nature: most of us feel "safe" when the tone of the person speaking to us is self-assured rather than indecisive and unsure. Your subjects are more inclined to feel motivated not by what you say but by how you say it; once again, it comes down to the sincerity of your request.

And, no matter where or who you choose to shoot, you should be, first and foremost, motivated to make images that feed the fires of your creative endeavors. Here is my approach to choosing who to photograph: First, I seldom ask anyone who I don't find interesting, which of course is very subjective, since what I find interesting may strike another as completely boring. And second, I've discovered that a few minutes spent simply observing a potential subject (sometimes discreetly) goes a long way toward determining how I want to photograph that subject. It is during these several minutes that I make mental notes about specific mannerisms or expressions I may wish to capture. Also, it helps, when I do approach a person, that I explain the reason I am interested in making the photograph.

Whether an image advances your career, wins a photo contest, or receives ten or ten thousand likes on Instagram is truly secondary to the greater reward. People photographers often work inside the fiercely protected psychological boundaries that many subjects possess, but whether it be immediate or several hours later, I often feel enriched by the shared experience and am grateful for that best "high" of all: connecting with others on what is surely a deeper level than the norm, whether they be family, friends, or strangers.

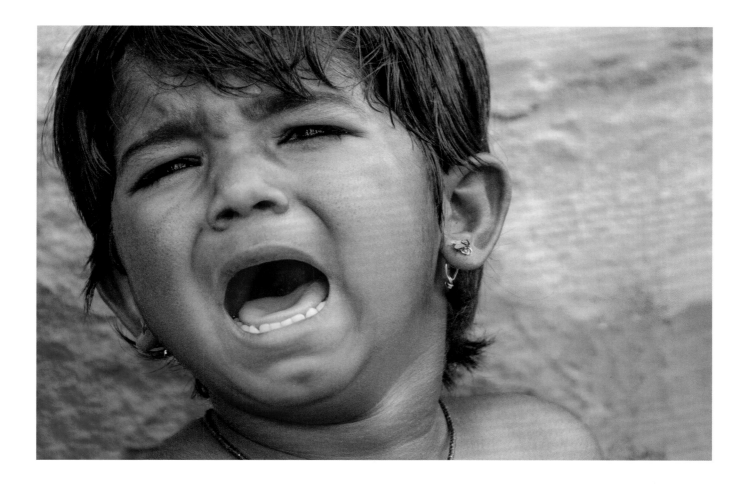

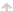

How many photographs of people have you taken in which the subject was expressing anger or sadness? It is *not* common for most of us to raise the camera to our eye and begin photographing at the first sound of rage or falling tears, yet it is our human nature to be drawn to other's misfortune, whether it be that couple arguing in Starbucks or the child screaming in pain as he rubs his skinned-up knees following an unfortunate bike spill.

Despite being witness to these times of discomfort, seldom do we consider making a photograph out of respect for the subject's privacy. I get it, yet the few times I have gone against the norm, I've been rewarded with an emotionally charged image that evoked far deeper responses than your standard "warm and meaningful" portrait. Thoreau was right: "The mass of men lead lives of quiet desperation." This quiet—and sometimes not so quiet—desperation continues from birth until death, so why not consider capturing the occasional sad time, along with all those other good times?

This little girl had just been given a flu shot from an outdoor medical clinic on the streets of Jaipur, India. Her mother was honestly elated when I showed her the photo and was quick to offer me her email address; that evening, I sent her a copy.

NIKON D500, NIKKOR 18-300MM LENS, F/6.3 FOR 1/200 SEC., ISO 100, DAYLIGHT/SUNNY WB

13

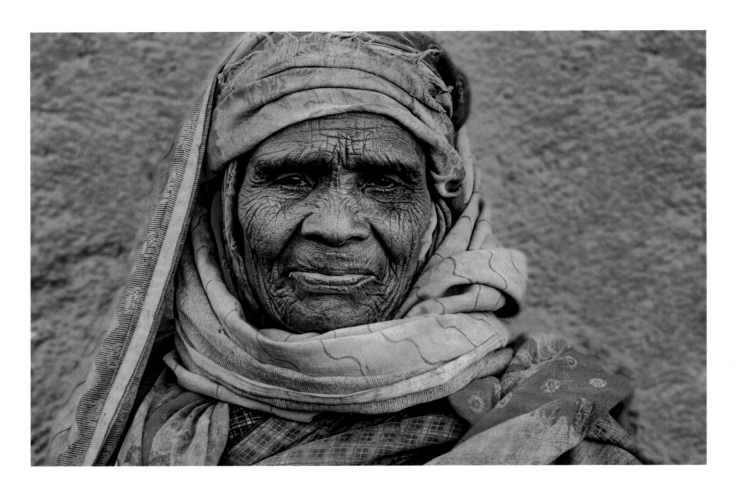

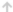

Following your very brief introduction ("Hi, my name is … I'm a photographer …"), what compelling reason do you offer a complete stranger you've asked to photograph? More often than not, my reasoning (beyond the fact that I find him or her "attractive") is that at that moment, in that light, in that location, and with their attire, I believe that I will be able to create a photograph they will find flattering. If I didn't believe that, then it would make very little sense to stop a stranger and take up their time for what is essentially a practice session. If you need practice, choose a friend or family member.

This woman was walking toward me on a very colorful street of painted houses in Old Harar, Ethiopia. She spoke just enough English to understand my desire to photograph her. The whole thing took, max, 15 seconds, including the 1/125 sec. it took to press the shutter release for the exposure you see here—of a great face, wrapped in colorful cloth, against a backdrop of complementary color.

NIKON D810, NIKKOR 24–120MM LENS, *F/11* FOR 1/125 SEC., ISO 400, DAYLIGHT/SUNNY WB

Approaching People

So you love photographing people, yet you don't like to approach strangers and your family is comprised of just so many members. Where are you going to find subjects to practice your craft? Short of being the most liked person in the world, most of us are lucky enough to make a few new friends each year, and how we make these new friends is, more often than not, through "referrals"—friend of friends—since rarely does the person we sit next to on the plane or share an elevator ride with become our best friend, let alone a photographic subject.

With that in mind, I still know of no better way (and yes, I'm aware of the countless "making friends" apps) to meet new people, people who can help expand your pool of subjects, than through referrals. In the workplace, this is called networking, and if you're a serious people photographer, the practice of networking should be high on your list of weekly tasks. The old saying "It's not what you know but who you know that counts" certainly applies to photographing people. You'd be surprised at the number of willing subjects your physician, minister, hairstylist, server, gas station attendant, and day-care center staffer can provide. And again, it does bear repeating that your sincerity and tone have a big impact on exactly how valuable these potential contacts will be for you.

Keep in mind that everybody you meet has a certain look that is unique to them, and the greater your circle of "looks," the greater your opportunities to photograph anyone from children to seniors with different styles of dress and under a host of environmental settings. And of course, "what's in it for your subjects" is a chance to have fun as well as record some great memories.

When I ask students why they don't take more pictures of people—in particular, of strangers—the answer I hear most often is "fear of rejection." They assume their request will be rejected, and rejection can sometimes sting. Truth be told, fear of rejection is justifiable. Throughout the world, the people you wish to photograph—friends as well as strangers—have something to say about you taking their picture, whether they express their opinion verbally or with a rude gesture. Even the strongest photographers feel a pang of rejection when a great subject makes it clear they are in no mood to be photographed. On more than one occasion, I have been turned down at what I felt to be the most inopportune time, as the location, the light, or the time of day was "perfect"— perfect for me, of course, but at that moment not perfect for a friend, family member, lover, or stranger.

The reasons people don't want to be photographed are, perhaps, many, but I've concluded that there are two main ones. First, most people say "no" simply because they feel that you couldn't possibly take a good picture of them at that time, at that place, wearing those clothes, and without them being able to "freshen up" first. Ironically, these reasons for refusing are the very reasons that draw you in in the first place: the time (the light is perfect), the place (the environment complements their personality or character), their clothes (their attire fits or contrasts sharply with the environment), and their appearance (dirty face, messy hair, sweaty brow, or the joy or sexiness they're exuding at that moment).

Second, people say no because they don't believe your intent. Again, nothing plays a more pivotal role in winning people's trust than the level of sincerity you convey. This is true even when photographing family members. Trust, like nourishment, is a universal need. Tell them why you want to take their picture.

↑

It can be frustrating when, at times, you can't communicate with someone who *does* speak your language and of course even more so when neither of you speaks the other person's language. It creates a level of frustration akin to sitting in a dental chair and being asked to answer important questions while your mouth is jacked open and full of dental instruments!

Despite several attempts to communicate with this street merchant in Jodhpur, India, I don't know how long he had been cleaning these very worn and battered pots and pans, nor whom his customers might be. But in a matter of minutes, his roaring fire and a mysterious white granular powder turned the insides of these pots into gleaming mirrors with better-than-new finishes. The speed at which he spun the very hot pots was really impressive; while one hand gripped each pot with a pair of pliers, his other hand wiped his "magic powder" on the inside of the pot and kept it spinning simultaneously.

It was the roaring flames and the spinning of the pot that triggered me to shoot at the relatively slow shutter speed of 1/20 sec., producing the motion effect. A note about postprocessing here: my primary exposure was for the dramatic, bright fire, which in turn created a lot of darkness in the shadows. To open up the shadows and recover detail, I later moved the Shadow slider to almost 90 percent, which accounts for the image's somewhat odd look—almost an HDR look, though it is only a single exposure.

NIKON D500, NIKKOR 18-300MM LENS, F/11 FOR 1/20 SEC., ISO 1600, DAYLIGHT/SUNNY WB

There's a reason, isn't there? Of course I've been turned down, many times, but I'm also quick to remind myself that every "No, thank you" means I am one person closer to an "Okay, why not?"

Rarely, if ever, am I a fan of shooting surreptitiously. I don't feel I'm being fair to the subject, and getting them to sign a model release will be difficult, at best, if getting model releases is your thing. Strictly speaking, there is not a stock photography agency in the world that would use a photograph of a person for commercial use (such as an advertisement promoting a product) without a model release. So to be clear, that great shot of the stranger who, to this day, has no idea you took their picture is useless in the commercial arena. (For more about model releases, see page 23.)

Although some photographers argue that being sneaky is the only way to get "real" people shots, I strongly disagree. I've shot some of my best "candids" because I made my presence known to the subject. The real joy in photographing people comes when subjects are free to pose willingly and when all parties involved agree that the final image is an accurate portrayal of the subject. And again, for those shooting digitally, you can share that accurate portrayal immediately via the monitor.

Finally, I want to stress just how important it is to listen to your subjects. As mentioned earlier, people do talk back, and oftentimes, what they have to say is worth its weight in gold. You may have everything all figured out in your mind, but don't be surprised if, after winning your subject's trust, they also have ideas about how they see themselves. One of the most important questions I've asked strangers as well as family members is this: "If you could look any way you want while being photographed, and in the environment of your choosing, what would I see and where would you be?" The answers may surprise you, but more than that, you may discover that they have is a favorite dress or a favorite hairstyle, or a favorite trick they can do with their eyes, or that they've always wanted to be photographed inside that barn down the road (a barn you've always wanted to get access to but didn't know who to ask). Or you may discover that they have a beach house and an infinity pool that meets up with the distant blue waters of the ocean, and now you have access to a location that would normally cost a fortune to rent.

Listening to your subjects, taking an interest in them, is absolutely vital. The many interactions I have had over the years have led to a number of the ongoing relationships I still have today, relationships that lead to invitations to return to these subjects' homes around the world, where awaiting me upon my arrival are several *new* subjects that my friends have found for me, thinking that of course I would like to photograph them as well.

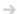

When you feel you've come upon a good portrait subject and, assuming the logistics are worked out (such as lens choice, aperture choice, background, and point of view), you will, in all likelihood, just before you shoot, feel compelled to say something along the lines of, "Smile please." Before you make that request, ask yourself what it was about the person that made you stop and consider shooting their portrait in the first place. Was it their smile, a gesture of their hand, or the intensity of their eyes? Maybe it was the light falling on them, or the color that surrounded them?

We are conditioned to always ask our subjects to smile, just as we have all been asked by family members or other photographers to smile since we were in preschool, yet there are countless portraits taken by photographers worldwide that would have been far more compelling without the subject smiling. Let there be no doubt that a genuine smile generates a warm response from the viewer, but don't forget to shoot "serious" portraits, too, especially when that is the biggest reason you were drawn to the subject in the first place.

This was certainly what attracted me to this "serious" shopkeeper in Chandni Chowk market in Delhi, India. At no point did I ask him to smile, simply because it was his forceful, intense gaze that caused me stop and take his portrait, along with the blue surrounding him that seemed to magnify the seriousness of his gaze. Maybe *not* having your subject smile is a better idea—something to consider on your next portrait outing.

NIKON D500, NIKKOR 18-300MM LENS AT 284MM, *F*/6.3 FOR 1/60 SEC., ISO 1600, DAYLIGHT/SUNNY WB

Honesty Is the Best Policy

Whether you know a subject or are approaching a complete stranger, tell them why you want to photograph them and what it is you have in mind. Be honest about your intentions. I can't overstate the importance of this. Don't walk up to the farmer at the roadside produce stand and tell him you're doing a story for *National Geographic* magazine when that's not true. Don't approach that woman on the beach and tell her you're doing a story for some travel magazine when you aren't. Tell the truth, and chances are good that your truth is my truth: "Truthfully, I am attracted to your look (or activity) and I know in my heart of hearts that I can make a compelling image of you that you will love!"

If you *are* serious about wanting to one day be hired by a magazine such as *National Geographic*, explain your aspirations to the farmer and that he could be instrumental in you reaching this goal, or confess to the woman at the beach that you aspire to freelance for a fashion magazine such as *Vogue*, and you need examples to showcase your creativity in photographing people involved in leisure activities. Most subjects, when told they can help you, are eager to do so, and of course the prospect of getting something in return—such as the jpegs or high-quality prints you promise to send them or, if necessary, financial compensation—is a bonus.

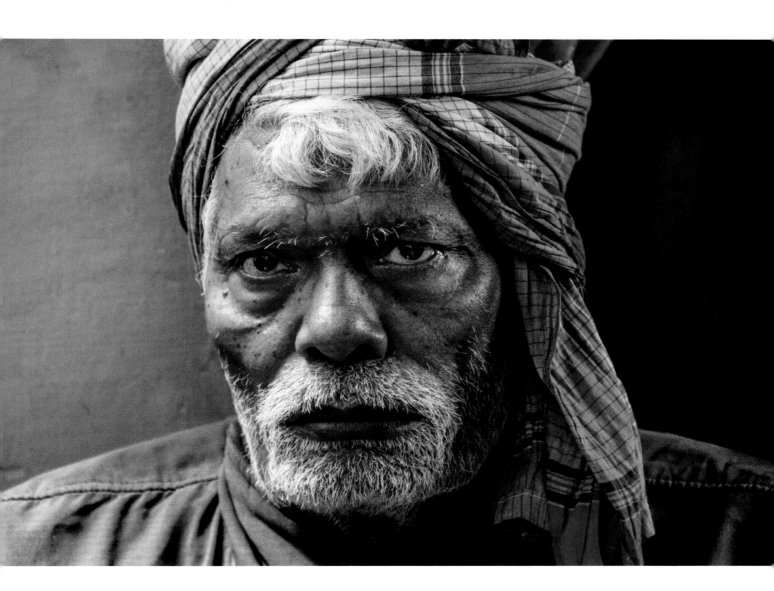

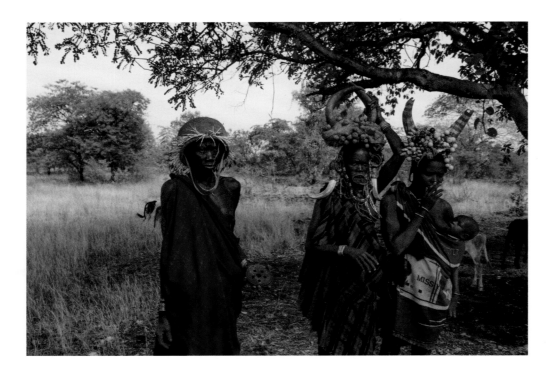

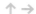

When it comes to photographing people all over the world, I first and foremost think about and look for potential backgrounds. In the studio, photographers shooting portraits and/or products are all too familiar with the importance of a "make or break" background. The background should be powerful enough to call attention to the person or product in front of it, but quiet enough that you don't notice it.

Compared to a studio, the world as we know it offers a far greater array of backgrounds in any number of colors, textures, and patterns, able to be rendered either in focus or out of focus, and with varying degrees of contrast, clarity, and tone—all effects that can usually be controlled in-camera by a combination of aperture, shutter speed, and lens.

Once I've decided on a background, I'll begin conversing in earnest with potential subjects. Following several minutes of conversation, which for me are intended to build trust as well as reveal a certain look I may wish to capture, I "move" the subject(s) into position and fire away, often while the conversation continues. These are usually meant to be simple portraits—eye-to-eye encounters between subject and viewer—and a clean background is, more often than not, key to their success. It's not dissimilar to doing background checks when interviewing people for a job: A potential employee with a clean background will be an employee without distraction.

As you can see in the photo above, the background of the portrait opposite is nothing more than the green foliage of a distant tree.

NIKON D500, NIKKOR 18–300MM LENS, *F*/8 FOR 1/250 SEC., ISO 320, DAYLIGHT/SUNNY WB

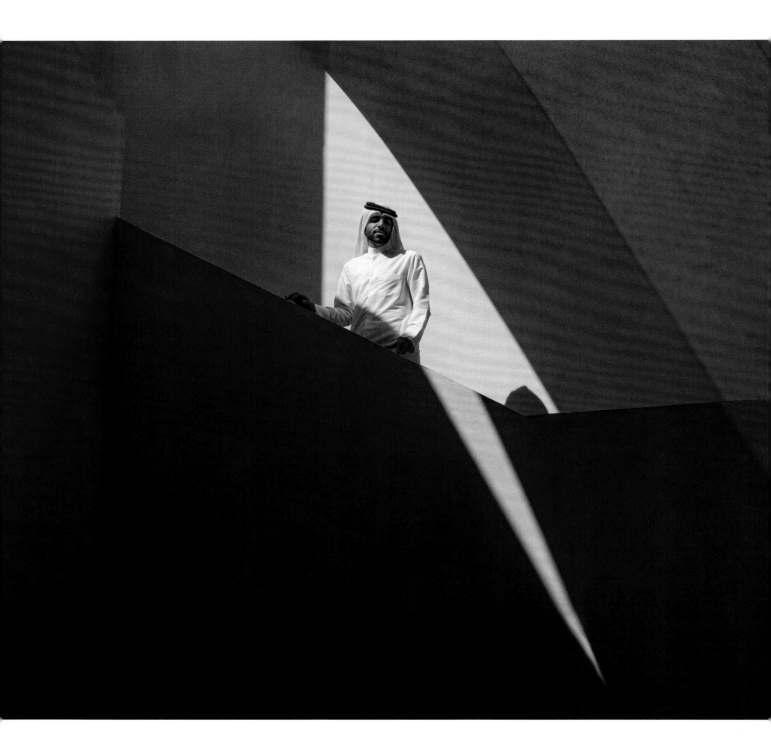

Getting People to Sign a Model Release Form

My students and readers of my books often ask me how I get complete strangers to sign model release forms. Of course, walking up to a complete stranger has its share of risk, but that risk is often minimized when you have a specific reason in mind when asking permission to take a picture. This isn't the time to simply say, "I don't have anything in mind, other than wanting to take some pictures of you." Rare is the individual who jumps on a waiting bus without first knowing where the bus is headed. You must at least offer up some reason for wanting to take someone's picture, and of all the "lines" I've used over the years, nothing has worked better for me than the truth. As already discussed, for me this truth is that I'm always looking to add more people images to my portfolio. I usually conclude by saying something like, ". . . and I'm hoping you can help me in accomplishing that goal by allowing me to take your picture." Nothing plays a more pivotal role in winning people's trust than the level of sincerity you convey.

When asking my subjects to sign a model release, I simply explain that someday I might get lucky enough to have the image published, and if I should get so lucky, I would do my best to see that they were made aware of it, but that, more important, I could never get the pictures I made of them published without their permission. "Can I get your okay on this release, which could allow both of us to have our fifteen minutes of fame?"

I still have paper model releases, but more often than not, my subjects now sign on my phone using a model release app. There are several of these on the market, but the one I have been using is called Easy Release.

As a general rule, I don't bring up the subject of model releases until the *end* of the photo shoot; there is no better time to ask someone to sign a release than when the excitement and enthusiasm for the photos you created is at its height. The only exception to this rule is when I'm dealing with hired models. I will ask them to sign the model release before I take the first photograph—something I learned the hard way years ago. At some point over the course of a two-hour (or two-day) photo shoot, a model may express reservations about photographs that they feel do not cast them in the most flattering light, figuratively or literally—while you feel just the opposite. Before you know it, the model might be refusing to sign the release unless the photos in question are not made available for commercial use. So when dealing with models, make sure that you get them to sign the release *before* any photos are taken. Sorry, but not all photographs of hired models are required to meet their approval.

Okay, so to recap: Some strangers will say no, especially if the interest you expressed in them was minimal at best, but more often than not, strangers are inclined to help you out and sign the release.

You see it: a wonderful arrow-like shaft of light creating a kind of superhero design that frames the subject, who stands atop a stairway, gazing out into an outdoor mall below. Quick, set the camera to "Sunny 16" and shoot before he turns away! Why use Sunny 16 here, instead of spot metering? Sunny 16 isn't influenced by white or black subjects, or any other color in a scene. It is a 100 percent manual exposure for sunny days that is older than the camera's built-in light meter: simply set your camera to f/16 with a shutter speed that is the same "number" as your ISO—i.e., if your ISO is 400, shoot at 1/400 sec. (For more about Sunny 16, see page 83.)

(For more about Sunny 16, see page 83.)

Did this subject sign a release? Sure. He was one of the attendees at the photo conference I was part of. Like I said, networking is another great source of "models."

NIKON D810, NIKKOR 24–120MM LENS, *F*/16 FOR 1/200 SEC., ISO 200, DAYLIGHT/SUNNY WB

Observing People

People-watching—everyone does it. It's not enough to just go up to anyone; you must watch to find the interesting subjects. And, whether you do it consciously or subconsciously, you make sweeping generalizations about the people you watch. "He looks like a football player," you remark about the 250-pound teenager with the thick neck at the mall. "She looks homeless," you think about the woman on the street with stringy unwashed hair, dirty jeans, and no shoes.

The broad generalizations and descriptions you make about people are greatly influenced by a number of factors, not the least of which are how you were brought up and Madison Avenue—i.e., print and television advertising. Beyond these, the three most important criteria that determine your reactions to the people around you are: (1) physical appearance, be it overweight, underweight, potbellied, athletic, blue-eyed, brown-eyed, natural, heavily made up, clean-shaven, bearded, weathered, youthful, long-haired, short-haired, blond, redheaded, and so on; (2) clothes, be they designer fashions, hand-me-downs, summer dresses, winter coats, business attire, formal wear, bathing suits, and so on; and (3) environment, whether it be work, play, city, country, school, church, mountains, desert, beach, a pool, in the United States, or in a foreign land.

As you observe people (whether they are relatives, friends, or strangers), listen to your feelings. Notice what you're drawn to: her walk, his mischievous grin, her long and bouncing hair, his blue eyes, her silly hat, his torn jeans, his wrinkled skin, her sports car, his automotive garage, her florist shop. Are you interested in the dirty faces and unkempt hair of the children from a broken home, or would you focus solely on the seven-year-old boy's worn-out sneaker and the dirty toe sticking out of it? Would you photograph the elderly man at the local diner with his coffee cup raised to his mouth as his tired eyes peer directly into the camera, or would you choose to photograph him looking off to the left or right? Perhaps a composition showing only his large, weathered hands grasping the cup showcased against his bright red flannel shirt would be more representative of what you're feeling.

The way you deal with your feelings determines which people you photograph and how you will eventually choose to photograph them. You might be less likely to photograph a subject who makes you feel nervous or frightened ("He looks mean, and he's big, too") than a subject who makes you feel warm and welcome ("He looks like my funny uncle, plus he smiled when I looked at him"). Another photographer, however, might find the "mean" subject appealing ("I can see the teddy bear beyond that mean attitude") and the smiling subject suspicious ("I don't trust that grin"). Understanding what you're drawn to visually is part of the art of understanding and photographing people. Everyone is unique, and it is these differences that makes capturing people so varied, challenging, and rewarding.

Street photography offers a host of challenges, but perhaps the greatest challenge of all is to *stay put* and believe the shot you are seeking will come to you!

In Paris, I came upon this storefront where wigs in all shapes, lengths, and colors were on display. At first I thought it might be fun to ask a bald man on the street if he would simply stop, turn toward the window, and look at the wigs—clearly an attempt on my part to stage the shot. But after only a few tries, the resulting images just didn't feel right. Surely someone might happen along and make this showroom window a good background. Some minutes passed when in from my left came this woman with red hair. High speed motor drive . . . done!

NIKON D500, NIKKOR 18–300MM LENS, *F*/8 FOR 1/320 SEC., ISO 1000, DAYLIGHT/SUNNY WB

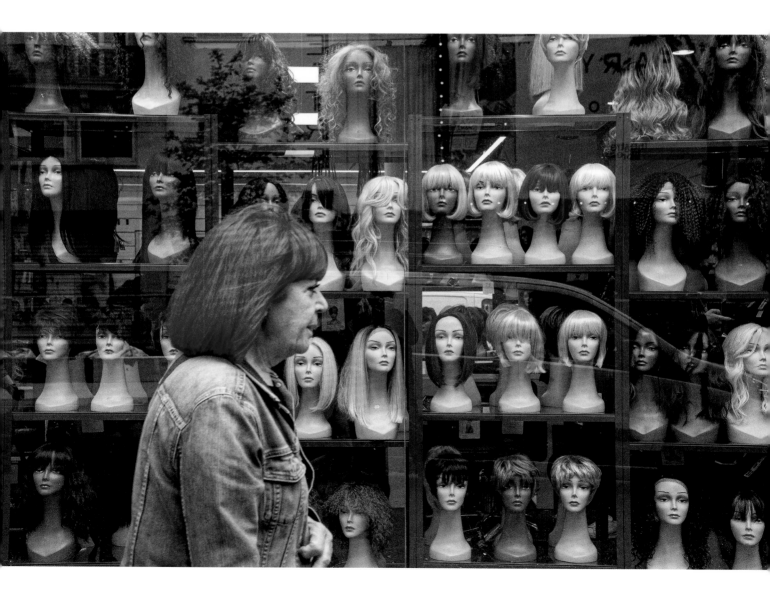

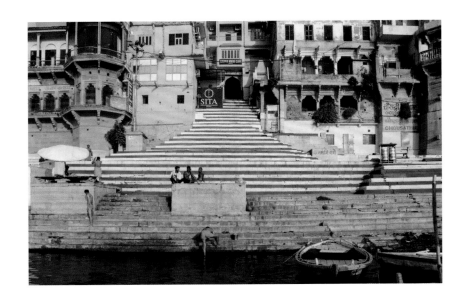

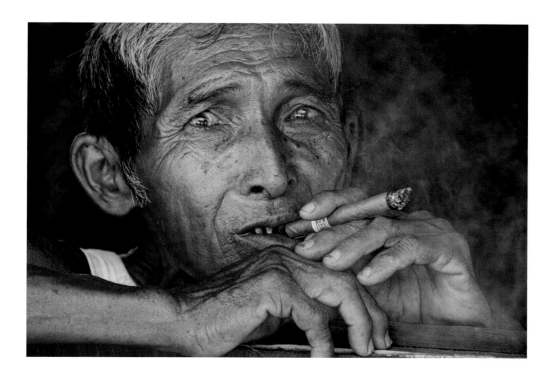

With the aid of a translator, I learned that this man was a peanut farmer living in a small village outside of Bagan, Myanmar. He was a married man, proud of his three children and two grandchildren. At fifty-seven years old, he had never traveled farther than forty-three miles, and that had been only twice, both times to the Buddhist temple atop Mount Popa. When I asked what one thing made him happier than anything else, I realized that I'd already been photographing his "happiest pleasure" for the last few minutes: "After a long day in the field," he said, "I love looking out my window and smoking a cigar!"

NIKON D810, NIKKOR 24–120MM LENS AT 120MM, F/6.3 FOR 1/400 SEC., ISO 200, DAYLIGHT/SUNNY WB

Shortly after you've shot the sunrise and the early-morning bathers in Varanasi, India, you and your boat captain would be wise to take a slow ride, hugging the shoreline of the Ganges as it snakes its way north through this most spiritual of Indian cities. Pay particular attention to the various steep and wide cement stair-cases that cascade down toward the river like expanding accordions, painted in shades of red, orange, pink, and blue that offer a welcome dose of contrasting color when the right person comes along. Wait for it, wait for it, wait for it. People come, people go . . . where are the colorful people this morning? Finally, here she comes, and *yes*, dressed in yellow: perfect!

NIKON D500, NIKKOR 18–300MM LENS AT 300MM (450MM EFFECTIVE FOCAL LENGTH), F/11 FOR 1/400 SEC., ISO 200, DAYLIGHT/SUNNY WB

People and Their Environment

Nothing can affect a subject's appearance more quickly than the surrounding environment. A portrait of a young man wearing a blue denim shirt sitting on a log at the beach can suggest that he is a solitary, introspective individual; however, a shot of that same man in the same clothing sitting on a bed in a jail cell might suggest that he's a hardened criminal or a sympathetic figure whose life took a wrong turn.

A tightly composed shot of a six-year-old girl's smiling face tells you only that she is happy; however, if you include the environment around her, you would convey a deeper understanding of her ear-to-ear grin because you'd show the blue ribbon in her hand as well as the Olympic-sized pool where she beat her competition in the background.

When you photograph people, whether at work or at play, the importance of the right environment can't be overstated. For example, if your seven-year-old has a gift for playing the piano, it makes sense to photograph him with the piano. If your boyfriend is a skin diver, then make sure to include the beach and palm trees in your portrait of him. And, if your mother or grandmother does, in fact, make the best homemade apple pie, then the kitchen (or an apple orchard) is the perfect backdrop for a picture of her holding her apple pie. Generally speaking, if the environment is going to be part of the composition, it should call attention to—or, at the least, relate to—the subject's character, profession, or hobby.

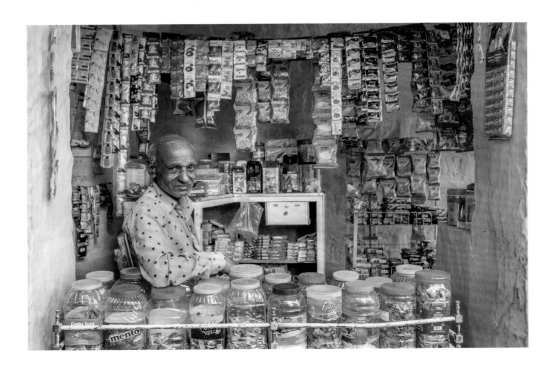

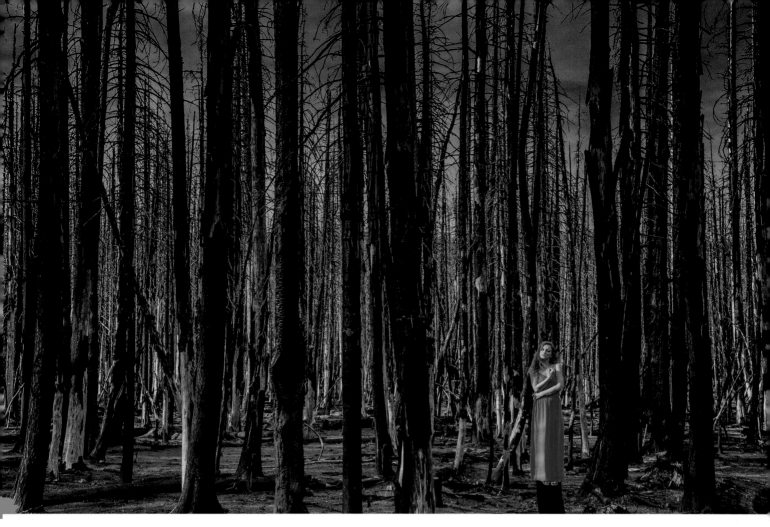

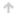

It was not a good year for the Pacific Northwest in terms of forest fires. Near the Mt. Adams wilderness area, including the pristine wildflower area of Bird Creek Meadows, a devastating fire wiped out hundreds of thousands of acres of Douglas fir trees, leaving in its wake a ghost town–like forest. There was, if nothing else, a clear opportunity to create images of contrast, which is exactly what I did by dressing Maja in a sparkling formal dress. Even more compelling, to my mind, is a nude photograph I shot of Maja standing on that same stump—naked, just like the trees all around her.

NIKON D500, NIKKOR 18-300MM LENS, *F/22* FOR 1/60 SEC., ISO 400, DAYLIGHT/SUNNY WB

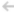

"I sell candy," said this truly "sweet" man in the Blue City: Jodhpur, India. "Been selling candy in this neighborhood for fifty-seven years, me and my wife."

Shooting on this narrow street of bright open shade made for an easy exposure. Since everything was a mid-tone "gray," I put the camera in Aperture Priority Mode at *f*/11 and fired away. (For more about "Who cares?" exposures, see page 172.)

NIKON D500, NIKKOR 18-300MM LENS, *F/11* FOR 1/200 SEC., ISO 320, DAYLIGHT/SUNNY WB

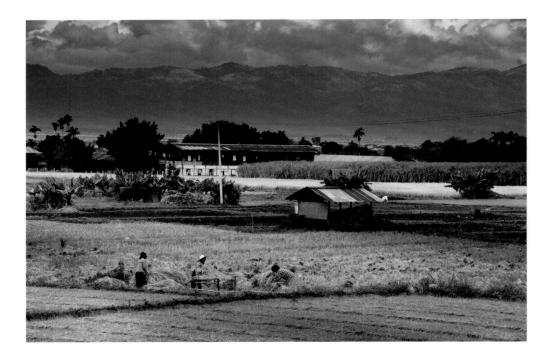

↑ ↗ →

How shy are you as a photographer? Unless you possess an inordinate amount of "extroverted" DNA, chances are good you will initially approach most strangers you wish to photograph with some degree of light-footedness and a gentle voice. I have often approached without my camera even visible, appearing to be intent on simply having a conversation—and sometimes, that really is all I want to do, at least for the first few minutes. It's a way to "take the temperature" of the possible subject (or should I say "take the temperament"?). Without a camera, I am, in effect, unarmed and harmless.

From the road, I could see that this rice harvest was well under way. I left my camera in the car, and my driver and I walked into the field. I began to take a genuine interest in the physical labor being performed by these women. After at least twenty minutes of careful observation, I had my driver explain that I was a photographer and would love to make some photographs, which they welcomed me to do.

I know of no better storytelling lens than the wide angle, the choice of most *National Geographic* photographers of days gone by. The reason for this is simple: it can shoot a close-up portrait while at the same time gather the all-encompassing landscape. With my ISO set to 1600, I was able to use a shutter speed (1/1000 sec.) that froze the action of this woman as she thrashed the rice, along with the all-important storytelling aperture of *f*/22 to record a massive depth of field, from the extreme foreground to the distant sky. This was a day to remember, if only because I learned that my skin itches terribly when exposed to the "chaff" that comes flying off of the rice bundles.

NIKON D810, NIKON 24–120MM LENS AT 24MM, *F*/22 FOR 1/1000 SEC., ISO 1600, DAYLIGHT/SUNNY WB

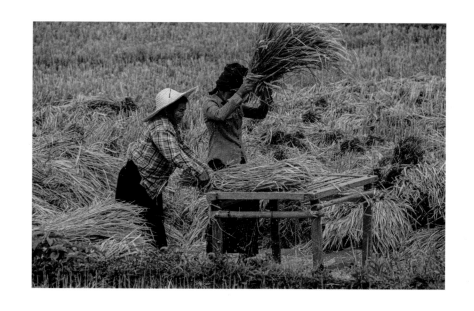

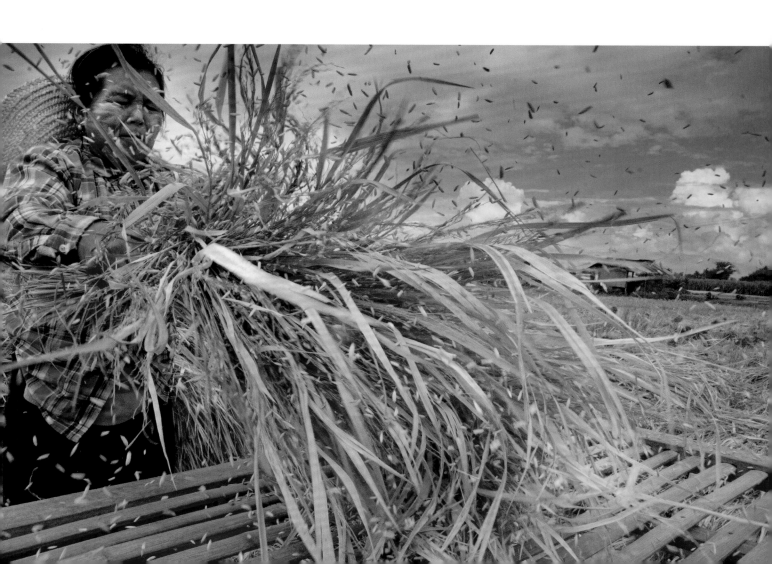

Contrasts

Besides obviously complementary environments, you can also photograph people in environments that contrast sharply with them. This is perhaps most evident in the work of some fashion photographers. Photographing models in coal mines, junkyards, or even huge bank vaults, for example, stands in stark contrast to the typical choice to shoot them frolicking on the beach, dining alfresco at a café in Paris, or buying flowers at an outdoor market—and is meant to surprise viewers. The contrasting environment calls attention to the clothing, and the viewer is quick to wonder, "Why would she be wearing that beautiful summer dress in a coal mine?"

Imagine for a moment the stark contrast of a nude figure lounging on the steps of the New York Stock Exchange, a well-known CEO sitting in an old, torn-up recliner inside a burned-out building, or someone dressed in winter ski clothing walking on a sun-drenched Hawaiian beach. Let your imagination run wild as you think up odd environmental juxtapositions for your photographs and you'll soon find yourself with a "shoot list" that will keep you busy making images for months, if not years, to come.

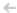

Around the world, spices are a normal part of everyday cooking, and in many parts of the world, Ethiopia included, a very hot and spicy red chili powder is as common as the salt found on kitchen tables throughout America. When I walked into one spice-grinding operation, the unmistakable scent of red chilies led me into a small, dark room where the air was filled with so much chili dust that not only did my eyes begin to tear up and burn but the interior of my now sniffling, burning nose felt like the perfect place for a fire drill!

Despite a working environment that would claim many victims, a lone young man was feeding hundreds of red chilies into the grinding machines and appeared as if the resulting chili powder was no more lethal than baby powder. I, on the other hand, continued with my near-death experience, only just managing to ask the young man to pose for a photo covered in all of his red chili glory. The room was extremely dark, I might add, and I found myself using an ISO of 6400, thus the somewhat grainy image.

Once outside in the fresh, hot air, I found a bottle of water and soon my throat was clear, my nose was no longer running, and my eyes no longer tearing. How does he do it—and still manage a smile?! My translator said that the man grinds for eight to ten hours each day! Needless to say, he is another person met on my world travels whose daily existence is beyond admirable. He'll keep grinding, and I'll keep shooting.

NIKON D500, NIKKOR 18-300MM LENS, *F/7.1 FOR 1/40 SEC.*, ISO 6400, DAYLIGHT/SUNNY WB

EXERCISE **Play with Environment**

Here is an exercise that I have my students do when I teach my online course about photographing people. It always proves to be quite revealing. The good news is you don't have to do this exercise with a total stranger—a friend, family member or coworker will be just fine. You will need at most several hours. With the emphasis on the environment, photograph that same person in no less than six different environments and notice how the environment has a direct influence on your perception of the person in that specific environment. Consider placing/posing your subject in the following environments: an alleyway, in front of a school, at a table in a coffee shop, near the edge of a stream or against a backdrop of ocean surf, in the forest, sitting behind the wheel of the car, standing in a doorway, sitting on a large set of stairs, lying on the ground while you shoot from above, in a pool hall, in a grocery aisle, etc. You'll quickly discover how the environment impacts your perception of the person being photographed.

People and Their Clothing

When you walk into a hospital and a person in a white uniform greets you, there's little or no question that that individual is a nurse. If, however, the same person were wearing faded jeans and a gray sweatshirt, you might question that nurse's abilities as a medical professional. Many people consider clothing to be an important barometer, indicating whether someone is rich or poor, liberal or conservative, playful or serious, meek or powerful. Simply put, clothing (or the absence of it) can define and redefine your character and personality. How many police officers look authoritative out of uniform? How many priests or ministers are identifiable as members of the clergy when they take off their collars? Defense lawyers are all too familiar with the power of attire, advising once shaggy-haired, raggedly dressed defendants to arrive in court with a haircut, suit, and tie to enter a plea of not guilty.

For most people, clothing is a primary form of identification and provides an immediate answer, albeit based in large part on assumption, to the question, "What do you do?" A portrait of a firefighter in uniform or a coal miner with an illuminated helmet leaves no doubt, as to how these people spend part of their time.

In many cases, clothing immediately identifies people's nationality or culture, as well. For example, if a young boy in lederhosen were to walk down a New York City street, many people might remark, "He must be from Germany or Switzerland." Similarly, a bald thirty-five-year-old man wearing sandals and a bright orange robe would immediately be thought to be a Buddhist monk. Granted, people stand out more when they are "out of place" (i.e., out of their normal environment), but what they also do is spark a vision of "another world"—or a larger world.

Finally, how many of us have toiled side by side with coworkers for months and not paid much attention to them until the company picnic? When you finally take notice of the people you work with on a daily basis, you discover that the usually conservative business attire of the white-collar world and uniforms of the blue-collar world give way to, perhaps, more revealing and flamboyant clothing. Keep this in mind when you're shooting, since clothing can add or detract from the essence of what you are trying to say about the person you're photographing.

↗

In this photograph of two young girls who have arrived at the market near the town of Turmi, in southeast Ethiopia, it is their vibrant, colorful dress that identifies them as African, easily differentiated from the standard attire of the United States, Asia, or Europe.

NIKON D500, NIKKOR 18–300MM LENS AT 100MM, F/11 FOR 1/125 SEC., ISO 400, DAYLIGHT/SUNNY WB

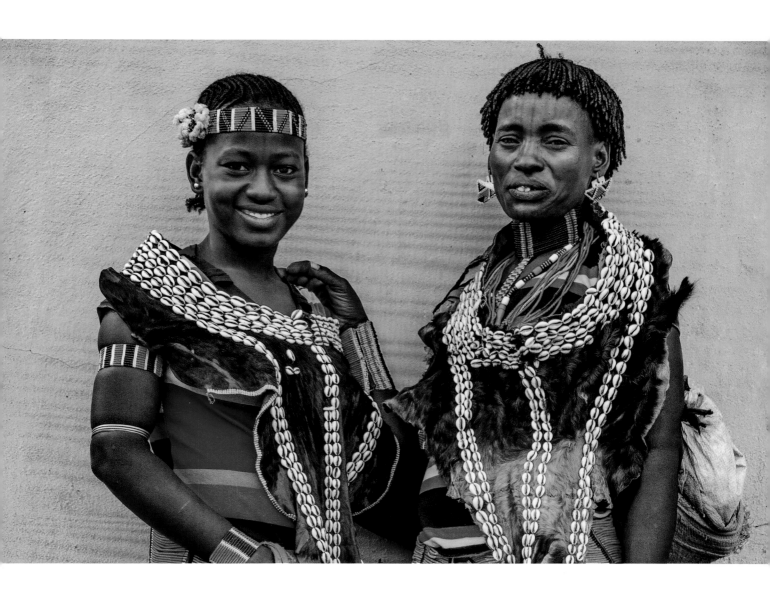

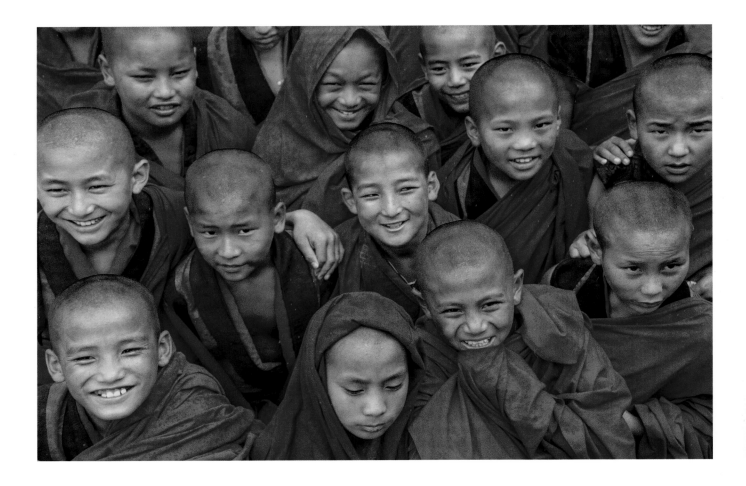

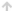

You would never guess that just an hour earlier, all of these young monks in Bhutan were engaged in a spirited game of soccer. Even when playing, they were still dressed in their familiar wine-red robes.

I felt it was important to shoot the boys from above, rather than making the standard eye-level group portrait with which we are so used to. I climbed up a small nearby rock wall and asked them to come in close and look up at me; being easily distracted young boys, some did and some didn't.

NIKON D500, NIKKOR 18-300MM LENS AT 35MM, *F*/16 FOR 1/200 SEC.,
ISO 640, DAYLIGHT/SUNNY WB

↓

Despite being set in an environment that speaks volumes about what we imagine or know to be true about the Mediterranean coast, this is a portrait whose success depends in large measure on the wardrobe. Yes, it is a red dress, but more than that is that it is a formal red dress, a party dress—not a dress for a funeral, not a dress for a job interview, and surely not a dress to wear in court when defending your client's burglary charge. It is the dress that defines the image and the celebratory mood; the environment serves only to call attention to where the "fun" is taking place. And speaking of the woman in the dress, she is Susana Heide Schellenberg, my coauthor on *Understanding Color*. She joined me in a recent workshop in Santorini, Greece, with the understanding that I would photograph her wearing one of her favorite red dresses as long as I, in turn, could use a photo or two for this book. Looks like we struck a deal!

NIKON D500, NIKKOR 18-300MM LENS AT 18MM, *F*/16 FOR 1/200 SEC., ISO 200, DAYLIGHT/SUNNY WB

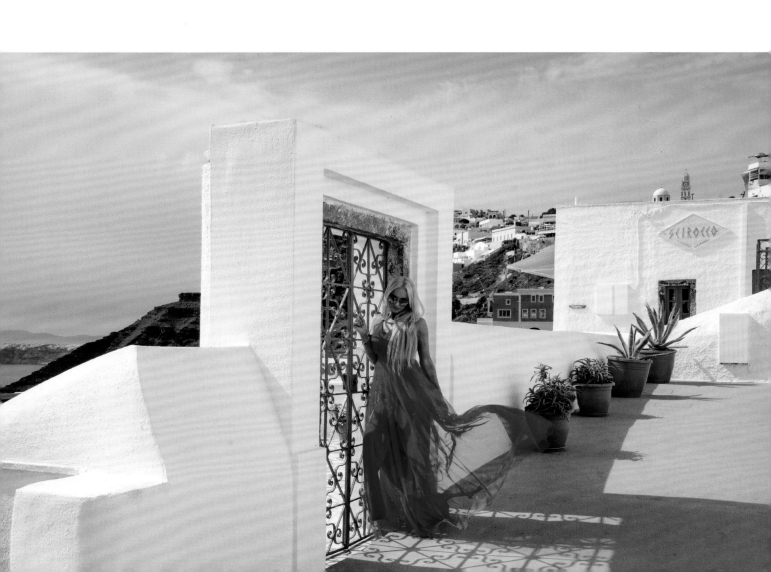

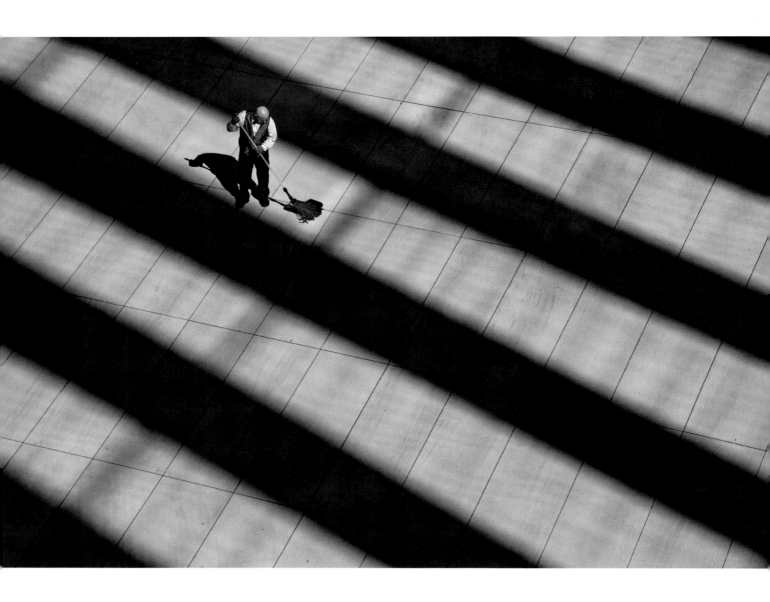

↑

In New York City, near the 9/11 Memorial, is the Oculus, understandably one of the most photographed architectural interiors in Lower Manhattan. Although this image does not call attention to the Oculus's modern design, it does call attention to its almost-empty ground floor on this weekday morning, as well as the maintenance worker mopping up a spill. Study this image for a moment. Notice anything unusual about the maintenance worker? It's his wardrobe! Simply because of the clothing he is wearing, his position feels elevated beyond the ordinary. I mean, look at his black slacks, shimmering vest, and the grand finale: a bow tie! I love it! All because of clothing, this guy is a "royal" maintenance worker.

NIKON D500, NIKKOR 18-300MM LENS, F/11 FOR 1/100 SEC., ISO 1250, DAYLIGHT/SUNNY WB

The Face as a Canvas

If the eyes are the window to the soul, the face is the wall that surrounds this window. And on that wall are a host of "knickknacks" on display that reveal character. The face suggests struggles as well as triumphs, compassion as well as anger. And that wrinkled brow? Does it speak of wisdom or depression?

Furthermore, the face not only conveys a multitude of expressions, but for many, it is also something to be adorned. In Western cultures, women and men decorate their faces in numerous ways, using anything from simple self-tanning

On the Face of It

How much information can you gather from the following scenario: You see two people facing each other at some distance from you but their faces are blocked from view. It's apparent, based on the sometimes subtle and sometimes rapid movements of arms and hands, that a conversation is taking place, but what kind of conversation is it? Jovial? Enthusiastic? Happy? Somber? Frustrating? Romantic? Sad? Any attempt at answering that question would be based, in large measure, on guesswork. Due to your distance, it isn't possible to make an assumption about a conversation that you can't hear without seeing the faces. If, however, you were able to clearly see both of their faces, you would be quick to note that the conversation was at times volatile, at times somber.

Experienced landscape photographers know that if the light or weather isn't quite right at a given moment, they must wait until it is (or come back when it is). Sometimes, the wait will only be minutes, but sometimes it may be hours or even days. In effect, landscape photographers must wait for the right "expression" to fall on the landscape, an expression that conveys the mood and emotion they wish to capture. And like the landscape (with its varying light and weather), the human face is ever changing. Expressions of anger, sadness, frustration, disappointment, doubt, indifference, and joy all might cross the faces of both people engaged in conversation.

Shooting close-up portraits of people's faces makes many photographers (and their subjects) uncomfortable. This type of "close encounter" confronts the boundaries of intimacy. Still, there are some photographers who thrive in this intimate environment; and they usually know the value of good conversation. Making your subject's face come alive for your photographs can be a challenge, to be sure. Startling questions, piercing statements, funny stories, and the simple comment "You look great!" can all combine to make your portrait work come alive.

To my mind, there is no better composition for a portrait than when you move in so close that you have, in fact, cut into the head. Sometimes this means cropping out the top of the head and some hair, and sometimes coming in even closer to cut off part of the subject's forehead. Even when the subject is a complete stranger to you, this deliberate crop creates a composition with an unusually intimate connection. Try it yourself and I think you will quickly discover the value in it.

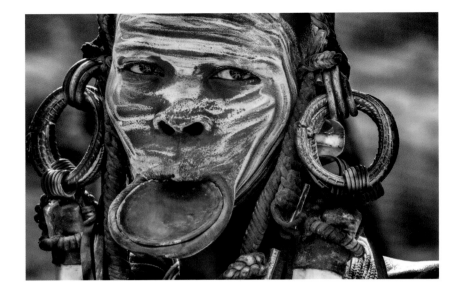

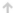

The wearing of these large clay lip plates is steeped in a tradition hundreds of years old. Women of the Mursi tribe in southeastern Ethiopia's Omo Valley begin cutting their lips around the age of twelve, initially inserting small discs and then, over time, these larger clay discs. It is a form of "makeup," a way to make one-self more attractive to single men of the tribe. Body scarification, the cutting of designs into the skin, is another tribal tradition, this one practiced by both men and women. Of late, some of the younger girls are saying "no" to the cutting of their lips, and in time this tradition may cease.

NIKON D800, NIKKOR 18-300MM LENS AT 300MM, F/7.1 FOR 1/500 SEC., ISO 200, DAYLIGHT/SUNNY WB

EXERCISE Creating Multiple Personalities with One Person

How many hats can you find in your closet, storage room, or attic? I have offered up this exercise to my students and oh my does it ever call attention to the power of the wardrobe! Five hats minimum, all different; they might include a simple ball cap, ski cap, fedora, cowboy hat, hard hat, beret, scarf, bandana, and a skull cap. Choose a friend, family member, or coworker and shoot up-close portraits against a plain background. Make sure to do this exercise on an over-cast day so you can avoid having to overcome the potential shadows that some hats will cast. You will be amazed at how quickly the "personality" of the subject is altered by a simple change in hats!

40

lotions to blush, lipstick, eyeliner, piercings, moustaches, and beards. In India, women mark their foreheads with different-colored dots to indicate their marital status (single, married, or widowed). Tribes in New Guinea place large disks in the lower lip, and tribes in Africa scar the faces of twelve-year-old boys with a hot stick as a rite of passage into manhood. Whether the face is adorned with a simple frown or smile—or with makeup, facial hair, or scars—how it is decorated says a great deal about the person, as well as the prevailing customs and culture.

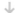

I was initially drawn to this eighty-nine-year-old Myanmar woman because of her unusual "blue" eyes, only to be quickly informed by my guide that the "blue" was cataracts. Yes, she could see, but her vision was always cloudy. As a photographer, I was reminded just how lucky I am to see the world so clearly. And should the day ever come that I, too, wake up with the onset of cataracts, I am doubly fortunate to have access to an eye specialist, unlike this woman.

The red/yellow background was a folded blanket initially sitting atop a nearby basket. With permission, my guide, with the aid of this woman's daughter, hung the blanket behind her as she sat on a bench in an area of open shade just beyond the sun's reach. Directly on the ground in front of her, bright golden sand lit up by the sun overhead acted much like a golden reflector, casting its wonderfully soft glow across her face.

From a distance of about three meters, and with the Nikon D500 and 18–300mm lens, I zoomed to around 220mm and shot the frame-filling composition you see here.

NIKON D500, NIKKOR 18-300MM LENS AT 220MM, F/6.3 FOR 1/250 SEC., ISO 200, DAYLIGHT/SUNNY WB

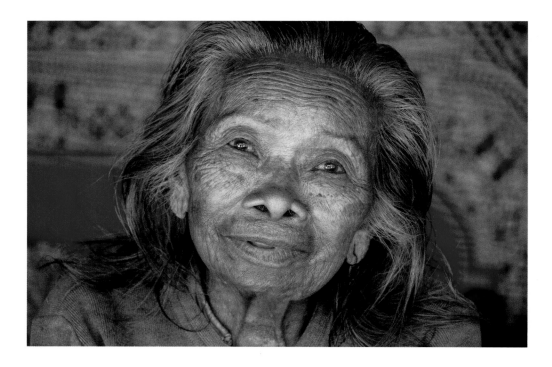

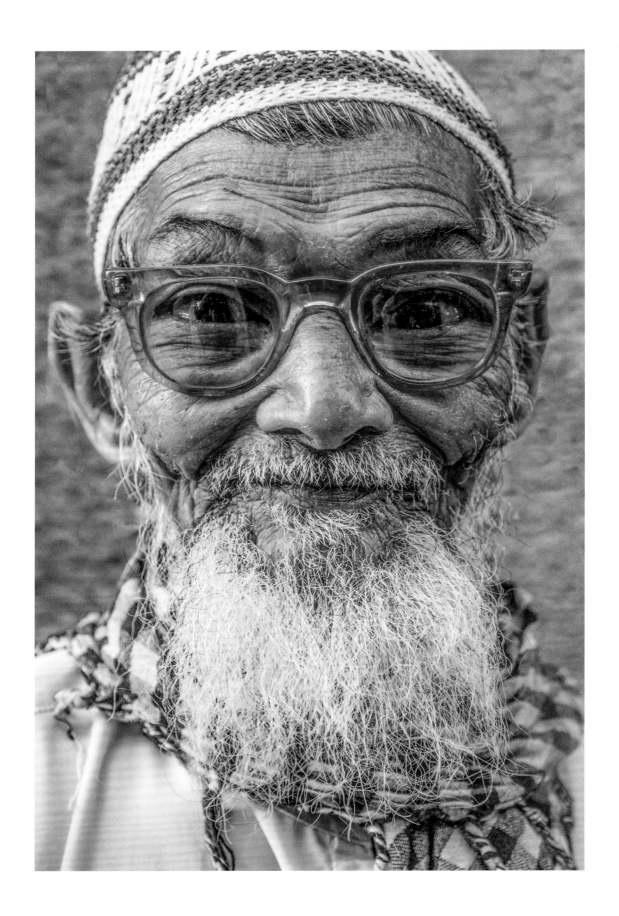

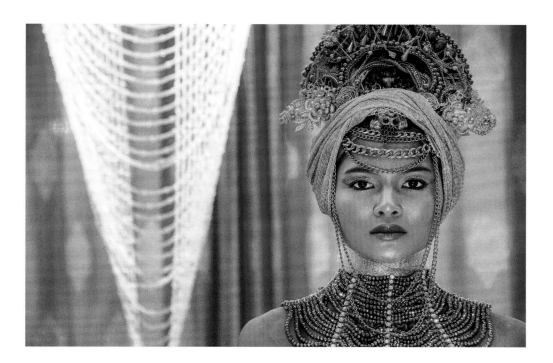

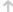

Perhaps no one understands the "face as a canvas" more than a makeup artist, since the face is, after all, their primary canvas. And I have met no one who is more passionate about the "art of the face" than Nattakun Plangedee, a makeup artist and model whom you'll see a few more times in this book, and for good reason. When Natt told me she wanted to dress up as a female King Tut, I knew the day would be both memorable and special, and we did create a number of great images that day, though none more elegant and "Queen Tut" like than the one you see here. Yes, Natt got away from the King Tut script, but I certainly was not complaining! This image was shot indoors with nothing more than the tungsten light that filled the large foyer of the second floor mansion that we had rented for several days of shooting in Delhi, India.

NIKON D810, NIKKOR 24–120MM LENS, *F*/11 FOR 1/200 SEC., ISO 800, DAYLIGHT/ SUNNY WB

While conversing with a young shopkeeper on the streets of Jodhpur, India, I felt a light tap on my shoulder. Thinking it might be one of my students, I turned around and was immediately greeted by a big smile from the gentleman you see here. "I just got new glasses," he said with the sort of excited voice normally associated with winning the lottery. "Will you take my picture please?" Moments after taking his picture, I learned that he had been without glasses for some time due to financial hardship, thus explaining his excitement about being able to see clearly once again. When photographing on the streets of India, it's not uncommon to be approached by the locals and asked to take their pictures, but this was the first time I was asked to help celebrate another man's vision!

NIKON D500, NIKKOR 18–300MM LENS AT 70MM, *F*/7.1 FOR 1/200 SEC., ISO 640, DAYLIGHT/SUNNY WB

Working with People

Choosing the Right People

A chief advantage that location photographers have over studio portrait photographers is the opportunity to photograph people in a seemingly infinite variety of environments all over the world. This freedom to choose not only which environment but also which people you photograph translates into far more opportunities to be truly creative. After all, there are only so many backgrounds one can use in a studio.

Perhaps more important, though, is that location photographers encounter subjects on their own turf, where, understandably, people are more likely to feel at ease, at least when they are first approached. But all of this freedom doesn't guarantee success. In truth, some of my most compelling subjects were at first the most resistant, but because they fit the part I imagined so perfectly, I simply had to be more patient than at other times. Eventually, short of someone being a fugitive or in a witness protection program, most if not all subjects will give in—if you are willing to invest the time.

The result of the increased subject variety that you get as a location people photographer is the increased importance of choosing the right people. One of the primary considerations of photographing anybody is making believable results. Whether you're on vacation or on a quest to someday be a commercial photographer, your goal should be to return with some hard evidence that you really did photograph a doctor or a homemaker or a lawyer or that fisherman from Scotland or that computer science major from Singapore.

Would you portray a person who is clearly overweight as a tennis pro? Would you portray a man dressed in dirty and worn-out clothes as CEO? Would you portray a very conservative looking twenty-five-year-old woman as the owner of a tattoo shop? Of course not, and it's not because you're prejudiced. It's because you want your subjects to be believable.

PRACTICE "Casting"

All of us have seen movies and, at one time or another, commented that an actor was miscast and not believable in a role. Perhaps you've even gone so far as to say that the actor didn't look the part. The same can apply to photography. Whether you're consciously or subconsciously thinking about someone's appearance, you'll find that there's always that one person you see who you feel is perfect for your planned composition. Whether your goal in selecting a subject is to win a photo contest or simply to add a compelling image to your photo gallery, think of yourself as a "casting director" and see how it influences your choices.

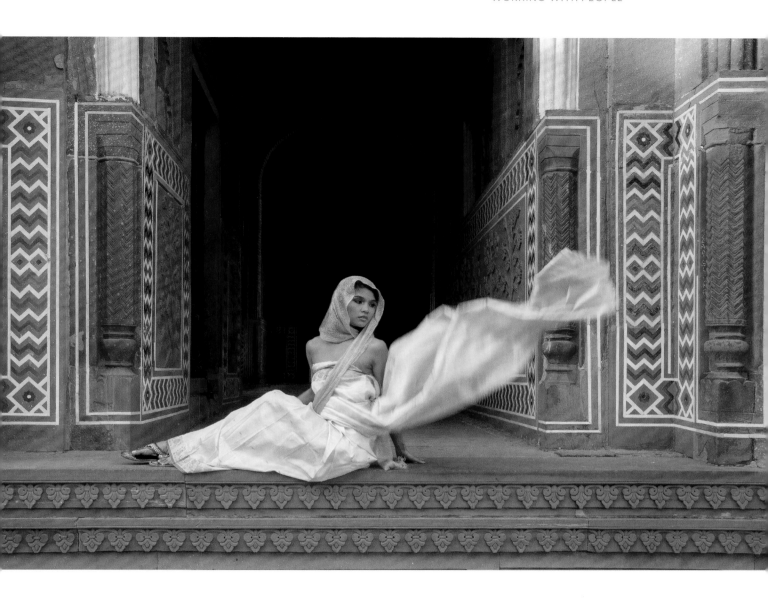

We planned an afternoon shoot in front of the Masjid (mosque) next to the Taj Mahal in Agra. The requirements for this shoot were easy: other than the need to wear Indian attire, Natt simply had to throw a portion of her dress in the air. Before it had a chance to settle, I would fire off a number of frames, intent on creating the illusion of a sudden gust of wind (a gust that you now know was named Natt). Over the course of twenty minutes we got more than enough material, thanks in part to the very high shooting rate (11 frames per second) of the Nikon D500.

NIKON D500, NIKKOR 18–300MM LENS, *F*/8 FOR 1/1000 SEC., ISO 400, DAYLIGHT/SUNNY WB

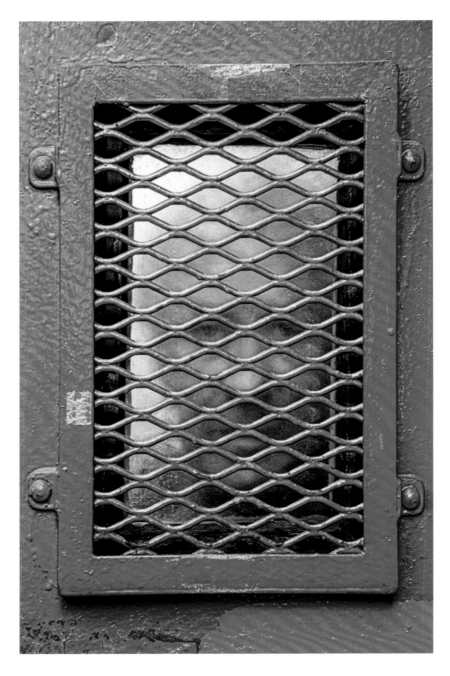

↑

Perhaps I've watched one too many episodes of *Lockup* on MSNBC—then again, if I hadn't watched that show, I might have walked right past this red door on a small street in New York City's Little Italy. The door was open, I might add, and fortunately one of my students was willing to play along. Even without knowing the backstory of this harmless photo, it might make you feel uneasy. My purpose in creating images is to (hopefully) make you *feel*, even if that means making you feel squeamish, uneasy, or even horrified.

NIKON D810, NIKKOR 24–120MM LENS AT 120MM, *F*/16 FOR 1/100 SEC., ISO 400, DAYLIGHT/SUNNY WB

Breaking Through the Shyness Barrier

One of the greatest challenges photographers face is learning to break through the shyness barrier; for some, that means not only the subject's shyness but the photographer's shyness, as well. Assuming you've gotten past the internal obstacle that keeps you from asking others to pose for you, how do you convey your intentions with sincerity, certainty, and confidence?

After talking with subjects for several minutes and getting a sense of them, I often ask a provocative question: "How do you define or see yourself?" Obviously, this question can't be answered with only a simple yes or no. It invites more conversation, and it's here where the experienced photographer has the edge—and now you will, too. At some point, you follow this question with another that I mentioned previously: "If you could look any way you want, wearing what you want, and do anything you want while being photographed, what would I see in the final image?" The purpose of this question is, of course, to draw the person into the photographic decision-making process, thereby opening them up to the idea of being photographed.

In addition, my success rate of taking pictures of reluctant people over the past fifteen years has exploded, and I owe a great deal of this "explosive" success to the use of a digital camera. I used to carry a Polaroid SX-70 with me, an instant camera similar to today's Fujifilm Instax. I would take snapshots of hesitant subjects, and quite often, the most resistant people were quickest to proceed after they saw the Polaroid of what I had in mind. I no longer need the SX-70, thanks to the immediacy of the digital camera's monitor. Putting people's minds at ease has never been easier now that they can clearly see, before I really proceed, just how great they'll look!

A final note about breaking through the shyness barrier: Some photographers insist on working alone when photographing people, without the aid of an assistant. I, along with scores of other shooters, feel the exact opposite. An assistant can engage the subject in conversation, keep an eye out for unbuttoned shirts or open zippers, flyaway hair, spinach in teeth, and any other potential problems that you might not notice. An assistant enables the photographer to concentrate on one thing and one thing only: creating great images.

I've shot on a few occasions without an assistant, and given a choice, I'll take an assistant every time. And just because you aren't a working professional certainly doesn't mean that you can't enjoy the freedom that comes from having someone else do the talking (as well as the "looking after") for you. If you know someone who enjoys engaging conversation and likes meeting new people, then you not only have a great assistant but a great "people gatherer." Put this person to work! You'll soon see a noticeable increase in the number of your people pictures—whether they be photographs of strangers in a foreign land, coworkers, or even just your family members.

A word of caution as well as another valid argument for employing an assistant: If you are engaged in photographing models, male or female, in any kind of intimate or sexual manner, whether semi-nude or fully nude, the assistant can also increase trust between you and the model, bearing witness that nothing unprofessional took place during the shoot. The last thing you need is to be accused of acting inappropriately, and having an assistant with you pretty much eliminates that concern for both you and your model.

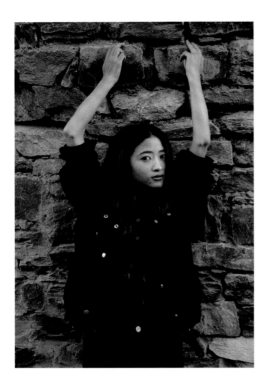

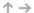

One of the shyest people I've ever photographed is Sita, a young Bhutanese woman. Sita was one of the employees at the eco-lodge where my students and I stayed over the course of four days. It was evident in my first encounter with Sita that neither I nor my students should even remotely consider photographing her because, by her own admission, she didn't like to have her picture taken, and she was quite adamant about it. Suffice it to say that following three days of friendly chatter, Sita agreed to meet me out back near the woodshed, away from every- one, in what quickly became a makeshift studio.

As you can see, we were shooting against a rock wall, but when Sita raised her arms and positioned them close to her head, her black denim sleeves created a black "frame," making for a very clean composition. Using Manual Mode, I moved in so close that my light meter only saw her face and none of the black—otherwise, the meter would have been influenced by the black and offered up an overex- posed setting in its attempt to make the subject gray. Also of note is that during the shoot it began to get a bit windy; although Sita was tempted to pull the hair back from her face, I asked her not to as I felt it added a welcome element of mystery. Sita was very happy with the images and, in fact, has already expressed an inter- est in "modeling" again when I return to Bhutan on my next visit.

Notice the blue cast in the background of the image above? I was on the north side of a building in open shade on a clear day—conditions in which many subjects and colors become "contaminated" by blue light. Yet this was one time I did nothing to get rid of it. In fact, I chose to enhance the blue light by adding about +30 percent of the Dehaze slider in Adobe Camera Raw during my brief postprocessing.

NIKON D500, NIKKOR 18–300MM LENS, *F*/7.1 FOR 1/125 SEC., ISO 320, DAYLIGHT/SUNNY WB

A Note about "Flaws"

If you've established a degree of trust with your subject (whether it's a family member, an acquaintance, or a stranger), most people will share some fairly intimate—and sometimes even startling—details about their lives and preferences. At some point in the conversation, you'll probably learn about a physical "flaw" your subject has and hates, and which makes the idea of being photographed unappealing. Ironically, it might be that very thing that drew you to this person in the first place. So how do you overcome that? In some cases you don't, but more often than not you might want to point out the positive aspects that you saw in the "flaw," whatever it was.

For example, if a person is self-conscious about wrinkles, feeling that all they do is serve as a reminder of lost youth and vitality, you might explain to your subject that you were drawn to this face of great wisdom, a face on which so many stories have clearly been etched. It's a triumphant face, a face of joy and sadness, a face of love won and love lost. It's a beautiful face that makes you feel safe. You know that you are in the presence of someone much wiser than yourself.

On the streets of the Mediterranean town of Cassis, France, the early-morning sidelight was casting its warm glow across the well-worn wall of what had once been a bakery. A portion of the strong sunlight was blocked by a large building across the street, causing a wonderful framework of shadow to wrap around both ends of the wall. As any experienced street photographer will attest, once you find a "treasured" location, be patient and the much-hoped-for "jewels" will appear. Over the course of the next twenty minutes, my students and I captured a number of locals walking through this scene, but everyone agreed that it was one of our own workshop participants, Mike McCoy, who volunteered to walk through the scene as a "local," who proved the most believable. Because this scene is flooded with the full sun of early-morning, all it required was the simple and reliable exposure formula of Sunny 16. (For more about Sunny 16, see page 83.)

NIKON D500, NIKKOR 18-300MM LENS AT 38MM, *F*/8 FOR 1/400 SEC., ISO 100, DAYLIGHT/SUNNY WB

Posed Versus Candid

Photographers all over the world frequently debate whether posed or candid portraits are more pleasing. I think that both types of portraits can be appealing when the photographer's primary goal is to depict the subject as accurately as possible. Everyone has been asked to pose for the camera at one time or another, even if it was just for a school portrait. For most people, those shooting sessions were very impersonal (and date back to kindergarten, I might add), and they were directed by the photographer to move, stand, or sit a certain way; to tilt their head "this way" or "that way"; and then, hardest of all, to "look right into the lens and smile."

Candids, on the other hand, are usually pictures of people who were unaware that their picture was being taken, or—and this is where the debate gets really interesting—they are pictures in which the subjects *appear* to be unaware that their picture was being taken. In "true" candids, the subjects are not directed or told what expression to convey; they are just being themselves at that moment in time. Unlike with posed portraits, with candids at no time is the presence of the photographer actually felt.

But what if the photographer is able to convey the idea of a candid moment while the subject is fully aware of the photographer's presence? For years we were led to believe that the famed French photographer Robert Doisneau had really captured a great candid of a couple sharing a kiss as they passed in front of an outdoor café and his waiting camera. The image, *Le Baiser de l'Hotel de Ville*, was and—as far as I am concerned—still is one of many Doisneau greats. But now we've learned that Doisneau staged the scene, instructing his models to cross in front of the café, sharing their kiss and warm embrace repeatedly, until he felt he had the one shot he needed.

In Doisneau's defense, I wouldn't be surprised if he had, in fact, seen another couple in a warm embrace, sharing a kiss as they walked in a somewhat hurried pace past a café he was seated at. I could believe that he might not have gotten that shot, but might have made a mental note of it and was soon engaging the help of some friends to re-create that moment. And what's so wrong with that? Back in 1950 when he made this image, the streets of Paris were often festive—the German occupation had ended only a few years before and love was once again in the air. It was time to be French again, and this, of course, meant open displays of affection. So what if he staged a moment?! The fact is, he should be commended for staging it so well. No one ever questioned that it was an authentic candid for all those years. Staged or not, does it really take away from the "truth" that the image expresses? It was an exciting and liberating time to be in Paris, a time to celebrate, and the image captured the spirit of that moment for all the world to feel and share.

As I've said in some of my other books, every photograph is a "lie," and if it succeeds, that lie will be full of truth. The lie I refer to here is, of course, the lie of composition. By the very act of selecting a certain composition, the photographer presents only a small portion of the scene—thus, the start of the lie. The tight crop of a full-frame shot of a child who smiles for the photographer says nothing about the real world of poverty that surrounds her; missing from the photographed scene is her house made of corrugated metal, the four starving dogs sleeping on her porch, and the raw sewage running past her house in the nearby ditch.

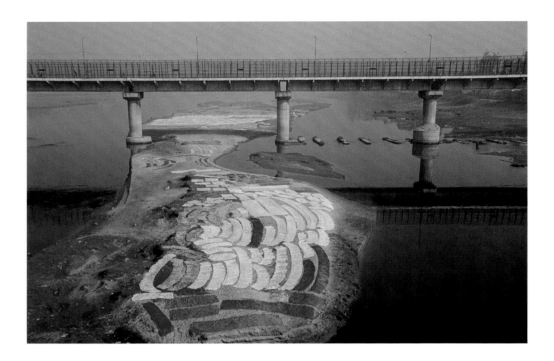

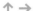

The Yamuna river runs right through Agra, India, a city most notable for being home to one of the Seven Wonders of the World, the Taj Mahal. Unlike the famous Ganges river, which runs through the holiest of India's cities, Varanasi, the Yamuna, in the minds of most, is "just a river," yet for me the banks of the Yamuna are the most colorful ones I've ever seen. Some days, they become carpets of color as freshly washed curtains are laid out to dry, creating a colorful patchwork quilt large enough to cover three hundred king-size beds!

On this particular morning, the laundry had already been washed and laid out to dry, but I needed someone to be near the laundry to lend a sense of scale and some human interest. Who could I find, especially while standing above it all, perched high atop a bridge? A few minutes went by and I spotted a couple of young boys bathing in the river, about fifty yards away. After some yelling on my part (which may have at first been interpreted as that of an angry old man), the boys figured out that I was asking them to play the lead role in my "movie" and soon they were running through the laundered fabrics, careful not to step on them. When all was said and done, I folded two 100-rupee notes into paper airplanes and let them fly into the excited hands of my young "actors." The boy in motion, combined with the bright colors surrounding him, infuses the overall composition with a sense of unbridled enthusiasm for the colorful life in which we live.

NIKON D500, NIKKOR 18-300MM LENS AT 247MM, *F*/11 FOR 1/320 SEC., ISO 200, DAYLIGHT/SUNNY WB

Ultimately, my feeling on the debate of *real* candid photos versus *staged* candid photos, or candid portraits versus posed portraits is simply this: If it makes me angry, if it makes me sad, if it makes me laugh, if it makes me feel, then it's the truth. If the subject conveys the message that you are trying to get across—regardless of whether you've staged, created, or even re-created the scene—and it does *not* look staged, then as far as I'm concerned, it is the truth! Hollywood has been staging, creating, and re-creating the "truth" for years, so why not photographers? Why not you?

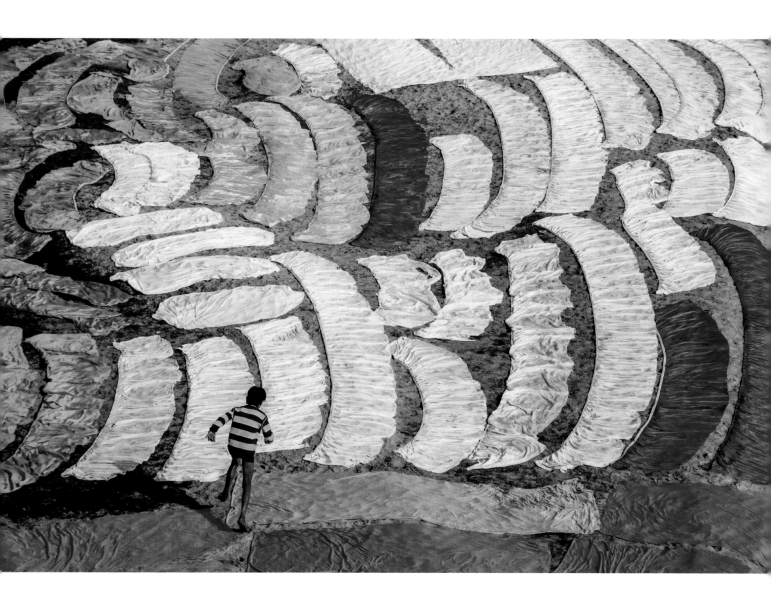

This example may feel a bit too extreme for some, but one technique that has proven effective for me, over and over, is to suggest to the person I'm shooting that they have just run into a large spider web and are trying desperately to get both the spider and the web off their face. That was certainly the suggestion here, during one of my many photography adventures in Myanmar, and I think it's fair to say that the idea produced a believable candid moment, allowing me to capture a gesture that suggests that we are witness to some truly happy news or the punchline of a great joke. As this woman's arms started flailing, natural and spontaneous laughter erupted from others in the room—so who's to say that the "moment" I captured isn't real?

NIKON D500, NIKKOR 18-300MM LENS AT 120MM, *F*/7.1 FOR 1/320 SEC., ISO 800, DAYLIGHT/SUNNY WB

In this example, you, the viewer, are able to "run" freely throughout the entire composition, since the subject has clearly turned her back on you—but then again, not so fast. Perhaps you are feeling a bit cautious? Do you feel the need to tiptoe quietly around the photograph, since you are not sure who you might "wake up"? Who is it, exactly, under that bright red hooded scarf? Relax . . . it's my daughter Chloë, who I directed to turn away from the camera to create a feeling of mystery, maybe even one of ghostly "horror" if we're not careful.

Although not that common, it's certainly possible to evoke emotions from the viewer—emotions by which the viewer might feel threatened or deep connection to—in the absence of direct eye contact. But when the subject of a photo looks straight at the camera, and thus the viewer, the viewer will feel a clearer response.

NIKON D500, NIKKOR 18-300MM LENS, *F*/11 FOR 1/200 SEC., ISO 400, DAYLIGHT/SUNNY WB

Eye Contact

Do the subjects of all your portraits need to look directly into the camera lens, making eye contact with the viewing audience, to be effective? In my opinion, the answer to this question is, more often than not, yes. But it's not always possible to manage this when shooting true candids, since for most candid photography, the subject isn't aware of the photographer's presence and, therefore, rarely (if ever) makes direct eye contact with the photographer and camera.

For the viewer, this lack of eye contact sometimes enables a greater study of the overall composition, since the viewer's eye is not drawn into the direct gaze of the subject. Additionally, viewers can easily laugh at the subject's plight or feel the subject's pain without feeling that they are lacking in sensitivity. On the other hand, when the subject of a photograph looks straight at the camera, regardless of what that subject might be doing, the viewer has a tendency to feel more deeply in response. This direct eye contact is, of course, all about connecting with one of our own. We don't feel the same connection when, for example, we make eye contact with a chicken or a cow. If we did, I doubt if many of us would be eating chickens and cows.

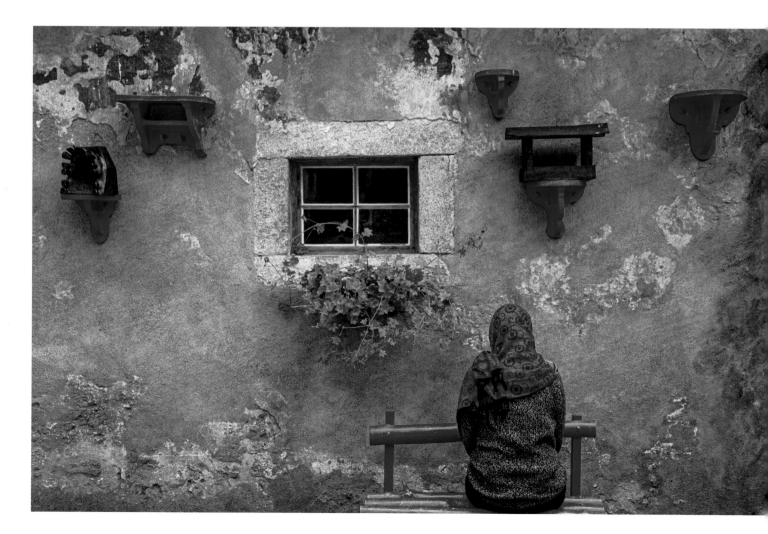

EXERCISE Creating Welcomed Gestures

Small, subtle gestures or suggestions from the subject can go a long way in exuding an "emotional" moment that could prove to be the decisive moment to photograph. Here are a few exercises to bring out that emotional moment: 1) As mentioned in the caption on page 56, have the person act as if they just ran into a spider web, 2) Ask them to pretend to swat a fly, 3) You (the photographer) fake a yawn and be ready for the subject to move their hand across their face as they try to now cover their own yawn in reaction to yours, 4) Ask the subject to focus on the pretend butterfly that just landed on their nose, 5) Have the subject count out loud, while smiling, with one hand opened and the index finger on the other hand counting each finger, "one, two, three, four, and five," and again "one, two . . ." all the while shooting, 6) Have them count again, but this time with a scowl, 7) Have the subject pretend there is large bowl of water in front of them and to take both hands and throw water on their face, 8) If the subject has long hair, have them turn away from the camera then quickly turn towards you with their hair flying and a large smile across their face.

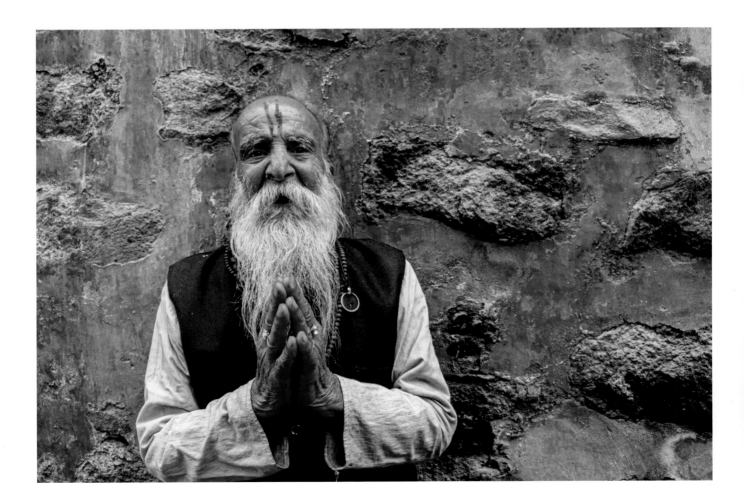

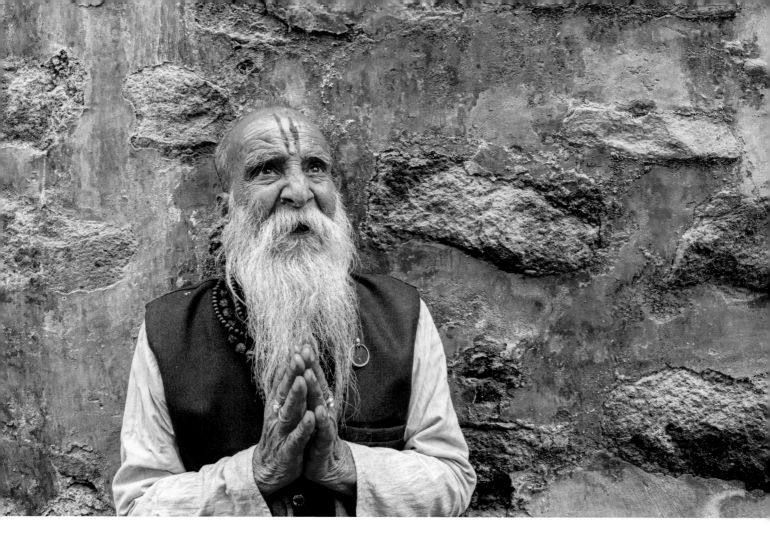

← ↑

In looking at both of these photos, it's obvious which one allows the viewer to wander about a bit without fear of being "caught"—and, of course, it is the photograph of the man clearly looking away, up toward the heavens. When he looks at you, you may feel inclined to look away (or not), but for sure, your emotional response will be in marked contrast to how you react when he is looking away. It is an important point if only to understand how your audience may or may not perceive the "story" about the people you photograph, particularly in portraits. Should they be looking at you or away at something else? Why not try both?

NIKON D500, NIKKOR 18–300MM LENS AT 45MM, *F*/8 FOR 1/320 SEC., ISO 100, DAYLIGHT/SUNNY WB

PLANNING & PROPS The Advantages of the Staged Candid

In many of the pictures in this book, my subjects were fully aware of my presence—yet I contend that many of these images qualify as candids. If only because photography is first and foremost a business for me, I rarely have the luxury of shooting true candids. I always try to have my subjects sign model release forms, and many times, I'll get them to sign a release before I've even taken the first picture. If I don't have the necessary release, I can't lease or sell the rights to the picture for commercial use, and chances are good that in today's litigious society I wouldn't be protected either, even if my work was limited to gallery exhibitions. Thus, I have no choice but to announce my presence as well as my intent.

The obvious advantage to working with subjects who are aware of your presence is that you are better able to plan your shots than you would be in a truly candid situation. And many photographers often want to include props in staged candid shots. The reason for this is that props call attention to the subject's "identity" (interests, talents, or profession). Again, this prop may, in fact, have nothing to do with the subject, but if the casting is done well, it does indeed make the image that much more believable.

A prop can be prominent (such as a pet boa constrictor hanging about the neck of a street magician), or it can be part of a background (the '65 Mustang behind the car buff). Either way, props are useful. Let's say you see a woman wearing jeans, a flannel shirt, a cowboy hat, and cowboy boots, against an out-of-focus background of green tones. Does she live in the country? More than likely. Does she own horses? More than likely. Does she listen to country music? More than likely. And you gather all this information not from the surroundings in this case but from the props (here, the clothing). Is she really a cowgirl? If you believe it, then she is!

Additionally, some props (such as musical instruments, garden tools, artwork, books, fruits and vegetables, a glass of iced tea, a teddy bear, or a cell phone) can solve the problem of what to do with the subject's hands. And subjects are more likely to feel relaxed when holding familiar objects. Obviously, choose props that are appropriate for the subject. For example, don't put a shovel in the hands of a man whose fair skin and overall look screams that he spends all of his time indoors.

↗ →

Although I was not *that* surprised, I did discover while editing the many photos for this book that I had a ridiculously small collection of images in which the subjects are not looking directly at the camera. In the two photographs here, the children are engaged in the act of blowing up balloons. (I sometimes carry balloons with me when traveling, an idea I got from one of my students.) Clearly, the youngest girl seems to be having a hard time of it ("I think I can, I think I can . . ."). As you look at the photos, it's easy to relax and smile, as the absence of intimate eye-to-eye contact puts you in the role of a passing stranger.

↗ NIKON D500, NIKKOR 18–300MM LENS, *F*/8 FOR 1/400 SEC., ISO 200, DAYLIGHT/SUNNY WB

→ NIKON D500, NIKKOR 18–300MM LENS, *F*/7.1 FOR 1/320 SEC., ISO 400, DAYLIGHT/SUNNY WB

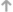

There he was, on the corner of 47th Street and Sixth Avenue in New York City, with a large smile across his face, answering the call of anyone who wished for a large, flavor-filled dollop (or two) of ice cream on that warm July day. As I've learned over the years, most entrepreneurs are agreeable to having their photos taken, especially in today's world of social media. "I would love to make a photo of you and your brightly colored ice cream truck and share it with my many followers on Instagram!" I said. In between his many customers, I managed to record this simple yet effective portrait conveying the child-like joy this man experiences with every ice cream cone he makes for his happy customers.

NIKON D500, NIKKOR 18–300MM LENS, *F*/11 FOR 1/320 SEC., ISO 200, DAYLIGHT/SUNNY WB

People as Themes

Most, if not all, photographers have experienced what I call *photographic depression* at some point in their lives. It may last for several days, weeks, or even months—no matter how hard we search our storehouse of creativity, we periodically find that the shelves are empty. For some photographers, this lull can be downright frightening, especially when it coincides with an important event or assignment. It's an especially serious problem for professional photographers, who are expected to deliver the goods and who seldom have the luxury of taking off for an extended length of time to "restock" the "shelves of creativity."

When I think about my own dry spells, I find that they usually happen when I'm shooting without a purpose or theme. Although subjects for themes may come relatively easily to nature photographers, people photographers might find it harder to define themes for their work. For example, a nature photographer can easily choose from waterfalls, barns, trees, flowers, butterflies, forests, mountains, deserts, or animals for themes. But when I suggest to students whose primary interest is photographing people that they consider a theme, they often look confused. Some students respond with ambivalence; they think that a series of simple headshots would hardly be a compelling theme. I might agree that a series of simple headshots is hardly compelling, but what if those same headshots were limited to people who were bald?

The first step, of course, is to select a theme. Suppose you decide to photograph only those individuals who have a deep love of gardening. You might begin by driving around your neighborhood, taking note of the yards that look as if they should be featured in *Better Homes & Gardens*. Stop your car in front of these houses, knock on the door, and introduce yourself to the owners. Compliment the people on their yard, and then briefly explain your current photo project (shooting portraits of gardeners). Since you're proposing to photograph homeowners in an environment that calls attention to their favorite pastime, people will probably agree to pose for you. As you develop this theme over time, you'll discover surprises in your pictures that you might not have even thought of when first planning these shots. For example, you might find that most of the gardeners have weathered complexions and rough hands, wear loose-fitting cotton clothes, and seem rather tranquil in nature.

Obviously, these pictures would be vastly different from a series of shots for which coal miners are the theme. Their world is usually dark, their faces are seldom clean when they work, and their eyes often seem scarred with fear.

Children provide an opportunity to shoot a theme that's often overlooked because it's so obvious. Beginning with your child's first birthday, have the child sit on a kitchen chair and hold the birthday cake. Repeat this exact composition for the next seventeen years. The resulting images will be fun to look at and cherished for a long time.

Other potential themes: people who wear hats, have blue eyes, have red hair, drive BMWs, wear uniforms, own horses, drink beer, make homemade jam, or work at the country store. Clearly, the list of potential themes is endless.

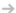

Never before or since have I consumed as much tea in one day as I did on this day in the small village of Myotin, Myanmar. Over a three-hour time period, I drank nine cups of tea. Tea was obviously the drink of choice, so it seemed only fitting to photograph one of my many subjects with a cup of tea.

In this instance, I saw an opportunity to showcase this elderly woman's colorful dress and her cup of tea along with the hands and feet that have toiled daily for many years, both in the nearby peanut fields and in her kitchen at home.

NIKON D810, NIKKOR 24–120MM LENS, *F*/11 FOR 1/100 SEC., ISO 500, DAYLIGHT/SUNNY WB

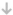

As I was walking down a narrow corridor in Jodhpur, India, I heard the sound of a television, and when I looked up, I saw a doorway about fifteen feet in front of me. It was slightly ajar and two feet were propped up—yeah, well, that was good enough for me, so I raised the Nikon D500 and the Nikkor 18–300mm lens to my eye, zoomed in a bit to the 120mm mark, and framed up the doorway and feet just as you see them here. There were some minor depth-of-field concerns since I was at an angle to the house and doorway, which meant that some of the image would have been out of focus. Since I wanted it all sharp, I shot the image at *f*/13 for added depth of field. Then I adjusted my shutter speed until 1/200 sec. indicated a –2/3 exposure (in the camera's light meter) and fired away. (For more on why I selected a –2/3 exposure, see "A Note about Underexposing on Purpose," opposite.)

NIKON D500, NIKKOR 18–300MM LENS, *F*/13 FOR 1/200 SEC., ISO 400, DAYLIGHT/SUNNY WB

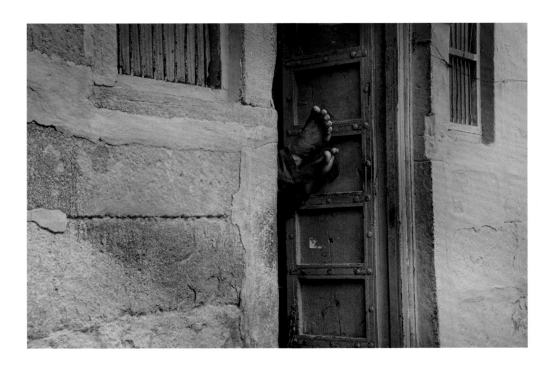

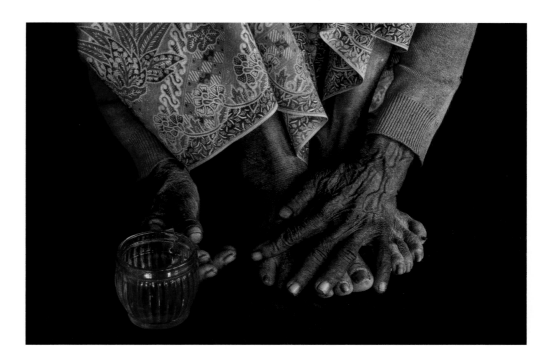

Hands and Feet

One of my favorite themes has been the study of hands (as seen above), and lately I've begun to look at feet with a discerning eye as well. I've been working on hands for more than twenty years, and I see no reason to think I'm close to the "end" of this exploration. And now that I've begun to look at feet, I can only hope that I'll be reincarnated as a photographer, since I have several lifetimes of work ahead of me with just these two subjects alone!

A Note about Underexposing on Purpose

I like to shoot almost everything a little underexposed, just to give the images a bit more contrast and color intensity. I generally opt for a –2/3 exposure. This means that when leading with an aperture choice, I then adjust my shutter speed until a –2/3 exposure is indicated by the camera's light meter. Throughout this book, whenever I refer to a "correct" exposure, I'm referring to this –2/3 exposure choice.

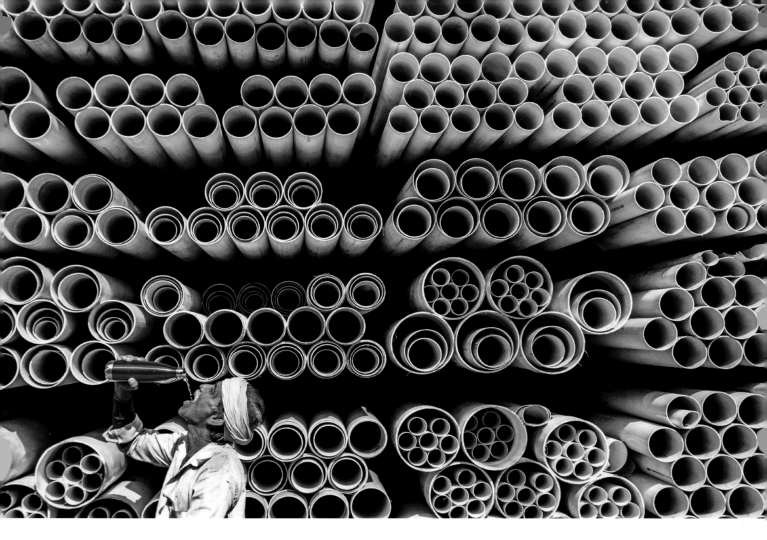

What is your "wait time" between capturing one truly compelling image and the next: One hour? One day? One week? One month? If you are experiencing giant time gaps between the loud gasps from your audience, you're probably a photographer who *takes* pictures rather than one who *makes* pictures—and let me stress, really stress, that chances are extremely high that you've heard or been told that you should *not* mess with or disturb the scene before you because, in doing so, it is no longer "natural" (whatever that is supposed to mean). Unless you commit to taking an active role *in the creative process*, you will be waiting "forever" until you find your next compelling shot. Be a picture-maker not a picture-taker!

While walking the streets of Agra, India, my students and I came upon a PVC pipe supply store, where we were confronted with a wonderful pattern of circles. It was a great background; all that was missing was a person, and after some pleading I got one of the shop's employees to sit down in the lower left of the composition. With the addition of a red water bottle from one of my students, I was even able to add a wee bit of color to the otherwise monochromatic scene.

NIKON D500, NIKKOR 18–300MM LENS AT 35MM, *F*/11 FOR 1/400 SEC.,
ISO 200, DAYLIGHT/SUNNY WB

People at Work

Most people spend a third of their life at work. Think about that for a moment. Now think about the number of times you have been extremely motivated to go out and shoot following a slide/talk presentation by one of your local camera club members that showed one compelling image after another of people at work. *That's never happened*, you might be thinking. Exactly. Most photographers do not venture out with the intention of shooting people at work. Why would they, since we tend to think there is nothing all that interesting about people at work?

Granted, if your idea of work is sitting at a desk in a sterile cubicle, I concur that this hardly conjures up an exciting image, but how about those of you who work in a factory or out in the fields where the great harvest takes place? Although your supervisor or boss would eventually fire you if you spent the entire day photographing your coworkers on company time, you can shoot during your lunch hour or coffee breaks. And because you know the other employees, as well as what goes on during the day, you have the chance to shoot both great candids and posed pictures. Thinking of the people you work with as your potential subjects, rather than just as coworkers you see day in and day out, will offer up numerous ideas and also serve to inspire you in other areas of your photographic work.

If ever there were fertile ground for photo opportunities, the workplace is it. Consider the wealth of subjects found outside the white-collar world: carpenters, loggers, welders, shipyard workers, farmers, cowboys, firefighters, police officers, taxi drivers, truck drivers, commercial fishermen, steel workers, oil-rig workers, garbage haulers, window washers, commercial painters, railroad workers, landscapers, and power-line workers. The environments in and around which these people work are some of the most colorful and picturesque. Additionally, you'll find an unlimited supply of props that go hand in hand with the subject right there on location. Blue-collar professionals are an untapped gold mine not only for portraiture but also for stock photography. And as evidenced by the decline in assignment photography being offered to freelance photographers today, it has become the norm for some companies to ask their own employees to photograph the needed imagery for annual reports, websites, and social media.

When you photograph people at work, you meet them on their turf, where they feel comfortable and often freely express their opinions and reveal their emotions. Workplaces can be high-pressure environments, and they're always distracting. As such, most employees are so busy they won't pay much, if any, attention to you and your camera—unless you direct them to. This is why photographers find the work environment to be a breeding ground for great candids. And people on the job are also willing subjects, grateful for the opportunity to be photographed at work so that they can finally show their spouse, friends, and family just what it is they do. After all, most people define themselves, in large measure, by their work.

You might be wondering how to approach people at work. Hang out at a truck stop and you'll not only find willing subjects but you'll probably be offered a chance to go on the road. The next time the garbage truck wakes you up with the loud clanking of cans, greet the haulers at the door and tell them what you have in mind. Go to a small sawmill and ask for the whereabouts

EXERCISE Using People to Express a Concept

I'm often asked where one goes to get "ideas" that result in creative and compelling imagery, and I can say emphatically that there is no one answer—but there *is* one constant thread from which most ideas are spun and that is simply asking, "What if . . .?" And it is with this idea of a "What if?" that I've put together the small list of ideas below that could produce the magic you seek when combined with the "right" person.

Which person you use, and that person's relative size in relation to the overall picture frame, will go a long way toward the success of your images. Should the subject be a man, a woman, or a child? Should the subject be casually dressed or in formal attire? Should the person be large in the frame or miniscule? The choices are yours, of course, since you are, after all, the casting director as well as the photographer.

→ It's not the load, but the way you carry it, that causes the breakdown.

→ It's lonely at the top, which explains my desire to achieve nothing.

→ A journey of a thousand miles begins with a single step.

→ Climb the stairway to the stars one step at a time.

→ Patience is the companion of wisdom.

→ No sky is heavy if the heart is light.

→ When our memories outweigh our dreams, we have grown old.

→ Great works are performed not by strength but by perseverance.

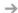

Imagine that every day—like "seven days a week" every day—you dye fabric for eight hours. You work outside but under a corrugated metal roof intended to deflect the rare rainfall. Most days, the outside temperature is at least 90 degrees, but under that corrugated metal roof, the steam rising from your wood-fired, boiling vats of color dye is trapped, quickly sending the temperature toward the 115-degree mark. And your pay? It's about ten dollars per day. And yet you are so happy! Another reminder that happiness is whatever you decide it is.

NIKON D500, NIKKOR 18–300MM LENS, F/16 FOR 1/800 SEC., ISO 3200, DAYLIGHT/SUNNY WB

of the independent loggers working in the nearby woods. Head down to the local harbor and make inquiries at the fish-processing plant. Visit a nursery and ask if you can follow the gardeners to their next job. You should photograph people at work because, if for no other reason, it gives you an opportunity to see, experience, and record how other people live, especially if you don't do a lot of manual labor yourself. In addition, you'll be a bit more versed on the subject of work and why people do what they do.

When I head out the door well before sunrise, with no plan but to return well after sunset, I *do* expect to return with a keeper or two, or even three, *if* a little luck crosses my path. Not surprisingly, by the end of these full days, I have formed an emotional attachment to these one, two, or three keepers. So, it should be easy for many of you shooters out there to relate to that god-awful feeling when you return home and discover that somehow, in some way, you've misplaced one of your 64GB SD cards—yes, the card that held two of the day's three keepers!

It's a sickening feeling, as you know, and soon the floodgates of grief open wide, letting in a deluge of anger, sadness, self-pity, and shock. It's only slowly, in the coming days, that you are able to accept the loss and move on. Now, imagine that almost nine months have passed since that dark day and, as you rummage through your camera bag, you come upon an old SD card stuck between a seam in the bag. And imagine, further, your shock, surprise, and *elation* when you discover it's the card you thought you had lost nine months earlier! That was the case with this image.

From up on a dike in West Friesland, Holland (one of my favorite landscape locations in all the world), I was able to compose this small dike, yellow buttercups, the representative rows of trees, and one lone road. All that was missing was someone on a bike. Thankfully, this is Holland, so the wait wasn't long for a lone bicycler, though the wait *was* long for my wished-for bicycler in red clothing (about twenty more minutes, in fact). But truth be told, the wait for this lone red bicycler was in fact nine months and twenty minutes!

NIKON D500, NIKKOR 18-300MM LENS, *F*/22 FOR 1/160 SEC., ISO 400, DAYLIGHT/SUNNY WB

70

People at Play

What is leisure time? Although this concept usually signifies different things to different people, it always involves pleasurable activities, such as playing in a company softball game, having a backyard barbecue, throwing a Frisbee, searching for seashells, pitching horseshoes, reading a book, fishing on a still lake, listening to music, camping, mountain biking, flying a kite, or going cross-country skiing. These are just a few of the many activities in which people participate, if only to relax and get their minds off work.

Unfortunately, the ability to effectively photograph people at play seems to elude many photographers. Put some thought into the overall composition and the message being projected. Spare me the photograph of your son holding up his prized seventeen-ounce trout with your distracting bright red Jeep in the background; instead, show me a shot in which he's standing in front of the lake from which that seventeen-ounce trout was taken. And don't forget to tell the story from beginning to end, which means showing me that first picture of just your son and husband's hands as they place a worm on a hook.

Spare me the shot of you and your friend leaning on your mountain bikes along with a description of the "rush" you felt as you both descended that hill with the forty-degree incline. Instead, show it to me! Get a superclamp and mount your camera on the front handlebars of your bike, shooting as you make that daredevil ride, or consider getting off your bike and panning the "rush" as other riders race by, using a shutter speed of 1/30 sec. This electrifying image won't require commentary. Then show me the grandeur of the rugged terrain by photographing your friend from a distance against the large, looming mountains. I'll have no trouble understanding your thrilling adventure.

Show me the intensity on your daughter's face as she pitches a horseshoe. After mounting your telephoto lens on your camera, walk up to her and fill the frame with her face and the perspiration that has formed on her brow. Then turn your attention to the lone rod rising up from the loose dirt upon which the horseshoes will land and focus tightly on the rod; set an action-stopping shutter speed of 1/500 sec. to freeze the dirt that will surely fly when the horseshoe makes impact.

When you're photographing at the beach, get down low with your wide-angle lens and set the aperture to $f/22$ to tell the story of your friend in the distance gathering seashells. Then finish the shoot by showing me the collection she has at the end of her stroll; compose the photograph so that only your friend's hands filled with seashells are visible. These are the kinds of memories everyone wants to capture on film.

Of course, you can argue that this is your leisure time, too, and that the extra effort such shots require is just too much. This is where you're mistaken. It doesn't take any more effort to shoot a compelling image than it does to shoot a mediocre one.

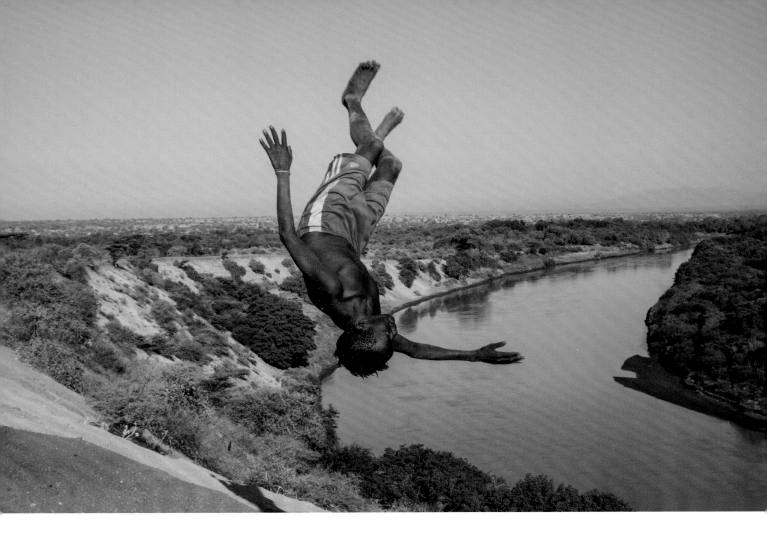

↑

Can you imagine, just for fun, doing flips off a steep hillside of loose sand? It's something the kids of the Karo tribe do every morning "just for fun as well as exercise," and although I don't have the still photos to share with you, there is a video of me joining in the fray and doing my best to be a kid again. (I survived, luckily!) Freezing the action was a no-brainer, as a shutter speed of 1/1000 sec. is all one really ever needs for most action-stopping exposures, and this morning's shoot was no exception.

NIKON D500, NIKKOR 18-300MM LENS, *F*/11 FOR 1/1000 SEC., ISO 400, DAYLIGHT/SUNNY WB

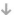

When I lived in Chicago, one of my favorite locations for photographing people was Millennium Park. On hot August days of stifling humidity, Crown Fountain, with its two impressive sculptures of granite and glass block, was a great place where both young and old could cool off under a refreshing wall of cascading water. Unbeknownst to most, this wall of glass block and cascading water served up the perfect "seamless background," where many subjects entered into what can best be described as an outdoor photo booth.

Over the course of one hour, countless subjects, most unknowingly, posed for my camera, but none more endearingly than this young boy wearing goggles.

NIKON D810, NIKKOR 24–120MM LENS AT 120MM, *F*/8 FOR 1/640 SEC., ISO 100, DAYLIGHT/SUNNY WB

Models

Hiring a model—whether a baby or a senior citizen—who fits an assigned role and is capable of expressing the desired emotion in front of the camera is seldom done by most amateur or even semipro photographers, because most photographers aren't looking to get into the business of photographing people.

Most photographers who *do* like to photograph people are content with photographing friends, family members, and strangers passing by on the street, which is all well and good, but if your desire is to one day be *hired* to do commercial photography shoots or you simply have a number of ideas and concepts that no friend or family member is willing or patient enough to be part of, then seriously consider the use of a model.

As of this writing, the first place to start is a well-known website called Model Mayhem. Within minutes you'll find an array of talent, both men and women, all over the world, all willing to do most anything, some for free and others for big bucks—though all of the models expect digital copies of the photos you take. Most, if not all, will sign any necessary model release.

You might find working with models appealing because both the photographer and the model can gain something from the "marriage." A new approach can make a photographer's images look fresh and may even renew their enthusiasm for their work. The model will get new portfolio shots and might find a photographer who can bring out their best in front of the camera.

Suppose that you want to get assignment work from advertising agencies whose clients sell products geared toward healthy lifestyles. These clients might include bicycle and running-gear manufacturers, as well as companies that make breakfast cereals and vitamins. As such, these companies want to show healthy-looking people wearing trendy exercise clothes and enjoying the good life because of the benefits they gain from bicycling, eating nutritious cereal, and taking the right vitamins. Unfortunately, your portfolio shows your expertise in photographing agricultural and travel subjects, and includes nothing that demonstrates an ability to photograph health-conscious people having

↗ →

During a workshop in Savannah, Georgia, one of my students, Lexi, availed herself to the rest of us as a model when necessary. It was late in the day when we came upon a stop with two end walls composed of a decorative metal with many holes, as you can see in the first image.

The strong sidelight cast an amazing pattern of light and dark across Lexi's face. In choosing to compose only half of her face, I have further elevated the strong graphic nature of the overall composition. A simple idea, to be sure, yet "difficult" to see if you remain committed to shooting safe portraits. Challenge yourself to leave the familiar and predicable approach to portraiture, or at least be willing to take an occasional stroll outside the box.

NIKON D500, NIKKOR 18–300MM LENS, *F*/11 FOR 1/200 SEC., ISO 100, DAYLIGHT/SUNNY WB

fun. Although you know you can do this, you won't get an opportunity to shoot such an assignment until you prove that you can, because art directors and photo editors tend to be very literal when looking for an assignment photographer. What you need is a model willing to do a test.

Once you're aware of a hole in your portfolio, contact models and explain your dilemma. Chances are good that some of the models, like you, want to be hired for advertising jobs but have nothing that shows they can do this type of work. After you choose two or three models, the "negotiation" can begin. This can mean that the model works with you in exchange for some usable prints, or you might agree to shoot additional images that the model needs, even if they have nothing to do with your specific requirements (a kind of "I scratch your back, you scratch mine"). It's important to note that "testing" models isn't meant as an opportunity for new photographers to hone their skills regarding *f*-stops and shutter speeds, but as a serious shooting session for experienced photographers who have a particular aim in mind.

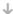

I have had the good fortune of working with the amazing Czech model Maja Zunova a few times over the years, and hired her again for a recent workshop in Ireland, where she modeled for my students one early morning at the Dark Hedges. As soon as Maja took up her position on the small country road, we all felt extremely lucky. It was as if we'd just happened upon one of the fair maidens of lore. Fortunately, a thin layer of cloud stretched across the sky, nature's rendition of soft-box studio lighting, creating an evenly illuminated scene and eliminating any concerns about hard shadows or sharp highlights. We shot until 6:30 a.m.; as we were packing up, the first of many other tourists began to arrive.

NIKON D500, NIKKOR 18–300MM LENS, SHOT IN APERTURE PRIORITY WITH VARYING APERTURES AND SHUTTER SPEEDS, ISO RANGING BETWEEN 800 AND 1600, DAYLIGHT/SUNNY WB

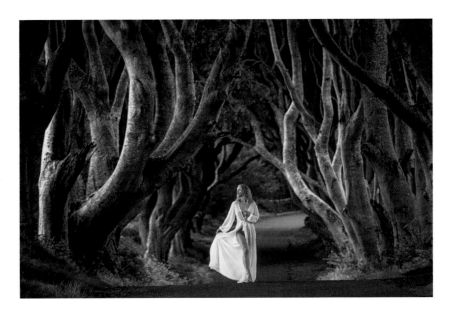

Making Portraits with Your Smartphone

Smartphones have become, truly, the camera you always have with you, ubiquitous with picture-taking. In many ways, photographing people with your phone is no different from using any other camera. You still want to think about light and composition, following all of the basic guidelines outlined in this book; however, here are a few specific tips for making the most of your smartphone when it comes to making portraits:

→ **USE PORTRAIT MODE.** Take full advantage of Portrait Mode, a setting offered on many smartphones. Portrait Mode creates a subtly out-of-focus background, thus putting all of the focus, literally, on the subject. To take full advantage of Portrait Mode, choose an uncluttered background, such as green trees, tall hedges, or building fronts, and make sure it's about thirty feet from the subject. (If your background is only five feet behind the subject, Portrait Mode will not render it out of focus as effectively.) Note: Out-of-focus green backgrounds are perhaps the most emotionally "powerful" ones, since green is a symbol of faith, hope, youth, fresh starts, new beginnings, and of course the spring season.

→ **USE FILL FLASH AT NOON.** I'm not a huge fan of using any smartphone's flash. In fact, I'm all for turning it off, never allowing it to even be left in Auto Mode; however, since most of us are "guilty" of shooting portraits of our friends and lovers on bright sandy beaches during that dreaded and harsh midday light, consider using your flash at these times. (Don't leave the flash on Auto; just put it in the "on" position and then turn it back off again afterward.) When the sun is directly overhead, it causes "shadow bags" under your subject's eyes. The flash will (somewhat) fill in those dark bags, making for more pleasing, evenly illuminated portraits.

→ **USE BURST MODE.** If you simply press the smartphone's picture-taking button and don't let go, your phone will automatically activate Burst Mode and take upward of twenty, thirty, even fifty photos in rapid succession. If you're trying to capture a fleeting expression or moment of action, one of these frames, if not several, should manage to be the "ultimate" capture. Pros do this all the time, shooting in Continuous High (CH) Mode, intent on capturing that often-elusive glance, smirk, smile, frown, or laugh. Once you have the twenty to fifty shots before you, slide your finger across and choose the one or two you like, throwing the others in the trash since Burst Mode can quickly use up a lot of memory.

→ **TURN ON THE RULE OF THIRDS GRID.** Most smartphone users don't even know that they have this fantastic tool available to them. To make sure your compositions are as compelling as possible, activate the Rule of Thirds grid. It's usually found in Camera>Settings>Grid. (See page 125 for more on the Rule of Thirds.)

→ **EXPERIMENT WITH APPS.** Knowing full well that today's news becomes yesterday's *old* news within twenty-four hours, I'll gamble here and recommend just one single app designed exclusively for taking smartphone portraits. Facetune allows you to do just about anything, from removing blemishes and scars to smoothing wrinkles, making yellow teeth white, adding hair to those going bald, and even changing hair and eye color. Disclaimer: Don't be surprised if Facetune is "yesterday's news" by the time this book goes to press!

Light

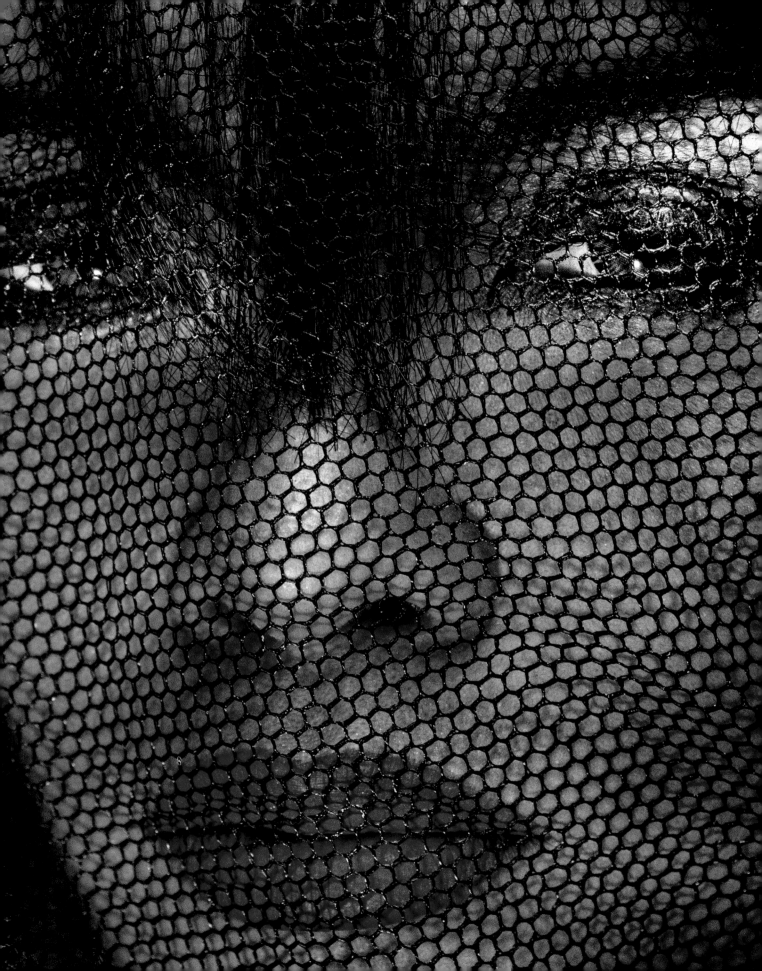

The Importance of Light

The importance of light (and lighting) can never be overstated, so I want to talk about light in general for a minute before I move on to the specifics of light as it relates to making photographs. Without light, no one would be able to see anything. For all intents and purposes, everyone would be blind.

The first light of morning assures people that a new day has begun. The proverbial light at the end of the tunnel indicates the conclusion of a sorrowful or difficult period. Light also has a direct effect on people's emotions and can dictate their moods. Almost everyone has had the blues. Sometimes this can be related to the seasons; for example, a common type of depression often occurs during the winter months, when light levels are at their lowest.

Whether it is harsh, gentle, glaring, or diffused, lighting plays the greatest role in determining the mood of an image. When you photograph a mean-looking woman under diffused light, you temper her appearance. Similarly, by photographing a meek-looking young man under harsh light, you can make him seem a bit cold and aloof. Both subjects would, of course, say *That isn't me!* upon seeing these photographs, and for good reason. The quality of the lighting and the impression it creates in the images will be in direct contrast to the way they normally define themselves.

Another important aspect of light is its direction, whether it is hitting the subject straight on, from the side, from behind, from above, or from below. To help you understand this, keep in mind how ugly and frightening people look for the fraction of a second they hold a flashlight under their chin and shine it on their face. This is a result of the light and its angle.

Photography involves three kinds of directional light: *frontlight*, which hits the front of the subject straight on; *sidelight*, which hits the subject from the side; and *backlight*, which hits the subject from behind. And then there's *dappled light*, a modified form of frontlight, and *diffused light*, the only nondirectional light, which simply means that it's evenly distributed throughout the scene. Diffused light is what you get on an overcast day or from a soft box. All five types of light take on different colors and tones depending on the time of day, and these colors and tones greatly affect how your subjects are defined.

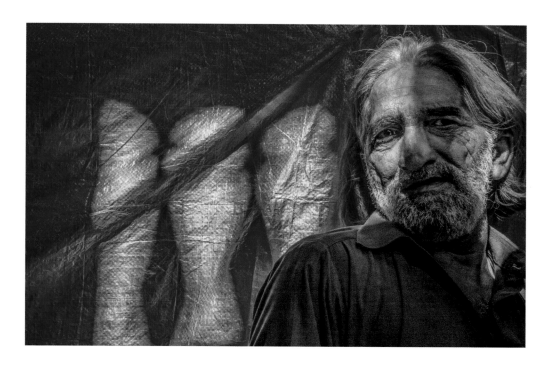

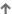

On more than one occasion I had crossed paths with this man, a delivery man of sorts, as he moved spices from place to place in a Dubai souk, often with a loaded-down hand truck. Finally, I got up the courage to ask him if I could take his photo and without hesitation he enthusiastically said yes. Almost simultaneously, I realized it was the worst possible time of day, especially for Dubai; it was high noon, when the sun is so harsh that just the thought of taking a portrait outside should be a punishable offense. I say that tongue-in-cheek, of course, but seriously, *no one* will look good at high noon in Dubai. And yet here I was with a very willing subject, a subject I had wanted to shoot for several weeks!

Just then I spotted a narrow alleyway with a bright orange backlit tarp of sorts and some light "leaking" from a canvas-like overhanging roof. I felt I just might be able to pull off a decent portrait. After shifting my point of view here and there, and directing my subject to make slight moves to the left, up, a bit down, now right—all in an attempt to get some decent light on his face—I finally started firing away. Although a mere two to three minutes had passed, it felt much longer. Taking a deep breath, I expressed my gratitude and assured him I would see that he got a copy, which he gratefully received from me two days later. All things considered, I was quite happy, and yet when I return to Dubai, I intend to try to find him once again and photograph him one more time, if he'll let me.

About his orange hair—he's from Pakistan, where dying one's hair (and even beard) orange is common practice, using the same dye women use for henna painting on their hands and arms.

NIKON D810, NIKKOR 24–120MM LENS AT 120MM, *F*/8 FOR 1/400 SEC., ISO 100, DAYLIGHT/SUNNY WB

Frontlight

What is *frontlight*? It's light that comes from behind the photographer and illuminates the front of the subject directly, or straight on. Since frontlight, for the most part, evenly illuminates a subject, many experienced photographers consider it to be the easiest kind of light to work with. The term *easiest* here refers to how challenging it is for the camera meter to read the light and make the correct exposure. Since a frontlit subject is uniformly illuminated, with no excessively bright or unusually dark areas, it is relatively easy to meter, and the final photograph will show an even exposure.

With today's sophisticated automatic cameras and their in-camera exposure meters, frontlit subjects, now more than ever, result in foolproof exposures; however, this doesn't mean that frontlight will always flatter subjects; you must exploit its color or intensity to help shape and define the subject's character and personality.

When experienced photographers speak enthusiastically about frontlight, most often it's in reference to its color. The two frontlight conditions that they favor most are the golden hues of early-morning light that linger for an hour after sunrise and the orange/golden tones visible about an hour and a half before sunset. These colors can add a warmth, passion, intensity, and even sentiment to a scene, depending on the age, gender, and clothing of the subject.

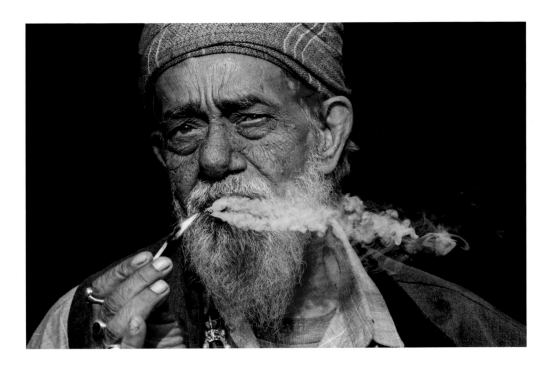

Sunny 16 Rule

Now is the perfect time to introduce you to, if not remind you of, the all-important Sunny 16 rule.

The Sunny 16 rule is a formula for generating a correct exposure that's almost as old as photography itself, used *before* the advent of the in-camera light meter. I still use it today, despite having a highly sophisticated digital camera at my disposal with no less than three built-in light metering choices.

F/32	1/25 SEC.	ISO 100
F/29	1/30 SEC.	ISO 100
F/25	1/40 SEC.	ISO 100
F/22	1/50 SEC.	ISO 100
F/20	1/60 SEC.	ISO 100
F/18	1/80 SEC.	ISO 100
F/16	1/100 SEC.	ISO 100
F/14	1/125 SEC.	ISO 100
F/13	1/160 SEC.	ISO 100
F/11	1/200 SEC.	ISO 100
F/10	1/250 SEC.	ISO 100
F/9	1/320 SEC.	ISO 100
F/8	1/400 SEC.	ISO 100
F/7.1	1/500 SEC.	ISO 100
F/6.3	1/640 SEC.	ISO 100
F/5.6	1/800 SEC.	ISO 100
F/5	1/1000 SEC.	ISO 100
F/4.5	1/1250 SEC.	ISO 100
F/4	1/1600 SEC.	ISO 100
F/3.5	1/2000 SEC.	ISO 100
F/3.2	1/2500 SEC.	ISO 100
F/2.8	1/3200 SEC.	ISO 100

Sunny 16 simply means this: If your subject is basking in the frontlight or sidelight of full sun (meaning that the sun is not obscured by any portion of a cloud or object), then to correctly expose any part of that subject and/or scene awash in sunlight, set your aperture to *f*/16 and choose the same number for your shutter speed as your ISO setting. For example, at *f*/16, with an ISO of 100, I would shoot at 1/100 sec. With an ISO of 200, I would shoot at 1/200 sec., and so on.

"Aha!" you say, but what if you don't want to shoot at *f*/16? What if you don't want that much depth of field? No problem! You can shoot at any aperture and/or shutter speed as long as the quantitative value of the aperture and shutter speed are the same as in the original formula (*f*/16, 1/100 sec., ISO 100). For example, let's say you're using ISO 100 and want a limited depth of field, so you choose *f*/5.6. You have opened up the aperture of your lens by a total of 3 stops: from *f*/16 to *f*/11 (1 stop), *f*/11 to *f*/8 (2 stops), and *f*/8 to *f*/5.6 (3 stops). So now, you must also decrease your shutter speed by three stops: from 1/100 sec. to 1/200 sec., 1/200 sec. to 1/400 sec., and finally 1/400 sec. to 1/800 sec., making your final settings *f*/5.6, 1/800 sec., ISO 100. To make this easier, I've created a simple Sunny 16 chart based on an ISO of 100.

The Sunny 16 rule works in full force starting about ninety minutes after sunrise and lasting up to ninety minutes before sunset. It can be an effective exposure setting for any frontlit or sidelit subject that requires little, if any, tweaking in postprocessing, regardless of the person's skin color or dress.

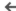

It was his orange beard and weathered face that first caught my attention, but when combined with the early-morning frontlight and a black background created by a canvas-covered tuk-tuk (a small golf cart–like taxi), I was determined to not let this subject get away. As I expected, he was reluctant at first, but after a mere five minutes of conversation he was agreeable "as long as I can smoke while you take my picture."

NIKON D500, NIKKOR 18–300MM LENS AT 300MM, *F*/10 FOR 1/640 SEC., ISO 400, DAYLIGHT/SUNNY WB

Sidelight

Sidelight hits a subject from the side, illuminating only half of the subject and leaving the other half cloaked in darkness. The combination of light and shadow creates contrast and makes this type of lighting powerful. In fact, sidelight is, by far, the most dramatic type of light. Subjects veiled in sidelight can suggest deception, danger, privacy, intimacy, and intrigue. The interaction of light and dark reveals and defines form, as one side of a subject's face or body is illuminated while the other side is left in shadow.

When experienced photographers want to render the texture of rough hands or wrinkled faces, for example, they illuminate the subjects from the side. They also know that when they shoot outdoors, sidelighting is most pronounced and effective during the early morning and late afternoon.

Sidelight offers you a range of exposure options. For example, you might want to overexpose the highlights, thereby showing subtle details in the shadows. Or, you might decide to underexpose the highlights so that you can turn shadow areas into seemingly infinite dark spaces in the final image. And in another case, you might want to arrive at some point in the middle. If so, you need to bracket exposures, a technique that I rarely endorse anymore since almost everyone has gone digital. But if you are shooting film, then to bracket you simply take an initial meter reading of your subject, shoot that indicated exposure, and then shoot two more images at the following settings: 1 full stop over the indicated exposure and 1 full stop under. But if you're shooting digitally, and if you're shooting in raw format, you can fine-tune the exposure in postprocessing.

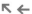

With excitement, I ran into the common area of the eco-lodge where I found Sita, a young employee, and expressed a strong desire to photograph her. "Right now there is some incredible, low-angled, warm, late-afternoon light, this really narrow band of light is coming into the main office area and it's not here for long, and oh my, would it ever be a great photo *if* I could steal you away for no more than thirty seconds and all you'd have to do is kneel or crouch just a bit so your face was being lit up by that narrow beam of low-angled light!" I then took a deep breath and after a mere five seconds, Sita said, "Sure"—and sure enough, I got a really nice portrait.

As you can see, that narrow spot of light hitting the wall would have been a "waste" of fabulous light if I hadn't found someone or something to put in front of it. So the next time you see a similar narrow beam of light, drop everything, grab your camera and a willing subject, and capture that fleeting moment of low-angled sidelight as it crosses the face of your subject.

NIKON D500, NIKKOR 18-300MM LENS, F/7.1 FOR 1/640 SEC., ISO 100, DAYLIGHT/SUNNY WB

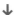

Boy in Mid-Flight, Jodhpur, India is a well-known image by the internationally acclaimed photographer Steve McCurry. Photographed in 2007, it shows a young boy with his back to the camera, in mid-stride as he runs away, framed on the left side by an iconic blue wall with red handprints, on a typical narrow street in the Blue City.

Eight years later, I was in Jodhpur when a strange twist of fate took place. Up at dawn, I ventured into the old city and within the hour came upon this same narrow passageway, with what appeared to be fresh handprints on the same wall. Fortunately for me, a woman in red was walking into the passageway as a narrow wedge of early-morning sunlight brightly illuminated the blue wall of red handprints. The shot was fortuitous. Shortly after I made this image, the woman stopped and started a conversation with me, and you can imagine my absolute surprise when she asked me if I knew a photographer named Steve McCurry—not a question I would have expected! "Why do you ask?" I replied, after first telling her that I knew of Steve McCurry but have never met him. She then told me that the "boy in mid-flight" was her son! Wow!

NIKON D810, NIKKOR 24-120MM LENS, *F*/16 FOR 1/400 SEC., ISO 400, DAYLIGHT/SUNNY WB

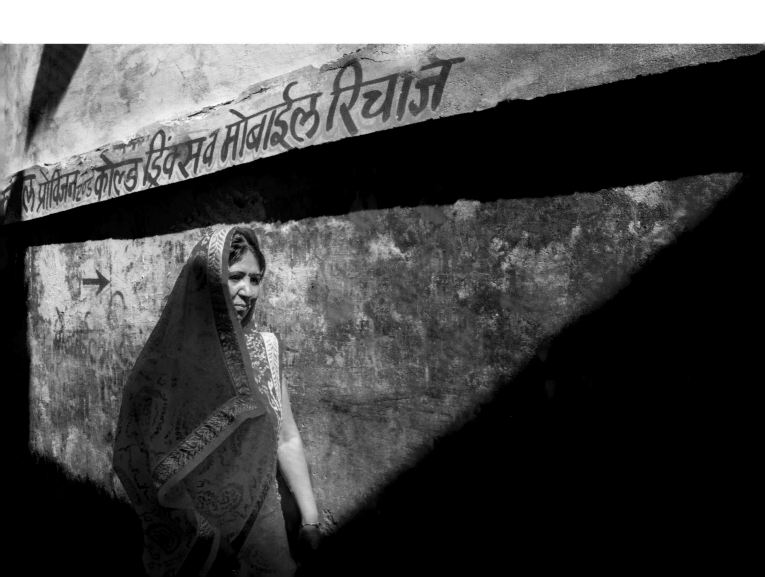

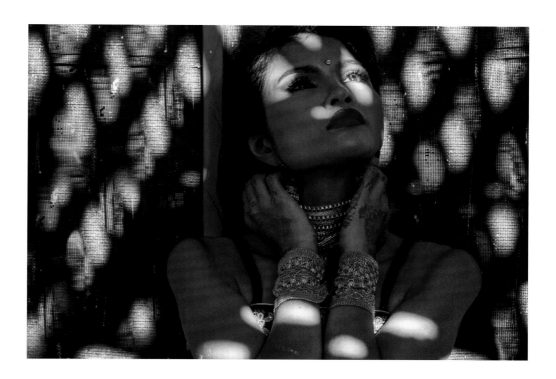

Just like moths to a flame, we photographers are drawn to the light, and on this particular late afternoon on the back streets of Jodhpur, India, I was quick to decide that *yes, yes, yes,* I wanted, I needed, *I must* create a composition with this amazing spotted light and my model, Natt. Unfortunately, this amazing light show was taking place against the screened wall of a small courtyard, about twelve feet beyond the locked gate of a securely fenced private residence.

Repeatedly pressing the buzzer at the gate seemed to do little to arouse any-one, but after what felt like hours (perhaps only two or three minutes), a young man appeared from the back of the property. I quickly explained my love affair with the spotted light on the distant wall, and obviously, he did open his gate to us—cheerfully, I might add. Another example where trust in the honest intentions of another is still alive and well!

Creating a "correct" exposure of Natt was much easier than you might think. I've witnessed many students take the "spray and pray" approach (aka bracketing) with spotted light, but with today's DSLRs, the dynamic range is such that one can set a Sunny 16 manual exposure and then simply overexpose it by 1 stop. For example, with an ISO of 400 and my aperture at *f*/16, I set my shutter speed to 1/200 sec. rather than 1/400 sec. This way, I was able to record both the highlights and moderate shadow details.

NIKON D500, NIKKOR 18–300MM LENS AT 115MM, *F*/16 FOR 1/200 SEC.,
ISO 400, DAYLIGHT/SUNNY WB

Backlight

If the sun is in your eyes as you are taking a photograph, your subject is in *back-light*. Regardless of what type of camera you use (film or digital), if your subject is backlit, it will, in all likelihood, record as a silhouetted shape—meaning that it will be devoid of all details, such as color, texture, and form. If your subject is a person, details like age, skin color, and attire will be lost.

The stripping of a subject's individual characteristics might explain why many experienced photographers prefer not to shoot silhouetted subjects—since silhouettes usually reveal nothing about a person's character. I couldn't disagree more (yet I have to admit that a simple headshot rendered only as a silhouetted profile does little to offer up much detail about how that person really looks). I feel that when you incorporate elements into the composition that relate to the subject, the statement about this person is actually embold-ened by the power of the backlighting. Sunsets and sunrises are the most obvious backlighting situations in which this is evident.

Lens choice has the most impact on determining exposure for silhouettes. Today's film and digital cameras do a great job of metering backlight situations, and this is particularly true when composing a backlit scene with your wide-angle lens. Since the size of the sun is reduced via the angle of the lens, you're free to simply aim, focus, and shoot; for those of you who shoot in Program, Aperture Priority, or Shutter Priority modes, this should be music to your ears.

And, yes, there are numerous wide-angle backlit opportunities out there, but most—if not all—of us are hungry for those backlit scenes in which we record that big orange ball as it meets the horizon. It's at these times that you must pay special attention to metering. When you use a telephoto lens with a focal length greater than 80mm, always take your meter reading off the bright sky to the left of, the right of, or above the setting or rising sun. (If you meter directly into the sun, you'll record an exposure that's often much too dark.) Assuming you're in Manual Exposure Mode, and assuming you've determined

↗ →

Almost every compelling frontlit scene offers an equally compelling backlit com-position, so before patting yourself on the back for a job well done on that frontlit photograph you just took, *turn around* and see if you have any opportunities to shoot the same subject backlit.

At a workshop in southeastern Ethiopia, near the town of Jinka, my students and I came upon a group of men and their shovels, separating the chaff from the wheat. Several students were quick to express their enthusiasm about the "explosive" frontlit scene before them (shown opposite, bottom). I was just as quick to remind them to also move around to the other side and face the sun, which would render the subjects into silhouetted shapes and might record a nice "starburst" of the sun.

↗ NIKON D810, NIKKOR 14-24MM LENS, *F*/16 FOR 1/500 SEC., ISO 200, DAYLIGHT/SUNNY WB

→ NIKON D810, NIKKOR 14-24MM LENS, *F*/16 FOR 1/200 SEC., ISO 200, DAYLIGHT/SUNNY WB

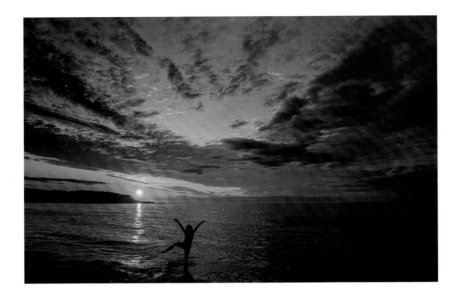

that the composition before you has few depth-of-field concerns (i.e., an *f*/8 aperture is okay), then all you have to do is point the camera to the left or right of the sun and adjust your shutter speed until the camera's meter indicates a correct exposure. Next, recompose and voilà, a perfect backlit exposure. When you take the meter reading before recomposing, make sure the sun is not in your viewfinder.

If you insist on shooting backlit scenes in Auto Exposure Mode, then you would still meter to the left or right of the sun; you would note the exposure so that when you recompose the scene with the sun in it, you can call on the Auto exposure overrides to get you back to the exposure you noted when metering without the sun in the scene.

If this sounds like a hassle, it is. And although it works, it takes a few seconds longer than shooting in Manual Mode—and those few seconds could cost you the shot. Furthermore, you may forget to set the Auto exposure override back to normal, and before you know it, you've shot a number of other shots that are "off" in their exposure. (If you don't have a grasp on shooting manual exposures, take a look at my bestselling book *Understanding Exposure.*)

Here, one of my students braved a sunset dip in the cold Atlantic waters of Northern Ireland. Because the sky was quite dramatic, I encouraged the students to forgo the temptation to shoot a telephoto silhouetted portrait and instead shoot a much wider and grander storytelling "portrait."

As far as metering, because we were using wide-angle lenses, the intensity of the sun was greatly diminished compared with shooting into the sun with a telephoto lens, so these shots could easily be done in Aperture Priority—with the understanding, of course, that since we were metering for the much brighter light in the sky, the person in the water would still be rendered as a silhouette.

NIKON D500, NIKKOR 10-24MM LENS AT 16MM, *F*/11 FOR 1/500 SEC., ISO 200, DAYLIGHT/SUNNY WB

For the many tourists who hire a personal driver and long boat for an evening out on Inle Lake, this shallowest of lakes that feeds thousands in Myanmar with its abundant fishing stocks and provides water to the nearby rice fields, a "ballet" by the local fishermen is on full display. The "stage" for this ballet is the very long yet narrow fishermen's boats. Willingly, and in anticipation of a well-earned tip, they make a number of body moves, all while hanging on to the old-style fishnet traps still used by some today. Although the fishermen are available and willing to perform the dance throughout the day, the best show takes place at sunset.

On this particular late afternoon in November, I had a total of three boats willing to entertain me (it was a slow afternoon on the lake). Needless to say, I had a field day of shooting opportunities, the below being just one of several hundred images that I shot. The added golden glow you see here is a direct result of using Shade White Balance (WB), a setting I recommend when shooting a sunset that's not producing much color on its own.

NIKON D810, NIKKOR 24-120MM LENS AT 50MM, *F/22 FOR 1/320 SEC.,* ISO 100, SHADE WB

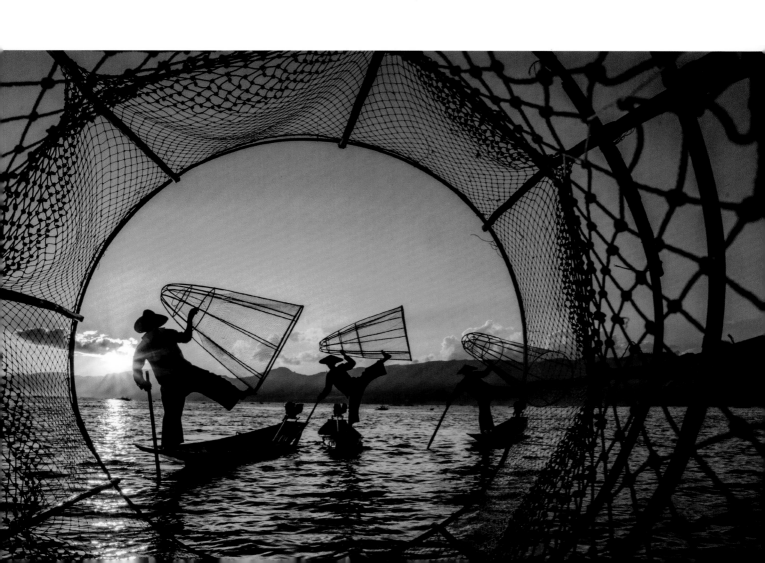

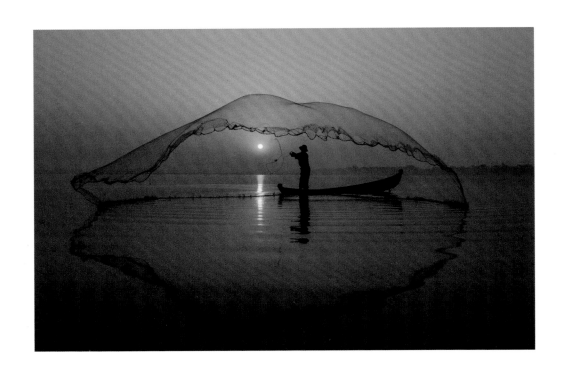

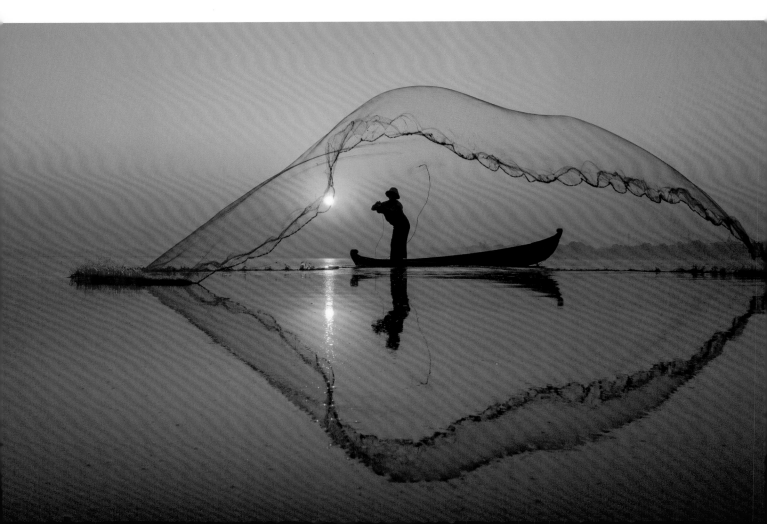

Using an FLW Filter

I have recommended the FLW filter in most of my other books and will do so again here, particularly when shooting silhouettes of people at work or play against the rising light of dawn or the fading light of sunset. The FLW is a magenta filter—my favorite color filter—and is made by several manufacturers, such as Hoya. It's normally stocked at the larger camera stores, such as Hunt's Photo & Video, Samy's Camera, B&H Photo Video, and Adorama. The FLW filter imparts an often-welcome magenta–subtle blue cast, which elevates the mood of the overall composition.

If you cannot afford the filter (or inadvertently left it behind), consider the next best alternative, which is to add the magenta color in postprocessing. In either Bridge or Lightroom, simply move the green/magenta "tint" color slider (found under the White Balance slider) toward magenta until you like the effect.

← ↙

Our meeting was nothing short of fate. The man casting the net in this photo is a local fisherman named Kim Monshin. I met him in a small village on the shores of Taung Tha Man Lake in Myanmar.

If not for my relentless thirst on an unusually hot day, even by local standards, I would not have sat down at the "locals only" cafe and ordered a bottle of water and glass of iced tea. Within seconds of sitting down, a young man approached me from a nearby table and asked in broken English where I was from.

Within minutes of announcing that I was from the United States, countless curious children started showing up, surrounding both me and the cafe with sounds of hushed laughter. They had no idea that I was carrying a pocketful of balloons and candy. In my best Burmese accent, I asked, "*Choi chin samalla?*" (this is a phonetic spelling of the Burmese words for "Do you want some candy?"). Seconds later, I was overwhelmed, much like a mother Labrador trying to feed twenty puppies!

The calm quickly returned, as did my conversation with Kim, and with great enthusiasm he was soon inviting me to join him the following morning around 5 a.m., when I could witness him repeatedly casting his net, *if* I had the time. I could not say yes quickly enough! Hours later, I was seated in a boat about ten yards from Kim; and as the sun began to rise, Kim began to cast his net.

Don't overthink the easy opportunity to freeze action. It's as simple as using a shutter speed of at least 1/800 sec. and then adjusting your aperture until a correct exposure is indicated by the camera's light meter. Since I was using an ultra-wide-angle lens, the Nikkor 10–24mm, I didn't have to make any special exposure calculations. The bright intensity of the sun was reduced due to the "vision" of the wide-angle lens, which makes almost everything smaller, pushing the background farther back—all to make room for what was about to come: Kim casting a net right at the crack of dawn! I have been fortunate over the years to find myself in the right place at the right time, but this morning felt like the best "right place, right time" in my entire photographic career. Opposite, you can see the image taken without (top) and with (bottom) the FLW lens.

← NIKON D500, NIKKOR 10–24MM LENS AT 12MM, *F*/16 FOR 1/1240 SEC., ISO 1600, WITH FLW FILTER

Reflectors

Thanks in part to photo-editing programs like Lightroom and Photoshop, and how easy they make it to correct exposure mistakes, the use of reflectors for portraiture has fallen off somewhat. This is unfortunate because reflectors, when used properly, can yield a better result and do so much quicker than postprocessing.

Reflectors are most useful when shooting backlit portraits, when the sun is *behind* the subject. In this kind of light, most photographers want to create a composition that includes a "hairlight" around the subject; however, without a reflector it can be difficult at best to record a good exposure of the face without losing the backlight to severe overexposure, or, alternatively, if you take a meter reading off the backlight, running the risk of underexposing the face.

When you aim a reflector into sunlight, it acts in many ways like a mirror, giving you a "secondary sun" that you can direct onto your subject's face. Using a reflector is like living on a planet with two suns: one that backlights your subject (the actual sun) and one that frontlights your subject (the reflector). Studio photographers have been using this two-light-source approach with strobe lights for years, so why not you?

Once you've reflected the sunlight back onto your subject's face or body using a reflector, move in close to set an exposure for the frontlight that is now hitting them. With the right aperture in place (which you've determined based on your depth-of-field concerns), simply fill the frame with the reflected light and adjust your shutter speed for a correct exposure (indicated by the camera's light meter). If you're so close that you can't get your subject in focus, don't worry: you're only interested in determining the exposure at this point. Assuming you prefer the ease of manual exposures in these situations, you then simply recompose the scene before you and shoot at this exposure.

There is, of course, one other concern: Who is in charge of holding the reflector? If you don't have four hands, this is a good time to bring someone along to be your "grip." This person's job is to hold the reflector. If you don't have someone who can come along, your subject should be able to hold the reflector for you, especially with head-and-shoulders portraits.

Of all of the reflectors out there, I know of no greater value than the 22- to 28-inch five-in-one reflectors, which are manufactured by a host of companies. (The important thing to remember is simply "five-in-one.") With its ingenious zippered design, you get a reflector that's 24 inches in diameter, in either silver or gold, and if you unzip the outer layer, you're left with a 24-inch white diffuser, ideal for those shots you have to take at midday. (When held directly overhead, the diffuser will reduce, if not eliminate, the raccoon shadows under a person's eyes.) When not in use, it folds into a compact pouch of only 10 to 12 inches in diameter, fitting neatly inside most camera bags.

Although this subject isn't backlit by the sun (she was photographed from the side while frontlit by the sun), I still suggested to my students that we use a reflector to throw some light onto her long, flowing hair.

The wind was really blowing during this workshop in Key West, Florida, and I recommended to Nancy that she be our model, since her windblown hair, shot with a slow shutter speed, would help us emphasize the windy day while also speaking volumes about her free-spirited personality. As I photographed her from the side, another student held a reflector behind her, bouncing the frontlight coming in from the window back onto her hair. Without the use of the reflector, Nancy's hair would have been "in the dark," so to speak.

NIKON D800, NIKKOR 24-85MM LENS, *F/22* FOR 1/30 SEC., ISO 100, DAYLIGHT/SUNNY WB

I have yet to visit any island more colorful than Burano, Italy, and as this picture clearly shows, it holds that distinction for good reason. On this particular afternoon, a long yet narrow swath of deep shade rested in front of the brightly lit houses beyond—houses that were basking in full sunlight. This was a wonderful opportunity to employ the Sunny 16 rule, which correctly exposes *only* those subjects in full sun; any subject (or part of the subject) in shade will record as a severely dark, if not black, underexposure.

So, let's cue the model, a student, and on the count of three, she leaps into the air, arms outstretched, all the while staying within that narrow swath of open shade. The resulting exposure is one of intense color and stark shape, an image of strong graphic design. Compositions like this can be seen throughout many of the #streetphotography hashtags on Instagram, but perhaps no one photographer is more prolific with this single idea than @george_natsioulus. Check him out if you're looking for more graphic composition inspiration.

NIKON D500, NIKKOR 18-300MM LENS, *F*/11 FOR 1/800 SEC., ISO 400, DAYLIGHT/SUNNY WB

I approached the taxi driver and introduced myself. I asked Felix to look straight ahead, his left arm resting on the car door, explaining that it might take a few minutes. I was desperate to see another red double-decker bus pass through the background. Not more than three minutes lapsed when one came my way . . . 32nd Street, 33rd, caught by a red light at 34th Street . . . "Felix, we're mere seconds away. Okay, here we go . . . green light, here it comes!"

Because my manually metered exposure was for subjects in sunlight (both the moving traffic and Felix's yellow cab), Felix, who was inside the taxi with very little light on him, recorded as a darkened silhouette.

NIKON D500, NIKKOR 18-300MM LENS AT 107MM, *F*/22 FOR 1/60 SEC., ISO 100, DAYLIGHT/SUNNY WB

An Often-Overlooked Backlight Opportunity

This is, arguably, an advanced exposure tip and a bit of a "twist" on the Sunny 16 rule, but it's an idea that might expand your vision in ways you've never considered before. Backlighting is not limited to sunsets and sunrises. Let me repeat that: *Backlighting is not limited to sunsets and sunrises.*

Any background that's at least 3 stops brighter than the subject in front of it *can* render the subject as a silhouette. If the sun were hitting a wall made of corrugated metal and a person were walking in an area of open shade in front of that bright and shiny wall, that person would be rendered as a silhouette (assuming you took your meter reading from the brighter wall).

Diffused Light

Another interesting type of lighting is *diffused light*. It is soft with subtle shadows. It makes faces look kind, enhances the calmness of an image, and noticeably minimizes wrinkles and other skin imperfections. And unlike frontlight or sidelight, both of which can restrict how you pose your subject, diffused light permits both you and the subject to move at will—because it's nondirectional.

Diffused light usually occurs outdoors when a high, thin layer of clouds blocks the sun, creating a sort of giant umbrella. And since it isn't harsh, you don't have to contend with subjects squinting or getting teary-eyed. Plus, nothing is easier than determining exposure when you work in diffused light. Whether you're shooting a study of hands, a face, a whole body, or a subject in a particular environment, every part of the image is uniformly lit. Thus, it's just a simple matter of "compose, aim, and shoot." There are no bright highlights or dark shadows to confuse the light meter.

Diffused light isn't identical to the illumination present when thick rain clouds fill the sky or when bright, sunny days produce areas of shade. If you look up and see the sun, you're shooting under diffused light, even if the sun is almost completely obscured. But if you look up and you have no idea where the sun is, you're shooting under the threat of rain.

Keep in mind that whether you're experiencing very cloudy skies or bright, sunny days with shadows, both lighting conditions contain a great deal of blue light. I once had a student who was feeling a bit anxious about his first "professional" assignment. He had been hired to shoot a friend's outdoor wedding. When he reviewed his shots, the overall results were pleasing, but he had failed miserably when he shot the family portrait. Since it had been close to noon when he had taken the group portrait on that sunny day, he had wisely chosen to move the family members to the north side of the large house in order to shoot them in open shade. The final images were far from inviting, however, because everyone was very blue, which of course suggested coldness and distance, not warmth.

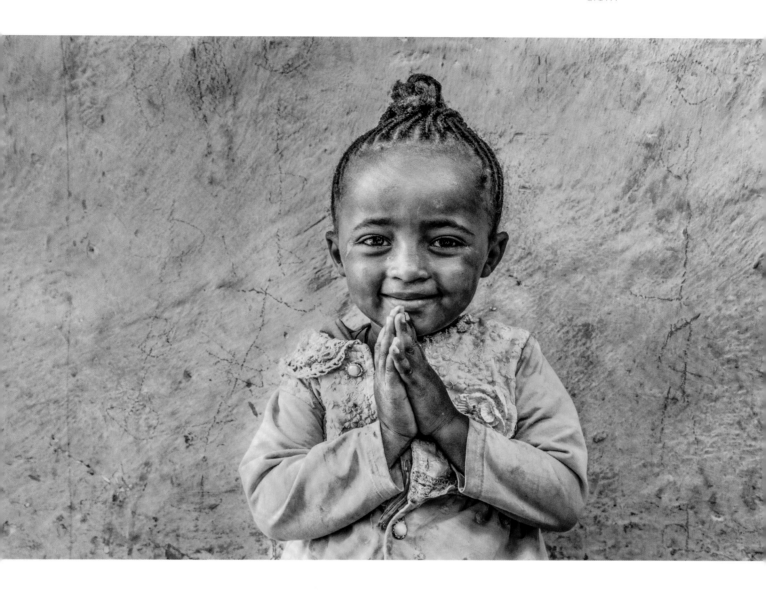

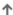

When I saw this little girl from the Dorze tribe of southeastern Ethiopia's Omo Valley "hiding" yet peeking out from around the corner of a very small 8 x 10-foot cement house that she shared with her mother, father, three sisters, and two brothers, I was determined to photograph her portrait. Dressed in a colorful pink shirt, a hue very similar to that of her house, she had quickly stolen my heart.

Feelings of gratitude and fate came to the surface as I positioned her against the south wall of the house in soft, shadowless light that complemented the equally soft pastel tones of the wall and her well-worn shirt, in welcome contrast to her soft, almost baby-like face.

Posing her couldn't have been easier. Right after she sat down in front of the wall, and without any prompting from me, she immediately folded her hands, just as you see here, as if she had a sixth sense of what kind of pose I would like.

NIKON D500, NIKKOR 18-300MM LENS AT 102MM, *F*/11 FOR 1/200 SEC.,
ISO 640, DAYLIGHT/SUNNY WB

Dappled Light

Those of us who like to photograph people are familiar with the "Big Three" lighting conditions: frontlight, sidelight, and backlight. But many are still not exploring the beauty of *dappled light*, primarily because they don't know where to find it.

One of the more common places to see and take advantage of dappled light is under trees, between 10 a.m. and 3 p.m. As the sun cascades down through the leaves, the light is scattered and softened—and, as in the image of the schoolgirl opposite, can create a spotlight effect on your subject's face, as if to further emphasize their importance.

Setting an exposure for dappled light is easy *if* you simply switch to Spot metering, pointing the very center of your viewfinder at the "spot" of dappled light and then setting your exposure to +$\frac{1}{3}$. This will allow you to maintain the effect of the soft dappled light as well as show detail in areas where there is no light. Note, once you're done shooting, return the camera's light meter to either Evaluative metering (Canon) or Matrix metering (Nikon).

Try seeking out dappled light to add one more valuable lighting option to your arsenal of portrait lighting possibilities. When you think of different types of lighting, and each type's relationship to an image's impact, dappled light has, perhaps, the most striking effect.

↗ →

The loud rush of children's voices is what initially got my attention. From the nearby monastery, I walked toward the sounds of excited children, shouts that one would normally associate with a large assembly of children anxiously awaiting the arrival of their favorite superhero or Disney princess. As I turned a corner on the small footpath, I saw hundreds of children assembling outside their respective classrooms at a large grade school several hundred feet behind the monastery, many dressed in their school uniforms. I located my driver/translator and soon we had gained permission to enter the school grounds; it was there that I came upon this group of five- and six-year-old girls in their beautiful dresses and face makeup. The makeup threw me off a bit, but I was assured that the assembly had nothing to do with a beauty contest and was mostly to do with celebrating the sixth-grade boys' soccer team having won the city championship for their age group. I proceeded to make a number of dappled-light portraits of the young girls, one of which you see here.

NIKON D500, NIKKOR 18-300MM LENS AT 300MM, *F*/7.1 FOR 1/400 SEC., ISO 100, DAYLIGHT/SUNNY WB

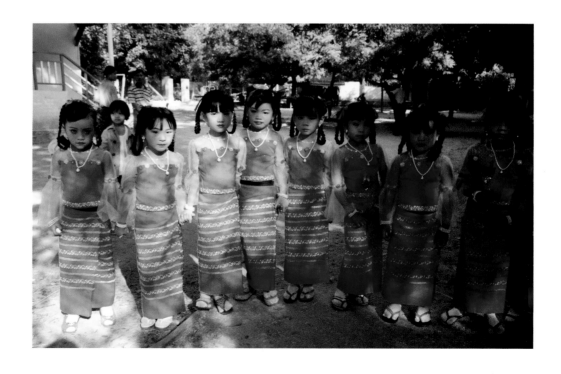

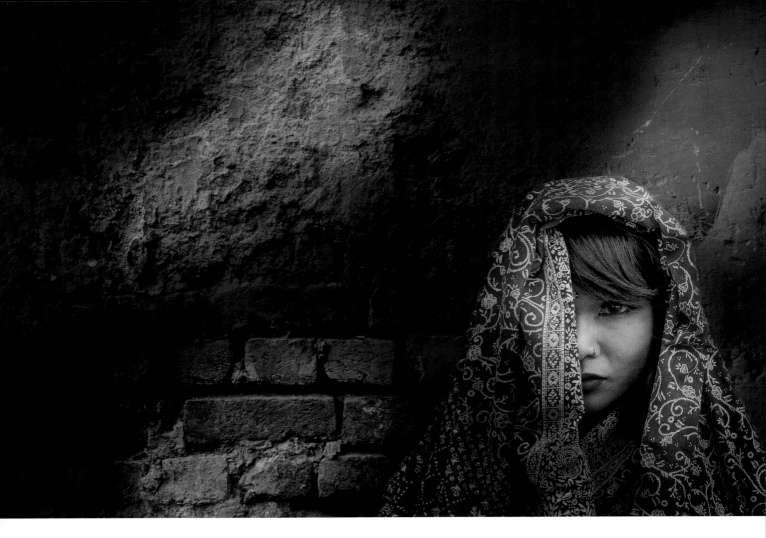

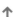

It's no secret that I love color, so it should come as no surprise that I plan my entire year around India's Holi Festival, or what I affectionately call "India's Festival of Colors on Steroids." Despite the festival lasting only one day, its colors last for another three to four days thanks to the colorful powders that cling to walls, doors, and windows. If you get extremely lucky, the colors of Holi match up with the equally colorful clothing worn by women in India, and then if you get *super* lucky, the wall you find will be under the "umbrella" of a large tree, blocking most of the sun's light and creating *diffused-dappled* light! Quick! Cue the model and shoot, shoot, shoot!

NIKON D810, NIKKOR 24–120MM LENS AT 120MM, *F*/11 FOR 1/160 SEC., ISO 400, DAYLIGHT/SUNNY WB

Difficult Exposures

With today's highly sophisticated cameras and their extremely dynamic range, are there really any situations in which the camera's advanced metering patterns are still challenged? Yes, as a matter of fact, and I can think of two situations that will give you "fits" unless you perform some kind of intervention with the light meter. In both examples, the problems involve subjects that are excessively bright or excessively dark, such as a bride in her white wedding dress, a groom dressed in black, really fair-skinned subjects, and dark-skinned subjects.

In fact, one of the most common questions I hear is, "How do you expose for subjects with dark skin?" Although there are several answers, including the use of Sunny 16 when the "white" or "black" subject is basking in frontlight or sidelight, there is one foolproof method that works for *everyone*, no matter if it's a fair skin color or a dark one, and no matter if you're shooting in full shade, dappled light, full sun, or under overcast skies. You can always get a correct exposure by taking a meter reading off of the palm of your hand while it is under the *same light* as that of your subject *and* if you set your exposure at +1, overexposing by 1 stop. In effect, you have just set an exposure for a gray card. The palm of your hand is exactly +1 reading of what a gray card would suggest, so yeah, it's like having a gray card at your disposal, to use anytime and any-where you choose.

And just what is a gray card? In case you didn't know, every camera's light meter is based on the simple principle that the world is a neutral gray color and that all subjects, whether they are in shadow, under dappled light, or in full sun, reflect 18 percent of the light they absorb. It is this expected 18 percent reflectance that your light meter is setting an exposure for. But some subjects, such as snow, a black dog, or a dark-skinned subject *do not* reflect 18 percent of the light. Snow reflects, on average, around 36 percent of the light, and dark-skinned subjects reflect only about 9 percent, so when your meter is con-fronted by such bright or dark subjects, it "freaks" and immediately suggests an exposure to, for example, make that white snow gray—in effect, creating gray, underexposed snow. Likewise, when your meter is confronted with a dark sub-ject, it will immediately suggest an exposure to purposely *overexpose* the subject to, again, make it gray. If snow and black dogs could talk, they would both say to the light meter, "Even though our reflected values are more or less than the 18 percent that you are calibrated for, please do not treat us any differently!"

Obviously, you don't want to record underexposed brides looking like they are wearing gray wedding dresses, nor do you want a dark-skinned person looking like they have "gray," overexposed skin, so again, one surefire solution, always, is to set an overexposure from the palm of your hand at +1.

Here are the simple steps for using the palm of your hand to set a correct exposure:

1 With the camera in full Manual Mode, select the aperture you feel will best provide your desired depth of field—such as *f*/22 or *f*/16 for a storytelling shot, *f*/4 or *f*/5.6 to render an out-of-focus background, or *f*/8 or *f*/11 if depth of field isn't a concern, such as for a subject seated on a bench against a brick wall. (For more on this, see "Choosing the Right Aperture" on page 165.)

2 Open the palm of your hand, making certain that the same sunlight or open shade that falls on your subject is falling on your palm. Adjust your shutter speed until your light meter indicates that you are +1 stop overexposed.

3 Now take a shot and smile at what a master of exposure you've become! It's really that simple.

Another method is to simply overexpose white subjects by +1⅓ and underexpose black subjects by -1⅓. You don't want a full one-stop here, which is why I add just an extra third.

Your camera's color settings are based on the RGB color space—red, green, blue— as are the colors seen on the World Wide Web. Here, I was fortunate to create a composition made up entirely of the RGB color space, with the help of Susana Heide Schellenberg, coauthor of my book *Understanding Color*. Susana is wearing a *red* dress, standing near a *green* plant that rests next to the *blue* steps, all surrounded by the white architecture of Santorini, Greece. It's a bit tongue in cheek, but it's a good example of a massive amount of white creating a difficult exposure situation. Despite the overcast skies, I still resorted to taking a meter reading off the palm of my hand, making certain that it read +1 before returning to the composition you see here and firing off a number of frames as Susana walked up the steps while looking up at me.

NIKON D500, NIKKOR 18–300MM LENS AT 23MM, F/16 FOR 1/160 SEC., ISO 640, DAYLIGHT/SUNNY WB

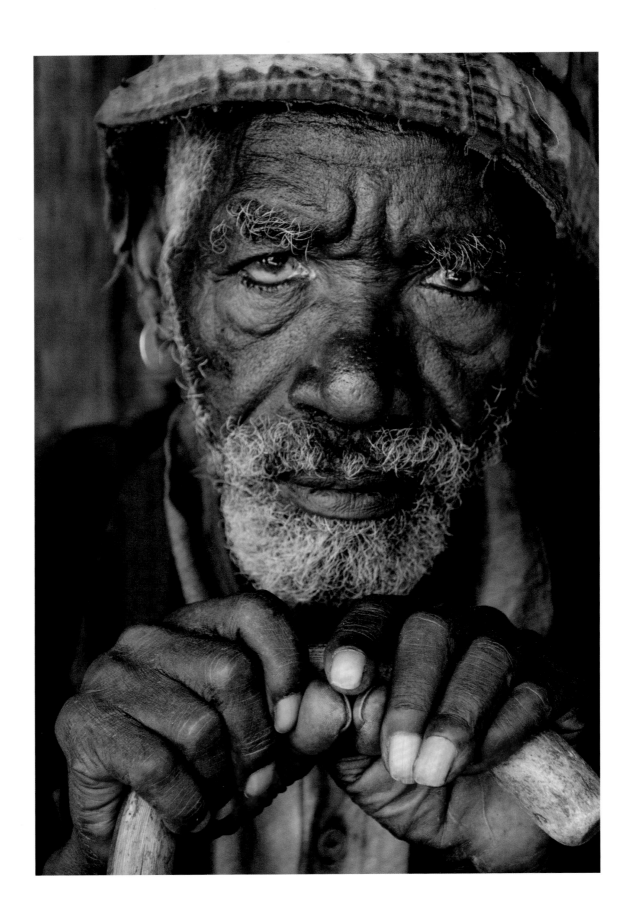

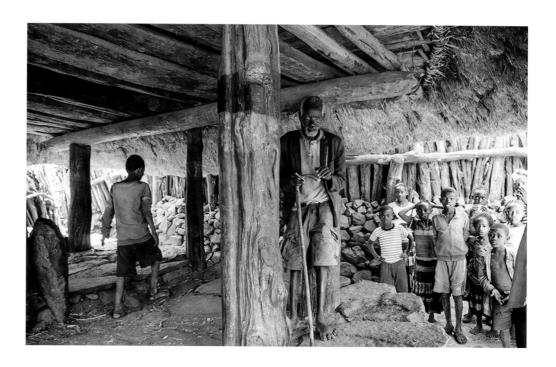

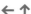

As I walked the narrow stone paths cut into the steep hillsides of this particular Konso tribal village in southern Ethiopia, I felt enveloped in what can best be described as a "wise energy," attributable perhaps to the thousands of Konsos who have left their marks on these same paths for the past five hundred years. The paths and sidewalls of once-jagged and craggy stones are now reduced to smooth, rounded surfaces, in marked contrast to the lone elder I came upon moments later—an elder Konso, whose life had certainly begun as a smooth baby, and evolved over time into a craggy surface of storied lines, even chapters. As he stared into my lens with the weight of a deep sadness, I wondered if perhaps I was a witness to his final chapter.

As is clear in the behind-the-scenes photo above, I photographed this elderly man under the cover of an outdoor deck-like structure. Although the light levels were even throughout, I was quick to set an *under*exposure of -1⅓ because of his dark skin. Remember, when the light meter sees a dark subject, it wants to make it "gray" and thus overexposes it. To avoid this, experience has taught me that dark-skinned subjects should be underexposed by, on average, about -1⅓ stops.

NIKON D500, NIKKOR 18-300MM LENS AT 300MM, *F*/7.1 FOR 1/320 SEC., ISO 200, DAYLIGHT/SUNNY WB

↑ ↗ ↘

Before closing this section of the book, it would be irresponsible of me to not address another common question I get regarding the camera's built-in Spot meter, another light-metering mode offered by almost every DSLR today.

First, I use Nikon's Matrix metering mode 99 percent of the time. Only on the rarest of occasions will I switch to Spot metering mode, which was the case with this portrait shot on the streets of Jodhpur, India.

As you can see from the setup shot above, this man was sitting outside in front of an open yet very dark unfinished storefront. All of that darkness surrounding the man was in marked contrast to the much narrower area of soft overcast light illuminating his face.

My attempt to meter this scene in Matrix metering mode resulted in the overexposed portrait you see opposite, top. Matrix gathered the light values of both the soft, brighter light *and* the much darker light from the interior of the empty building, thinking it should render an average exposure between the two areas of light and dark. As you'll notice, the light meter did a fairly good job of getting an overall average exposure; the man's face is a bit overexposed, as is the once-dark interior. But we *only* want the man's face correctly exposed; we want that dark interior to be rendered really dark so that the man jumps out in stark contrast to the background.

Since I wanted to set a correct exposure *only* for the man, I switched to Spot metering, which renders a light meter reading from only a one-degree area directly in the middle of the frame. Then I pointed the camera and lens at the man, centering him in the frame just long enough to set my exposure. With my meter reading now set, I recomposed and there you have it: the "perfect" exposure seen opposite, bottom. And just a reminder: *Do not forget to switch from Spot metering back to Matrix metering when you're done.*

NIKON D500, NIKKOR 18–300MM LENS AT 300MM, F/8 FOR 1/320 SEC.,
ISO 800, DAYLIGHT/SUNNY WB

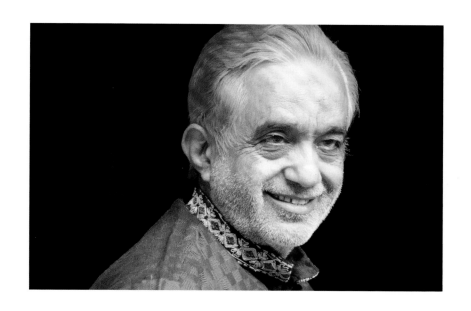

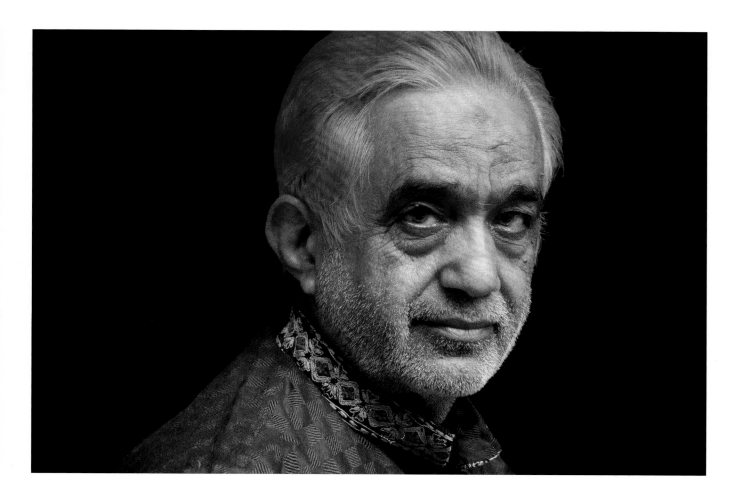

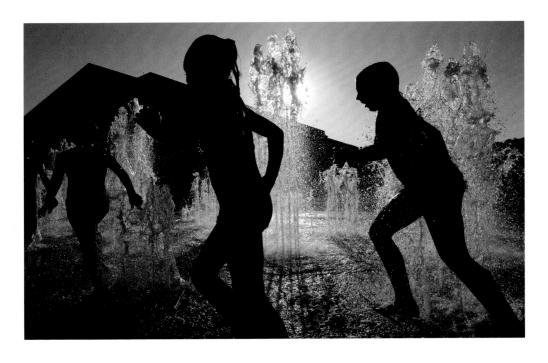

White Balance

It's important that I go on record, hopefully for the last time (at least for the foreseeable future), to say, emphatically, *do not use* the Auto White Balance (WB) setting. It almost always generates an image that suffers from an overall cold and blue cast—and a portrait cast in cold, blue light is, most of the time, far from flattering.

Due to the advances in the color values of most digital sensors today, I highly recommend using the Daylight/Sunny WB setting for 98 percent of your picture-taking efforts. Some will argue that it's best to leave it on Auto and then adjust the image later in postprocessing, but I've found that, more often than not, in post my students adjust the WB to end up around the Kelvin color temperature of 5200, which just so happens to be Daylight/Sunny. So why not eliminate at least one step from your postprocessing? If on the rare occasion you do want an image to be more "blue" or "yellow," you can make the changes accordingly.

Having said that, I will note that changing the WB can be a "fun" way to alter the overall mood of an image, and I'm all for opening up an image to experimentation.

↖ ↙

Having the option to change the WB at any given moment is probably my second-most-liked feature of shooting digitally. (The ability to change the ISO from one shot to the next is my favorite feature; this coming, of course, from a guy who shot film for thirty-plus years.)

It was around 2 p.m. and 93 degrees on this July day in Lyon, France, and with my WB set to Daylight/Sunny, the image of kids playing in the fountains looked exactly as it should (see the image opposite, bottom); however, I wanted to evoke the warmth of the hot day, so I chose to manually set a custom WB of almost 9000 degrees Kelvin, and without question this resulted in a much warmer, more golden image (opposite, top).

As far as overall exposure, this was easy stuff: f/22 for front-to-back sharpness and, needing an action-stopping shutter speed of at least 1/1000 sec., I metered for the strong backlight and then adjusted my shutter speed until 1/1250 sec. indicated a -⅔ exposure, which I always prefer (see "A Note about Underexposing on Purpose" on page 65). With the camera in CH Motor Drive (continuous shooting) mode, I just fired at will whenever I felt the overall composition was active and filled the frame.

↙ NIKON D500, NIKKOR 18–300MM LENS, F/22 FOR 1/1250 SEC., ISO 640, DAYLIGHT/SUNNY WB

↖ CUSTOM WB OF ALMOST 9,000 DEGREES KELVIN

Composing Powerful Portraits

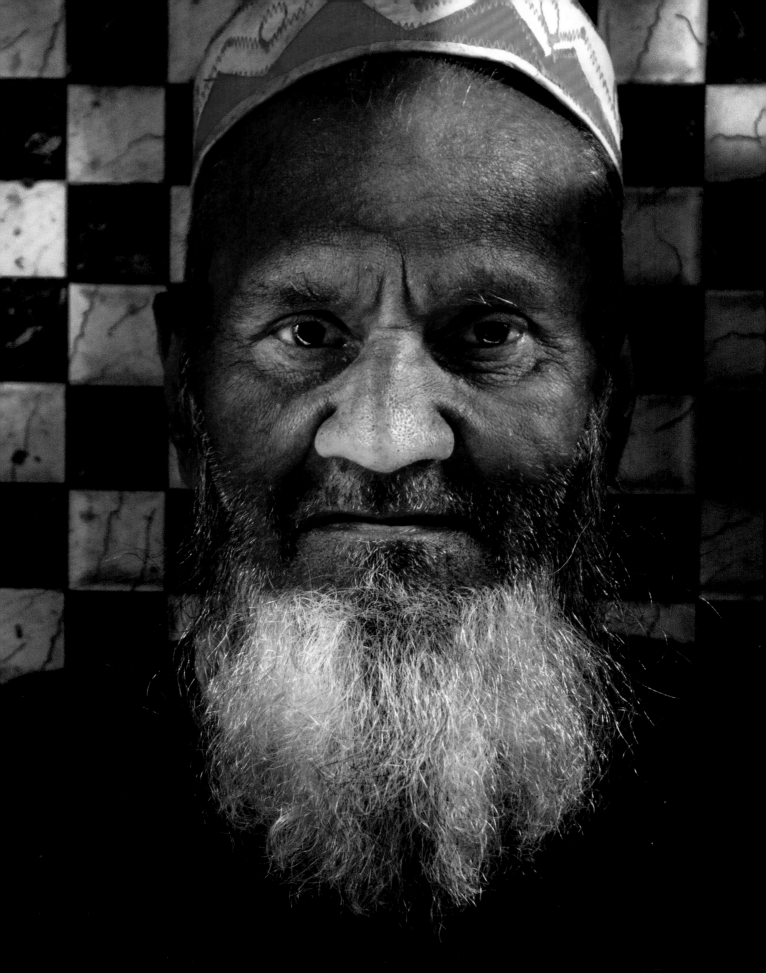

What Is Composition?

Photographic composition is based, in part, on order and structure. Every great image owes much of its success to the way it is composed, which is, in essence, the way its elements are arranged. With any good image, several variables are involved in the process of putting together a compelling composition. You can make the human subject appear small and distant against the drama that might be unfolding in a panoramic landscape. You can also decide to fill the frame, edge to edge and top to bottom, with only the crowd at a football game, cropping out the players on the field below and the sky above. You can include a background that complements the subject or, alternatively, that serves as a shocking contrast to the subject in front of it. You can also choose to emphasize a subject's weathered and worried face by moving in close, or you can step back just a bit to include the hands and face of the obstetrician whose skills have brought so many "subjects" into the world.

In addition to these choices, you can utilize two specific characteristics that dominate every successful composition: tension and balance. Tension, which is the interaction between the picture's elements, affects the viewer's emotions. Balance organizes the visual elements and keeps viewers from tripping over the photograph's meaning.

As you compose, you'll discover that finding the best spot for your subject isn't always easy. This is particularly true when you photograph subjects whose environments are supposed to call attention to their characters or professions. Here, you must always be careful not to include extraneous material in the frame that detracts from the subject. For example, your '57 Chevy sitting on blocks in the driveway thirty feet behind your daughter has nothing to do with her splashing in her pool, so make sure that the car isn't visible in the frame.

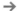

Not until this day did I fully appreciate the moves of the window washer, moves that one might normally associate with a symphony conductor or a passionate first-grade teacher writing out the alphabet on the chalkboard, one large letter at a time. His hand was in perpetual motion. Fortunately the windows in this hotel lobby were long and tall, allowing me as much as five minutes to shoot a number of frames at 1/500 sec. before he moved into an area of open shade. Why 1/500 sec.? Because that right hand of his was moving. Also, to be clear about the odd blue cast: this has more to do with the tint of the hotel windows than the actual sky. Yes, it was bright and sunny, but at this midday hour the sky was hardly this blue.

NIKON D500, NIKKOR 18–300MM LENS AT 117MM, F/11 FOR 1/500 SEC., ISO 200, DAYLIGHT/SUNNY WB

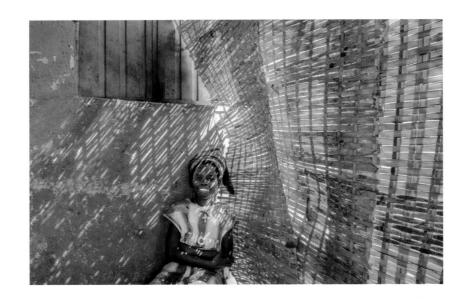

Fill the Frame

As I mentioned in one of my previous books, when you order a cup of coffee, you expect to get a full cup, not so much because that's what you paid for but because the "composition" of the cup just doesn't look right unless it's full. Neither a half-full nor a three-quarters-full cup is enough. In much the same way, effective composition almost always demands that you fill the frame, not half full, not three-quarters full, not spilling over the sides—just full.

The biggest challenge many amateur, and even some professional, photographers face is getting close enough to the subject to fill the frame. You can, however, easily solve this problem. You can physically move closer to the subject, switch to a longer lens, or in some cases have the subject walk toward you.

Although it rarely happens, you *can* get too close to your subject, which is comparable to overfilling a cup with coffee. The most obvious example of this is when you eliminate information in the composition that is paramount to the story you're trying to convey. For example, if I were asked to shoot a portrait of a mechanic and the prized 440 horsepower engine he just overhauled, I would include the man as well as his engine in the photograph. Showing only the mechanic with his arms crossed, holding a socket wrench, would leave out a critical element of the scene: the engine. Similarly, suppose you want to shoot a portrait of a sculptor. Since the artist's hands are what help to define the individual's profession and character, it would be unfortunate and completely inappropriate to move in so close that you leave the hands out of the composition. Filling the frame often means getting closer to the subject, and you can achieve this most easily simply by walking closer.

↖ ←

Years ago (and yes, it still seems like yesterday), I suffered from a terrible foot ailment that plagued just about every beginning photographer back then—and despite all of the advances made with cameras, that same foot ailment plagues even more photographers today, including millions of smartphone users. The foot ailment I'm talking about has many names: concrete foot, paralyzed foot, shy foot, even dead foot. The fact is, most beginners don't move forward due to their dead feet, and they come up short in filling the frame. And when the frame isn't filled, your viewing audience can see it right away. As with a half-filled cup of coffee, they sense that they're getting "robbed" of a much more fulfilling drink.

The good news is that this ailment is easy to fix. More often than not, you only have to take two steps forward to fill that cup. Just remember this mantra: Two steps forward is but a fair price, resulting in a picture that is often twice as nice.

In the small town of Turmi, Ethiopia, the country's colors were on full display in this little girl's clothes. After taking two steps closer, I was able to record a much better composition of a cheerful and beautiful young girl bathed in some equally cheerful and beautiful light.

NIKON D500, NIKKOR 18–300MM LENS AT 65MM, *F*/11 FOR 1/80 SEC., ISO 125, DAYLIGHT/SUNNY WB

Before moving on from the importance of filling the frame, I want to call your attention to the importance of *not* filling the frame, too. The idea of shooting only a "partial" portrait seldom occurs to most, which is unfortunate since a partial portrait creates a completely different viewing experience, one that the viewer isn't used to.

"Shy," "mysterious," "alluring" are all words that might be used to describe the look of this young Indian model named Kayra, photographed in the Blue City: Jodhpur, India. It's not a look caught by chance, but rather a deliberate, posed, and directed portrait—a partial portrait, like when you catch the first glimpse of a partially opened gift.

The idea for this photo began earlier in the day, born from a failed effort on my part to photograph a different girl, a stranger who had turned away from me as I attempted to photograph her when she came around the corner of a similar narrow walkway . . . further proof that failure can be a great motivator.

NIKON D500, NIKKOR 18-300MM LENS AT 300MM, *F*/7.1 FOR 1/320 SEC., ISO 200, DAYLIGHT/SUNNY WB

118

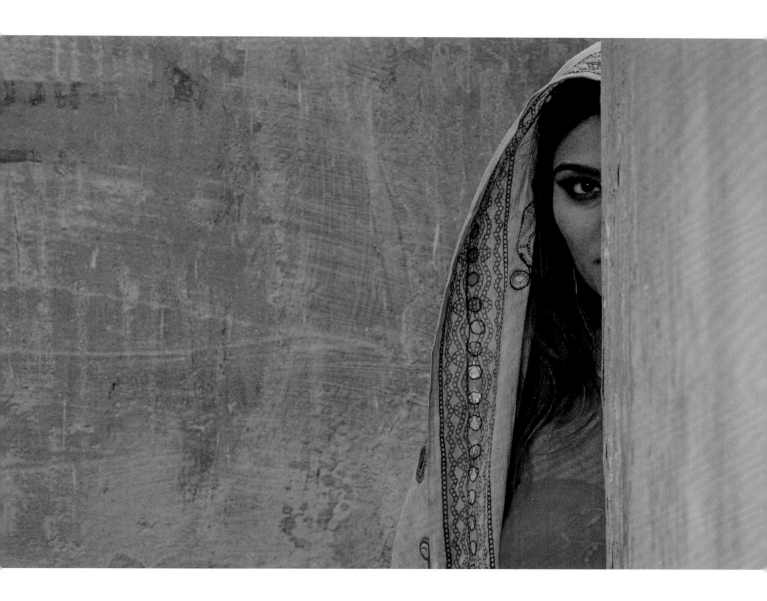

The Vertical Format

"Portrait mode" is the latest buzzword term for the vertical format, and I only mention it here because photographers are now under the mistaken impression that *all* portraits should be shot in "portrait mode." I want to be quick to dispel that notion. Throughout this book there are many portraits shot horizontally in "landscape mode" (another term I don't like, since it suggests that *all* landscapes should be shot as horizontals—but that's a topic for another book!).

Yes, many of my students do embrace "portrait mode," unlike ten or fifteen years ago, when they only "saw" in "landscape mode," but this portrait mode doesn't mean "high school yearbook portrait mode." What I mean is that it's still paramount that you come in close, as close as if you were just getting that one last shot before cutting off part of the person's forehead. More often than not, the use of portrait mode finds the subject not quite filling the frame, surrounded by ample "breathing room" above the top of the head, much the same way our high school portraits left breathing room over our heads. Most of the time, you *do not want* breathing room. You want "in your face" compositions so that the viewer becomes engaged, maybe even feeling the need to gasp for air.

Just as you might feel transfixed by these blue eyes, they accounted in large measure for why I wanted to photograph this elder member of the Erbore tribe in southeastern Ethiopia's Omo Valley. Further attraction was provided by his orange headscarf, which provided heightened color contrast, as orange and blue are complementary colors.

This man's "blue eyes" are in fact dark brown but afflicted with the cataracts almost guaranteed for every elder in his village, after decades of daily exposure to an extremely bright sun constantly reflecting off of white sand. According to his wife, both the size and color of his "blue" cataracts had grown substantially over the past twelve months. So is he blind? No, but when I asked him to describe my physical appearance, he was only able to describe me as a "foggy shape."

An age-old question I'm asked repeatedly is, "When is the best time to shoot a vertical?" My answer is always the same: Right after you shoot the horizontal. And so, without hesitation, I shot the compositions you see here, both made inside his straw hut next to a south-facing window that softly illuminated his face.

One thing of note is that, almost without fail, I compose portraits so tightly that I cut into the person's forehead. Obviously, not everyone agrees with this style, but here is my simple reasoning: I want the viewer to feel close to my subjects. I want the viewer to feel their joy, their plight, their laughter, their sadness. When I come in this tightly, most agree that the encounter feels far more intimate.

NIKON D500, NIKKOR 18-300MM LENS AT 167MM, *F*/7.1 FOR 1/320 SEC., ISO 1600, DAYLIGHT/SUNNY WB

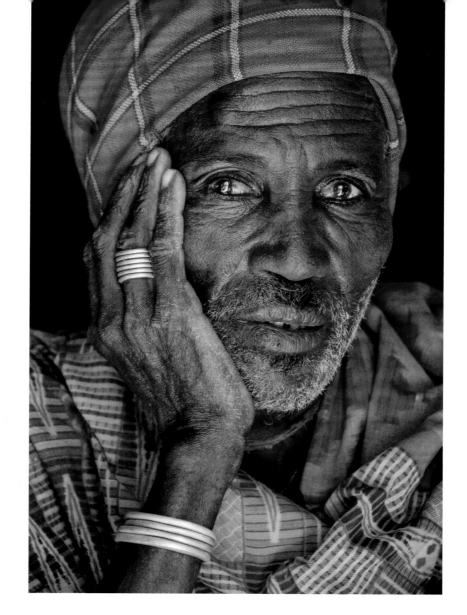
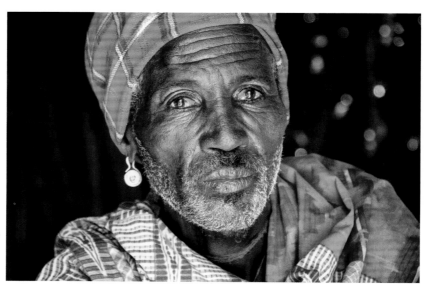

Some students are quick to point out that they can easily crop into the image and "save it" from the cutting-room floor. I often reply by asking, "Why not do the crop in-camera?" Of course, I then hear this reply: "If I crop in-camera and then want to show more of the face, well, then I don't have it." Your job as a photographer is to "sculpt" the portrait, which means you will work the subject much like a sculptor would with chisel and hammer. You begin with the high school portrait and then start chipping away until you are in really close. You have now covered your bases and at no point are you running the risk of "throwing away" valuable pixels due to cropping, since you have covered all the angles and all the distances from the high school portrait to just a striking composition of a single eye.

Once you become more familiar with considering which subjects should be horizontals and which should be verticals, you'll discover that some subjects can be shot either way—and why not? Now you're having twice as much fun!

During one of my summer workshops in Oregon, my students and I met a small crew of wheat farmers, including young Ashley, the woman seen here. Another day of harvesting had come to a close for them, yet we still had about thirty minutes of light left. I asked Ashley if she would mind playing the central role in what I hoped would be a "ghosted" silhouette portrait of her against the strong backlight of the setting sun and her enthusiastic response made it clear she was all in.

Simply put, when there is a backlit scene and the subject is able to kick up enough "dust" (in this case, superfine dirt), the backlit fog-like dust cloud, in combination with the actual person, creates a shadow of the person in front of it. I am not a physicist, so don't ask me how this works—all I know is that a "ghost" shows up, and after a few kicks by Ashley as she walked toward us, we easily saw her "ghost." If you know of an east- or west-facing unobstructed location where the terrain is dusty, grab a friend or family member and try this yourself!

As far as metering, it's easy stuff: use an ISO of 400 and you can simply set an f-stop of 16 to 22 along with a shutter speed of between 1/500 and 1/800 sec., both fast enough to freeze the action. Also, consider using Shade WB, which will impart an even warmer sunset.

NIKON D500, NIKKOR 18–300MM LENS, F/16 FOR 1/640 SEC., ISO 400, SHADE WB

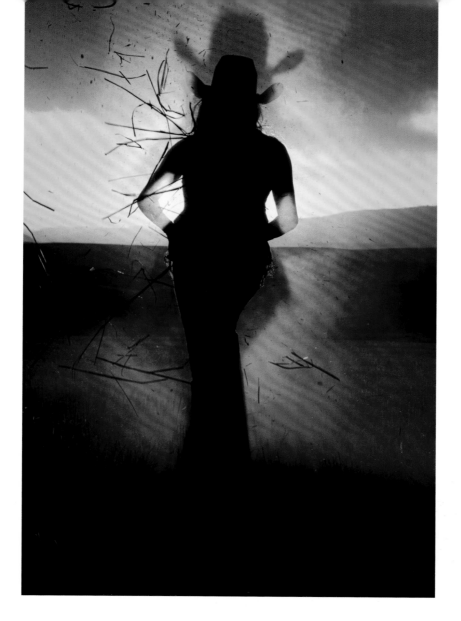

The Rule of Thirds

Much of the pleasure people have in life is based on the idea of a "sweet spot." Suppose you get up from the couch and feel a terrible itch in the middle of your back, so you ask your partner to scratch it saying, "Over a little bit. Now down. Just a bit more to the left. Now up. Good." That's a sweet spot. And if you're familiar with tennis, you probably know that players try to hit the ball at the sweet spot in the center of the racket.

In terms of photographic composition, there are four sweet spots, which are related to the Rule of Thirds. According to this principle, if you can imagine a grid of two evenly spaced horizontal and two evenly spaced vertical lines dividing the picture frame into nine equal rectangular sections, the four points at which these lines intersect are the sweet spots. So, for example, carefully composing a portrait with the eyes on the top-third line, both at sweet spots, is likely to elicit a response similar to the "Aaah!" that follows scratching that itch or the "Wow!" after a tennis player smashes an ace.

Perhaps the easiest and, often, the best examples of the power of the photographic sweet spot are compositions that use people to indicate scale in an awe-inspiring vista. Although a building, ship, forest, or other landscape may dominate the frame, a person placed on one of the four points of intersection within that frame brings a sense of size and scope to the scene. If the individual didn't appear in the photograph, viewers would see only a massive structure or a vast open space. Thus, the subject's presence and placement are quite important to the success of the image.

↖ ←

Both of these photographs have what I call "giveaways." A giveaway is something we get for free, something we didn't have to work for or spend money on.

Do you see the "free gift" in both of these images? If you understand the principles of the Greek Mean, the Golden Section, or what is today commonly referred to as the Rule of Thirds (a term, by the way, that was first introduced in the late 1700s), then you will see that both of these images are clearly divided into horizontal thirds (by the staircase behind the woman and the wooden poles holding the corn). In effect, you have a top-third and a bottom-third line right before you, without having to visually work for it.

This isn't a book devoted exclusively to composition, so I apologize for glossing over the Rule of Thirds here, but it's worth mentioning that in both of these photographs, the main subjects also follow the Rule of Thirds placement. In the top image, the woman is placed in the left vertical third. In the bottom image, the man's face is placed inside the middle of the middle third.

↖ NIKON D810, NIKKOR 24–120MM LENS AT 88MM, *F/5.6* FOR 1/320 SEC., ISO 400, DAYLIGHT/SUNNY WB

← NIKON D500, NIKKOR 18–300MM LENS, *F/10* FOR 1/200 SEC., ISO 400, DAYLIGHT/SUNNY WB

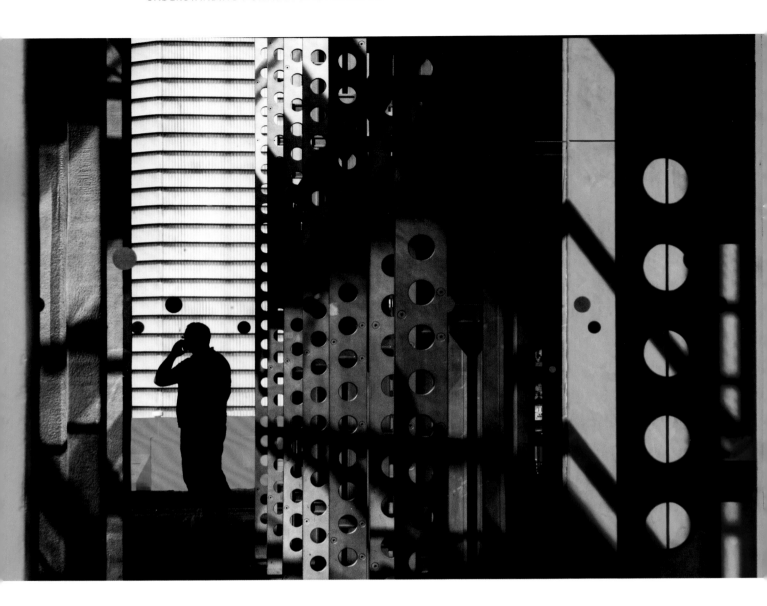

Note the sets of parallel lines in this photo and how the man at the convergence of those lines is in the left vertical third. The strong elements of line and color dominate this image initially, but then along comes the stark black silhouetted shape of a man who clearly doesn't fit the pattern—and, thus, it is he who seems to be the subject, which of course is correct. Yes, I am using line and color to call attention to the main subject, with a slightly more subtle display of the Rule of Thirds.

NIKON D500, NIKKOR 18-300MM LENS, *F/22* FOR 1/100 SEC., ISO 200, DAYLIGHT/SUNNY WB

Point of View

Most, if not all, beginning photographers tend to shoot everything from their eye level or from the spot where they first caught sight of a willing subject. But shooting from these points of view seldom leads to compelling imagery. For example, the cute picture of your daughter sitting on a swing would have had more impact if you had knelt down to photograph her at *her* eye level. Or, suppose you photographed a man in a brightly colored outfit at a crowded festival in Mexico City. If you had moved in closer, you would have eliminated the other people in the image who are distractions. Are your compositions often predictable, shot at eye level, and lacking any real impact? Then perhaps you need to start searching out fresh points of view.

Try climbing up stairs to shoot looking down on your subject. Lie on your back in order to shoot looking up at your subject. Fall to your knees and greet children at their eye level. Lie down on your stomach and frame cattle branding through the boots of a cowboy watching the action from fifteen feet away. Shifting your point of view is an easy way to improve your compositions.

By the same token, if you move close to a picket fence and shoot it at an angle, the repeating lines in the final image will draw the eye to the woman weeding the flower bed by the end of that fence. To eliminate a distracting background, simply move a bit left or right to hide it behind your subject. If you want to make someone look very important, all you have to do is get down low and shoot up as the subject looks straight ahead. If you want to make that same person look authoritative, keep your point of view the same but have the subject look down at the camera with folded arms. To call attention to someone's love of solitude, position them in a large open space, such as a park or a dry lake bed, and shoot looking down on them from a tree or rock using a wide-angle lens.

Changing your point of view about sex, politics, or religion leads to a whole new way of looking at the world. This holds true for photography, too. You can breathe new life into tired, worn-out subjects when you view them from a fresh perspective. And while changing your point of view can be scary, it can also keep life exciting and filled with adventure.

EXERCISE **Use the Grid Lines in Your DSLR**

Here is one of the easiest visual exercises to train your eye to "see" compositions before you: turn on the grid lines. Most digital cameras today offer a "Rule of Thirds" grid that either shows up on the digital monitor (when viewing your images) or inside the camera's viewfinder. Often, these grids are an option you need to select when setting up your camera. (Smartphones also offer this feature, turned on in your settings.) Needless to say, if your camera (or smart-phone) offers these Rule of Thirds grid lines, use them! They will only help you create even more compelling images and, in turn, will further train your eye to see.

The two-hundred-year-old Ubien Bridge, built from teak, stretches across the southern end of Taung Tha Man Lake in Mandalay, Myanmar, affording those who cross it an elevated view of the lake and the activity below.

From roughly twenty feet above the lake, the early-morning calm of the water and the reflections of clouds were briefly interrupted by two fishermen and their narrow boat, slicing through the water like a sharp knife through cellophane. This was one of the few times I've shot clouds with my camera pointed to the earth below. Note that this was *not* the time to use a polarizing filter as it would have done a fairly good job of removing the surface reflections (the clouds), which of course I did not want to do.

NIKON D500, NIKKOR 18–300MM LENS AT 42MM, *F/11* FOR 1/250 SEC., ISO 640, DAYLIGHT/SUNNY WB

128

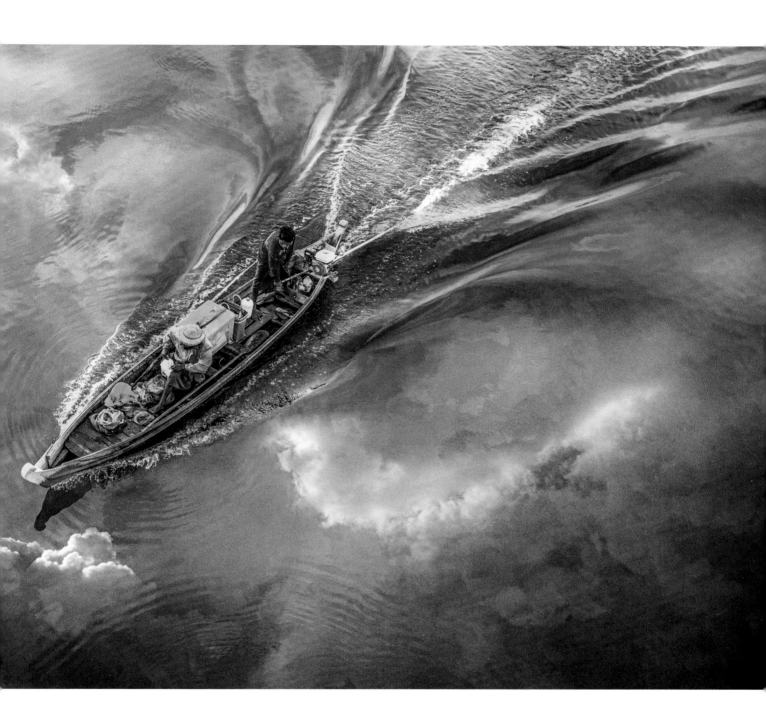

On the island of Santorini, Greece, in the town of Oia, there is an art gallery with a seating area out front, and if you time it just right (midday), the narrow openings in the slatted roof create a wonderful striped "canvas" across the gray and red terrace. Having taken in this scene several days prior, I suggested to Michelle, my business partner at my online school, that I would buy her an *inexpensive* red summer dress if she would then model for me at this same art gallery. Needless to say, it was win-win for both of us. Here again, the shot only works because of the downward point of view.

NIKON D500, NIKKOR 18–300MM LENS AT 18MM, *F*/16 FOR 1/60 SEC., ISO 50, DAYLIGHT/SUNNY WB

Surprise, surprise! The many fields of tulips seen blooming throughout Holland in late April are *not* grown by the farmers for the cut flower market but rather for tulip bulbs—bulbs that you and I buy from our local nursery or the garden centers of home improvement stores around the world.

On average, about seven days after a field blooms, the farmer returns to the fields and uses a special machine to cut all the blooms, thus forcing the plant to put its energy into the bulb. Come September, almost two billion of these adult bulbs are dug up, separated from their "baby" bulbs, and exported around the world, while the "babies" are replanted in October, becoming adult bulbs by the following spring. The circle of life!

Here, an overcast day made for an easy exposure, since light levels were even throughout the composition. And shooting from an elevated roadway meant that I was able to create this very graphic composition of color and converging parallel lines without including any dull gray sky.

NIKON D500, NIKKOR 18–300MM LENS AT 270MM, *F*/22 FOR 1/200 SEC.,
ISO 800, DAYLIGHT/SUNNY WB

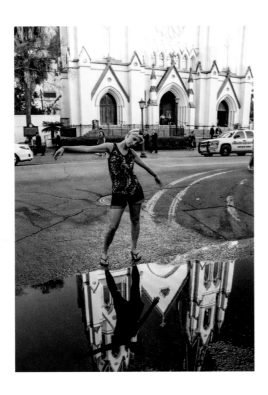

↑ ↗

Although it was brief, the afternoon rain shower left behind a puddle large enough to capture a reflection of the twin-spired church across the street, and with the help of Lexi, a willing student in my Savannah workshop, the other students and I had the makings of a "fine art" abstract. *But* I felt we needed to create a bit of "disruption" in an otherwise highly organized, tightly focused composition, much like the unexpected wail of a baby in an otherwise quiet movie theater, so I reached for a small stone nearby and let it splash: disruption accomplished! The splash effect further amplifies the abstract nature of the overall composition.

The composition seen here relies on both a great depth of field (to show both our foreground subject, Lexi, and the "distant" church) and a fast shutter speed (to capture the height of the splash), so *f*/22 at 1/1000 sec. it was. To get a correct exposure in the late-afternoon light with such a small lens opening and blazingly fast shutter speed, an ISO of 2000 was necessary. Lexi records as a dark silhouette because she's in open shade and the exposure was set for the much brighter frontlit church and sky.

NIKON D500, NIKKOR 18–300MM LENS AT 88MM, *F*/22 FOR
1/1000 SEC., ISO 2000, DAYLIGHT/SUNNY WB

People as Abstracts

Another area of photographic creativity that needs to be added to your arsenal of ideas for photographing people is the "abstract." Too often when we think of photographing people, we think that the subjects have to be easily recognized, and God forbid we alter their appearance, yet when the appearance of the subject or subjects *are* altered, a new "portrait" is born, and more often than not this new portrait is met with a combination of excitement and welcome surprise.

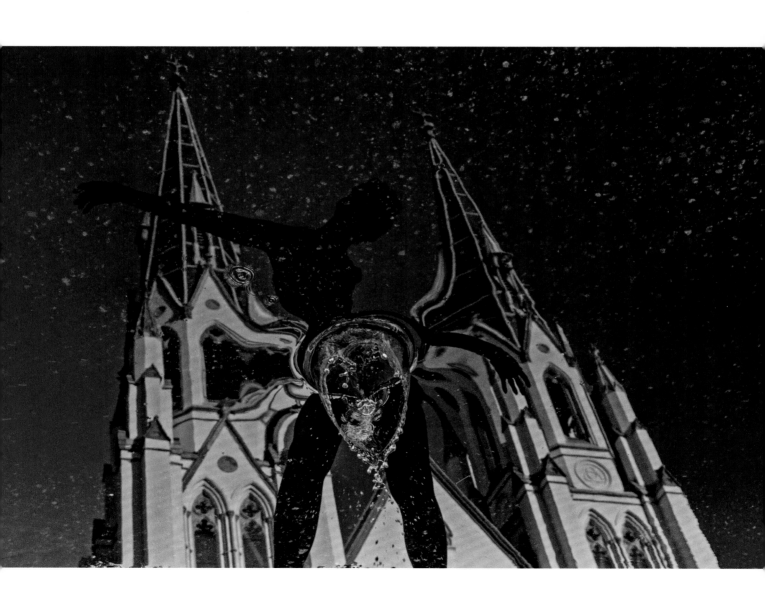

I've been to Jodhpur, India, eight times—in winter, spring, summer, and fall—and I've yet to see it rain. (Yes, it does rain there, but I've yet to witness to it.) And even if my timing did coincide with the rain, I would still be hard-pressed to find a rain-covered window, since most houses in the Blue City use cloth coverings, screens, or simple wooden shutters but not glass windows.

Time to take charge, so after finding a narrow alleyway that I felt was ideal, I put my 12 x 16-inch piece of clear Plexiglas to use, attaching it to a small portable light stand and spraying it with "rain" from my spray bottle. I then called upon my model to walk through the scene, and a rainy day in the old Blue City of Jodhpur was created.

NIKON D500, NIKKOR 18-300MM LENS, F/11 FOR 1/160 SEC., ISO 800, DAYLIGHT/SUNNY WB

↑ ↗ ↘

Textures! They really are everywhere, such as in this plastic tent, which made for an amazing foreground. The key in this case was to focus solely on the plastic but also include the out-of-focus yet very colorful background. Don't forget to use an aperture of ƒ/11 or ƒ/13—not small enough to render the background in focus but simply into discernible and recognizable shapes of colorful umbrellas and people enjoying a hot summer day. Just another example of what's possible *without* Photoshop or some "paint by number" suite of textures. The world in which we live is one with tremendous in-camera creative potential!

NIKON D500, NIKKOR 18-300MM LENS, *F*/13 FOR 1/320 SEC., ISO 200, DAYLIGHT/SUNNY WB

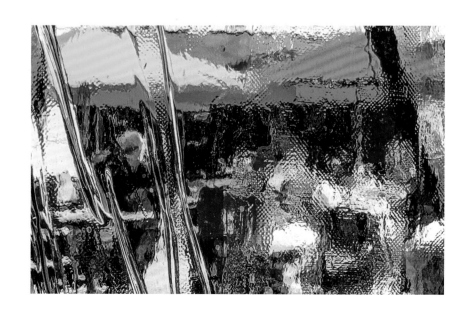

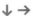

"You can't see the forest for the trees" is an expression used to criticize anyone too focused on the details (the trees) and not focused enough on the big picture (the entire forest). Yet experience has taught me, at least in the world of photography, that just the opposite is true: many photographers can't see the trees (the details) because they are too focused on the forest (the big picture)! Let's say you find yourself in a boat on the Ganges river in Varanasi, India, at dawn, and you are focusing on the "forest" (the big picture), shooting the temples and the colorful crowds of people on the steps leading down to the river *but* never once seeing the "trees"—in this case, the compositions of colorful reflections on the water and the occasional individual meditating within these holiest of waters. Photographically speaking, maybe the criticism should be, "You can't see the *trees* for the *forest*."

NIKON D500, NIKKOR 18-300MM LENS AT 220MM, *F*/22 FOR 1/200 SEC., ISO 640, DAYLIGHT/SUNNY WB

REFLECTIONS

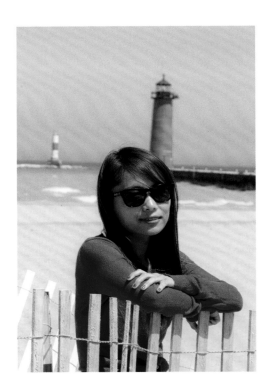

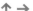

Here is an example of a common mistake: when a background subject/object merges with your foreground portrait, such as the lighthouse seen coming out of the head of my friend Aya above.

Sometimes these types of mergers are easy to spot, especially when using a moderate telephoto lens. But when using a moderate wide to normal lens, as was the case here, there is more of a sense of depth and distance between one subject and the next, making a merger harder to notice; it's as if the brain allows for the merger to be excused. But in my mind, a merger is a merger, no matter how close or far, and unlike a deliberate merger, this kind of merger is akin to the subject being "impaled." The simple solution, as shown opposite, was to move my subject or myself so that the new point of view made clear that the lighthouse was, in fact, *not* attached to my friend's head but was a unique and distinct structure capable of standing on its own.

NIKON D810, NIKKOR 24–120MM LENS, *F*/5.6 FOR 1/800 SEC., ISO 100, DAYLIGHT/SUNNY WB

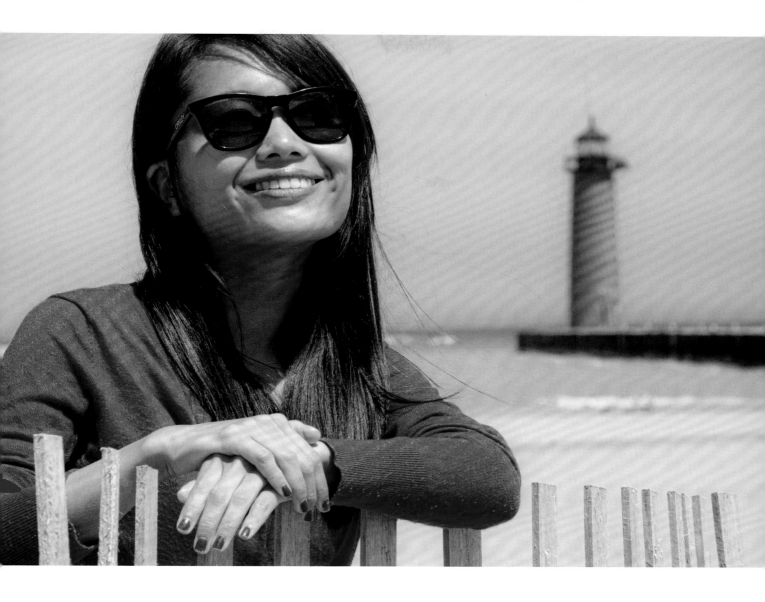

Mergers

There are two kinds of mergers in photographic composition: mergers that work and mergers that don't. The mergers that don't work are, of course, those that give "birth" to distracting objects that appear to be part of a person's anatomy, such as the proverbial tree growing from the top of a subject's head.

Mergers that *do* work also, surprisingly, create objects that seem to grow out of a person's anatomy, but they are specifically shot with humor in mind, more often than not. Check out Instagram for countless examples of mergers that are used for a photo's benefit.

Working Your Subject

Given that about 97 percent of today's photographers shoot digitally and the days of worrying about film costs are long gone, there's no longer any excuse for *not* working your subject!

To better understand what I mean by "working your subject," think of the following string of questions: Is there a better way to shoot your subject closer (by moving nearer or changing lenses)? Is there a way to shoot looking down on your subject (by climbing stairs, a tree, a ladder, a bed, the roof of your car)? Is there a way to shoot looking up at your subject (by lying on your back or changing to a wide-angle lens and looking up)? Is there a way to make the subject look more active (by turning your camera to make a diagonal composition)? Is there a way to make the subject stand out from a busy mass that surrounds it (by combining the narrow angle of view of the telephoto lens with a large lens opening)? Is there a way to increase the subject's visual weight (by making sure your background doesn't fight with your subject)? Is there a way to make the subject smaller to good effect (by changing lenses, moving farther away, or placing the horizon line near the top third of the composition)? Is there a way to make the subject more dignified (by trying the vertical frame)? This is working your subject. If everyone invested the time with each subject, really working them, I know everyone's photography would improve.

↗ →

Upon entering a two-room schoolhouse in Ethiopia's Omo Valley, my eyes immediately caught sight of a young boy from the Karo tribe sitting on the floor with his head resting against the wall and partially inside a "luminous window." I was quick to shoot first and ask questions later. Confident that I had a shot or two, I asked *why* he was sitting on the floor, and specifically inside the surrounds of a "luminous window." His answer? "I was dreaming about the day I will go to Addis Ababa and work with computers, and sitting in the light helps me dream."

NIKON D500, NIKKOR 18-300MM LENS, *F*/11 FOR 1/100 SEC., ISO 320, DAYLIGHT/SUNNY WB

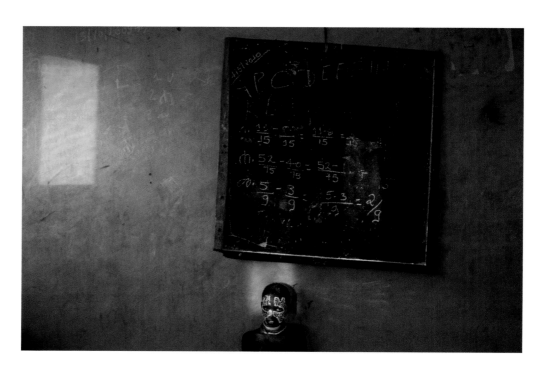

Framing within a Frame

One surefire way to make an image more appealing is to introduce foreground subject matter that calls attention to and frames the main subject in the background. This technique is often referred to as "framing within a frame."

To do this successfully, avoid any foreground subject/frame that distracts the eye. Instead, choose one that leads the eye into the frame or frames the distant subject such that you at first don't even notice the frame. Also, ask yourself the following: If I remove the foreground subject, will I miss it? And, will the frame enhance the overall composition? If the answer is "no"—if, for example, the foreground frame dominates the composition or is more of a distraction than a complement—then the framing is not successful.

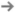

"Framing within a frame"—often done with doors and windows—is such a simple and effective compositional technique, yet it still isn't used enough by photographers in their portrait work. Because it almost always creates a "layered" effect, a front-to-back image of subtle depth, don't be surprised that it creates the illusion of a three-dimensional image. Natt and I had been shooting for the better part of the day in the old Blue City—Jodhpur, India, when we came upon a large porch of an abandon home, where a lone shaft of streaming late-afternoon light was "begging" to be photographed. Natt of course accommodated the "plea" from the shaft of light.

With today's digital sensors, the dynamic range has reached far beyond the days of film and this is one example where that range is a good thing as it allowed me to record a correct exposure of Natt as she stood in the diffused shaft of light, while also recording the detail and color of the enclosed porch itself. Note the layered effect, the front-and-back sense of depth. That is the magic of "framing within a frame."

This was one of those rare times when I found myself calling upon the storytelling aperture choice of $f/16$. Because I was in somewhat close, I needed the extra depth of field that $f/16$ would provide, allowing me to record front-to-back sharpness. If I had used the "Who cares" aperture of $f/8$ (see page 172), for sure that foreground blue wall would be soft. With my ISO set to 800 for the fading light, and resulting shutter speed of 1/125 sec., I was able to easily handhold the shot. No more than ten minutes later that shaft of light had faded. One final note about framing within a frame: not all doors and not all windows make great frames, so choose wisely and consider the color, the texture, and the surrounds of the doors and windows you wish to compose. The door or window should be a complement, not a distraction.

NIKON D500, NIKKOR 18–300MM LENS AT 50MM, *F*/16 FOR 1/125 SEC.,
ISO 800, DAYLIGHT/SUNNY WB

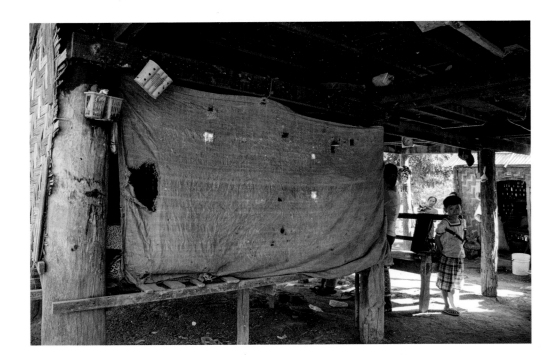

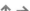 ↑ →

Imagine that you find yourself in a small Myanmar village, away from the crowds. It's midday and the light is harsh, but lucky for you, you spot a blue canvas tarp put up for privacy reasons, and in that "wall" is a large tear—so large, in fact, that if someone were to look through it, it would frame them rather nicely. Now the hunt is on to see if you can entice one of the locals to be your willing model. After a small search, you find her, though first she wants to put on some makeup. Twenty minutes later, there she is, peering out with a smile that says, "Life is good!"

NIKON D500, NIKKOR 18-300MM LENS, *F*/8 FOR 1/160 SEC., ISO 400, DAYLIGHT/SUNNY WB

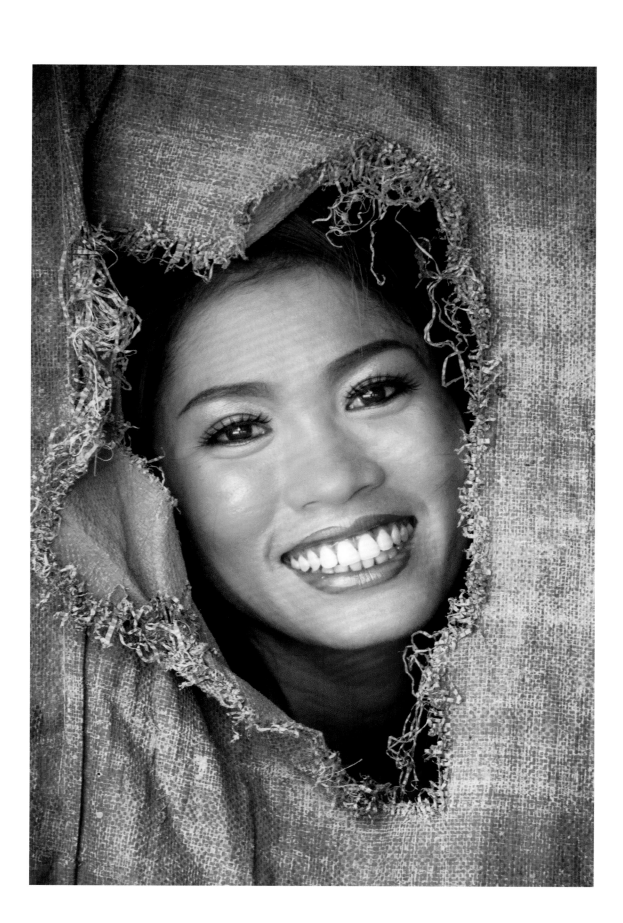

Scale

Think of scale as a thermometer or an IQ test and it becomes apparent just how powerful a compositional tool it is. A thermometer tells us how cold or hot it is, and an IQ test can tell us just how intelligent we really are.

The power of the human form when seen in a photographic composition is much like these tools. "Wow, is that ever a big piece of machinery!" you remark as you see the "tiny" figure standing next to it. Or "Wow, that's a huge cliff!" you exclaim as you notice the two rock climbers scaling the cliff face. Think about making use of the human form to point to the scale of surrounding elements, whether they be big or small.

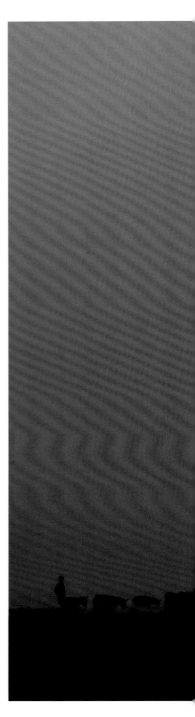

We were in a race against time! I was on a mission to shoot a sunset with these huge fig trees, and I had all of five minutes to shoot—though considering that I was shooting at 1/500 sec., five minutes was in fact an eternity. I felt so lucky to have come upon a group of these large trees *and* find local cattle- and sheep-herders walking across the dusty terrain. Their silhouetted shapes bring a welcome and tremendous sense of scale to the massive trees. Because we are so familiar with the shape of the human body, it becomes a great "tell" when included in land-scapes like this, offering a reason for the viewer to respond with, "Wow, those are *big* trees!"

NIKON D500, NIKKOR 200-500MM LENS WITH TC1.7 (A TELECONVERTER THAT EXTENDS THE FOCAL LENGTH OF THE LENS, TURNING A 500MM FOCAL LENGTH INTO AN EFFECTIVE FOCAL LENGTH OF 1200MM), F/13 FOR 1/320 SEC., ISO 100, DAYLIGHT/SUNNY WB

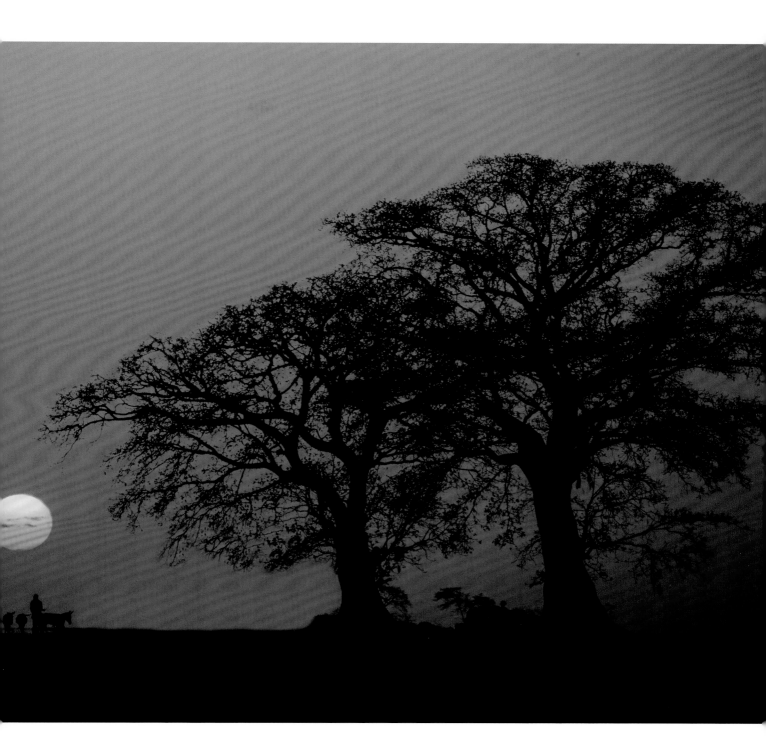

Shooting Better Selfies

I'm not one to shoot selfies, so I may not seem the most obvious choice to discuss the "proper" and most effective way to shoot them, yet I'm clearly a fan of photographing other people. So by enlisting the advice of several friends who are "selfie queens and kings" as well as calling upon my own photographic knowledge, I would like to offer my top tips on shooting selfies. If followed with religious fervor, these tips will result in far more "likes" than you ever imagined—and for many people, more likes is right up there with winning the lottery!

FACE UP TO IT. Just as when shooting photographs of others, make it a point to fill the frame with your face. And by this I mean *just your face*—not your face and the dirty dishes on the countertop, not your face and the flagpole growing out of the top of your head. Come in close enough so that your forehead is cut off a wee bit. The resulting image will convey a greater sense of intimacy.

USE A SELFIE STICK. If you're using a smartphone, consider using a selfie stick to hold your phone, which will put it farther from your face. The lenses on most smartphones are closest to a moderate wide-angle lens, which, when held close to your face, can cause unwanted distortion (such as making your face wider or more elongated).

FRAMING WITHIN A FRAME. Consider any opportunity to frame your composition *within* a frame, such as standing in an open doorway. The "frame" surrounding you will place even more importance on you. Note that when you extend both arms in front of you to hold the phone with both hands, your arms can also create a framing effect.

VENTURE BEYOND YOUR FACE. Selfies of body parts can be just as flattering as, if not more so than, those of your face. Have new shoes? Why not lie on your back, raise your legs straight up, and shoot your legs and new shoes against the blue sky and white puffy clouds? Have a new bracelet? Consider shooting just your glistening wrist against the backdrop of an equally glistening New York City skyline.

CHOOSE SIDES. Since most selfies are best shot with the face at an angle to the camera, experiment with which side and which angle is best. Most of us have a good side and a better side, so make a point of deciding which side is your favorite.

THINK ABOUT THE LIGHT. The soft light of an overcast day will be much kinder to your face, but be careful with early-morning sidelight, since it will call attention to every "nook and cranny." Definitely take advantage of dappled light opportunities, such as finding a pocket of light or a shaft of light coming through trees. Make it a point to stand in the soft dappled light so that the brighter light elevates your importance in the image.

SHOW EMOTION. Don't be afraid to express genuine emotion in your selfies! Smiling is obviously the norm, but consider other ways to express yourself, particularly when you find yourself grimacing or you are confused or angry, or you are pouting, frowning, or feeling embarrassed.

REMEMBER YOUR PHOTOGRAPHY BASICS. The same advice offered throughout this book for shooting others also applies to photographing yourself, especially in the areas of composition and light. Don't forget to experiment and shoot both vertical and horizontal compositions.

USE TRIGGERS AND REMOTE FIRING DEVICES. The use of radio-controlled remote firing devices is normally associated with wildlife photographers who create a kind of "blind" for just the camera—setting it up near a watering hole on the African plain, for example, or in their backyard near a bird's nest—and then "hide" as much as one thousand feet away. The photographer then fires the camera simply by pressing the trigger in their hand, which sends a signal to the remote trigger hooked up to the camera, which in turn fires the camera's shutter, recording the otherwise impossible shot. It's only recently that we've started seeing these same remote triggers being used for the "ultimate" selfie.

Often, and for reasons that are obvious, when it comes to taking selfies we have but one option: using the camera's built-in self-timer and then getting a maximum of ten seconds to do whatever it is we need to do before the shutter releases. Of course, having a mere ten seconds means that we cannot venture far from the camera before the shutter fires, so our creativity is a bit limited. But with a remote trigger, you can take all day if you wish, since the camera is under your complete control. In effect, a remote trigger is like having a friend along who does nothing but support you and agree with whatever pose you wish to try in whatever environment you wish to try it. So long as you stay within one thousand feet of your "friend," you can create just about any kind of selfie you desire.

Triggers are also great to use when doing group shots of which you're a part, especially since they let you keep shooting during and after the roars of laughter that often happen when organizing group portraits; these spontaneous moments often account for the most memorable shots, unlike the often "cheesy" group portraits that everyone participates in when making just the one shot with the camera's self-timer. Again, the trigger is under your control. It fits snugly in the palm of your hand where no one can see it, ready to be fired whenever you feel the moment of spontaneity.

Backgrounds

How critical is the background in terms of creating strong images? In my mind, 99 percent of all compelling people pictures can't survive without an effective one, and more than 50 percent of all images owe their success to the background. The stock photography industry has embraced the importance of backgrounds so enthusiastically that many of the larger agencies' catalogs contain more than two hundred background shots: vivid blue skies, white cumulus clouds, orange and red sunsets, green grass, autumn leaves, and wildflower meadows are just a few of them. And when you combine such striking backgrounds with people, those backgrounds become even more important. They can make an ordinary image extraordinary.

Backgrounds don't always have to be recognizable, clearly defined elements; they can take the form of out-of-focus colors or shapes. A successful background most often relates to the subject or enhances its importance, and can provide a contrast to the subject placed in front of it: For example, it makes perfect sense to photograph a turkey farmer from above while he sits in the midst of his two thousand gobbling turkeys. It would make no sense at all to lie down in an empty field and shoot up at the turkey farmer against a blue sky.

In much the same way, it is appropriate to photograph a little girl at her eye level against an out-of-focus background of green foliage as she hunts for Easter eggs at the local park; green is the color of spring, and the blurred background places the emphasis on the child. It would make no sense at all to photograph her with the visibly crowded parking lot as the background. When you consider backgrounds for people pictures, ask yourself, *Where is the connection*? Having a beautiful background but the wrong subject—or the right subject but the wrong background—serves only to magnify this question in viewers' minds.

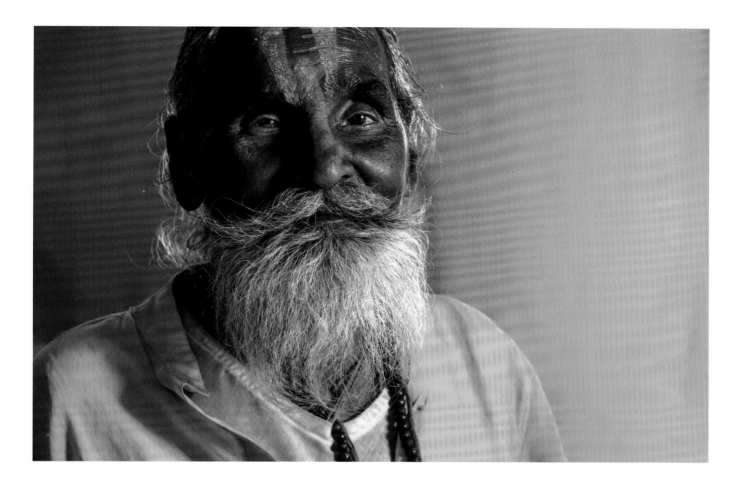

↙ ↑

One Sunday morning in Jaipur, India, a distant yet loud banging of drums and horns captured my curiosity. With my ears leading the way, only a few minutes later I found myself inside a Hindu temple, and within seconds, I was being encouraged with nodding heads and numerous hand gestures to take all the pictures I wanted.

Only two minutes later, at most, I felt the soft grasp of a hand on my arm, and as I turned around I came face to face with a sadhu (a holy man). Smiling, he quickly whisked me away to a large room behind the temple where many thin sleeping pads were spread out along the wide and expansive concrete floor. I concluded that I was now in the "dorm" where, based on those many thin mattress pads, I guessed more than forty sadhus slept and dreamed.

Note the background of brightly colored fabrics. I proceeded to have my subject stand about twenty feet from these background fabrics, and with my 18–300mm lens at 300mm and using an f/6.3 aperture, I was able to quickly transform the fabrics into out-of-focus tones of color while filling the frame with the individual portrait of each sadhu. Due to the somewhat low light in the room, I ran the ISO up to 3200. Ten minutes later, I was back outside the temple entrance, feeling more than grateful for another memorable morning in incredible India.

NIKON D500, NIKKOR 18–300MM LENS AT 300MM, F/6.3 FOR 1/200 SEC., ISO 3200, DAYLIGHT/SUNNY WB

Lens choice (see page 175) and point of view (see page 127) play very important roles in making the connection between the subject and the background. When you shoot with a wide-angle lens, your backgrounds will, for the most part, be sharply defined. And while objects in the background can be noticeably defined when you use a telephoto lens, the telephoto is more often called upon to reduce backgrounds to out-of-focus shapes or colors. Even the most unflattering of environments can be turned into appealing backgrounds via the telephoto lens. The lens's ability to render muted backgrounds is one reason why it's popular with seasoned professionals. But it's up to you to find the right background that, when turned into an out-of-focus color or shape, connects with the subject.

I once heard an art history professor say that no great painting was ever accomplished without a background. The same can be said of people pictures. I have said it many times in my online courses, as well as in my workshops, and it bears repeating here: If you make it a habit to spend more time looking at your background, your success rate with people photography will increase immeasurably. What good does it do to have a really great representation of your human subject if that subject has to compete with a distracting background?

Sometimes the problem is as simple as the proverbial tree growing out of the subject's head (see page 141). And we've all seen live newscasts with the reporter speaking enthusiastically to the camera while that one person in the background waves his arms, doing a good job of calling attention to himself and away from the main subject. A distracting photographic background is just like that person waving his arms around. It's difficult to concentrate on what the reporter is saying due to this background distraction, and the same will be true in your portrait work, unless you spend the few seconds necessary to really look at your background before pressing that shutter button.

I often look for backgrounds of color that contrast with the subjects in front of them. And if I'm unsuccessful in finding such backgrounds, I can always dip into my bag of "tricks," pull out a large piece of colored fabric, have an assistant hold it at a distance of about ten feet behind the subject, and instantly transform a colorless or busy background into a simple and clean background of out-of-focus tones.

↗ →

With my Nikon D500 and 18–300mm lens at 300mm (an effective 450mm focal length), and my aperture wide open at $f/7.1$, I took what some might say was an unconventional approach to this image, shooting down the side of a wall painted with a colorful mural and focusing on the model, Wassana Jonjun (who is wearing blue contact lenses). From practice I knew full well that the unique vision of the telephoto lens would stack and compress all that color surrounding Wassana into a wash of out-of-focus color of varying degrees of tonality. Additionally, I knew that the telephoto would reduce the distant blue- and orange-painted building behind her into a wash of out-of-focus color as well. Get to know the vision of your lenses!

NIKON D500, NIKKOR 18–300MM LENS AT 300MM, F/7.1 FOR 1/800 SEC., ISO 200, DAYLIGHT/SUNNY WB

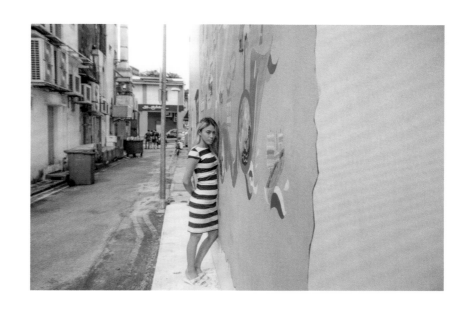

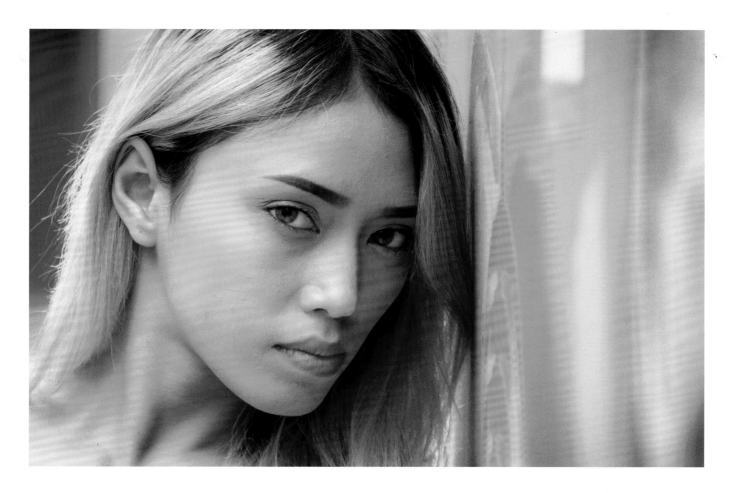

EXERCISE *Expanding Beyond Human Vision*

The best exercise I know of to expand your vision is to walk the streets, the beach, and/or the mountain trails with a camera, at first using a wide-angle lens, moving left and right, focusing near and far, tilting your head up and down, and then a mere fifteen minutes later, switching to your telephoto lens and repeating the above. You don't need to shoot anything; just *look* at what that lens is "seeing." If you did this daily, for thirty minutes max, for just a few weeks, the unique visions of your wide-angle and telephoto lenses would leave a lasting "imprint" on your brain, opening up a whole new world of wide-angle and telephoto compositions that you would normally miss.

A golfer, through practice, knows what each of their clubs can and cannot do. In the same way, experienced photographers, through practice, know the unique visions of their lenses, including which lens can do "this" and which lens can do "that." Keep a lens up to your eye a few minutes each day, if only to train your eye to see.

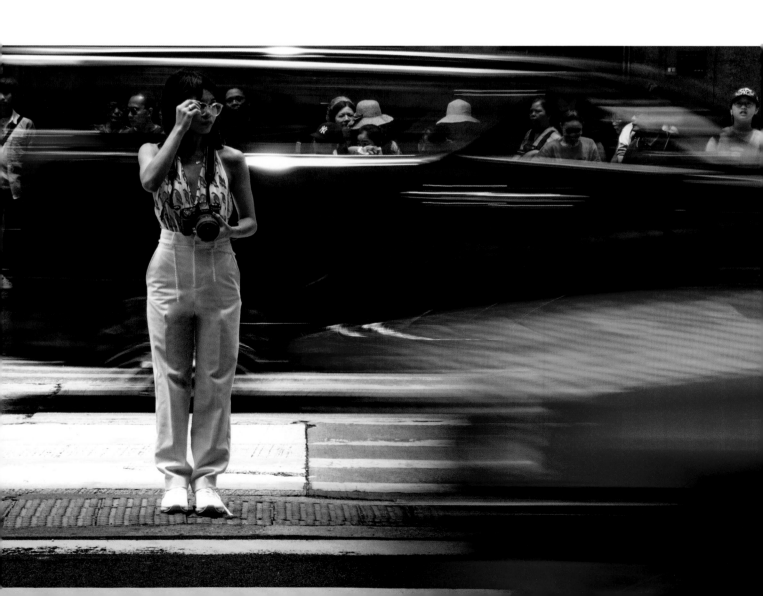

Shutter Speed

There is motion all around us. Most obviously, there's sports. America is a very sports-minded country, and not a weekend goes by that doesn't showcase two or more sporting events. Next to a baby's first few weeks of life and the family vacation, sports-related activities are probably the most-often photographed subjects. And besides shooting the actual sports action, many amateur and professional photographers want to capture the *participants'* emotions and produce good compositions as well.

Beyond sports, the hustle and bustle of life produces all sorts of action that's of interest to the photographer. Successfully shooting action-filled subjects requires not only skill and experience but also the right shutter speed. Only a fast shutter speed is capable of rendering such exacting detail and emotion on film. When action—such as a motorcyclist zooming over a hill, for example—is coming toward you, a shutter speed of 1/250 sec. freezes the subject in midair. But if you're shooting parallel to the motorcyclist flying over the hill, a shutter speed of 1/1000 sec. is a must.

When it comes to the creative use of shutter speed, about 99 percent of all professional and amateur photographers still opt for using only the fastest shutter speeds, such as 1/500 sec. and 1/1000 sec. But the opposite end of the shutter speed dial offers a multitude of alternative creative effects that most photographers never discover. Action-filled subjects take on a whole new meaning when you deliberately photograph them at unusually slow shutter speeds.

If you're a purist who still believes in the age-old standard of razor-sharp, everything-in-focus pictures, I don't expect to change your way of thinking. But if you're a photographer who's looking for some fresh approaches to photographing people, I strongly recommend that you consider stretching the limits of your slow shutter speeds to the fullest. Try shooting all of your people pictures handheld at slow shutter speeds of 1/4 sec. or 1/2 sec. for the next week. The compelling imagery that often results will become additional ammunition for your growing arsenal of creative approaches. Much of what you do will be experimental, but as is often the case, new and exciting "discoveries" can only be made in the "laboratory."

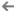

Busy streets like this one in Mong Kok, Hong Kong, offer motion–filled opportunities, to be sure, but are often overlooked, in part because these situations require the use of a tripod. Your camera needs to remain still, letting the cars do all the work to become "brushstrokes." It's a relatively quick 1/15 sec. exposure, but often a lengthy endeavor for everything to come together: the right color of "brushstrokes," mainly, but also perfect timing so that the "brushstrokes" are spaced with just the right opening for the calm under pressure.

NIKON D810, NIKKOR 24–120MM LENS, *F/22* FOR 1/15 SEC. WITH A POLARIZING FILTER, ISO 100, DAYLIGHT/SUNNY WB

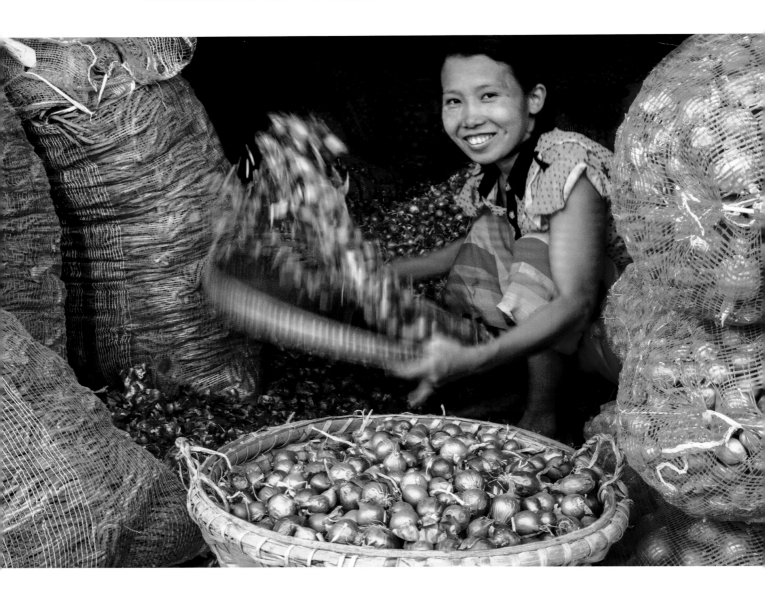

Motion really is everywhere. This woman "shakes" red onions all day long, loosening some of the outer skins as well as whatever soil remnants are left when they arrive from the fields. Up and down, up and down: here was a chance to imply the motion of these dancing onions. Once she happily agreed to have her picture taken, I determined that a shutter speed of 1/30 sec. would do the trick (after trying 1/60 and 1/80 sec.) and asked if she could throw the onions in the air *but* keep her eyes on me. I surmised that it would be easy for her to take her eyes off the dancing onions, considering that she had thrown them into the air every day, seven hours each day, for the past two years. I asked her if she could do the job with her eyes closed, and she smiled and asked, "Why would I close my eyes?" One of those small "lost in translation" encounters that I'm sure you have experienced, too.

NIKON D500, NIKKOR 18–300MM LENS, F/13 FOR 1/30 SEC., ISO 50, DAYLIGHT/SUNNY WB

Every photographer who is passionate about taking pictures is on a never-ending journey of creative expression and strives to be inventive. Using slow shutter speeds when common sense suggests that this approach probably isn't a good idea has proven to be a successful venture for many photographers. The resulting photographic compositions are filled with tremendous movement and tension. They convey strong moods and emotions and are anything but boring. You might not be able to identify the sport or activity, but in the midst of the blurred motion, you can recognize the human form. Fast-action shots made with slow shutter speeds are alive. They can resurrect memories of an earlier exciting time or confirm the current excitement in your life. Everyone, by nature, feels invigorated when there's movement in life, and everyone at one time or another has experienced boredom, life without movement.

Freezing Action

Freezing the action of moving subjects is a relatively easy exposure. A shutter speed of 1/500 sec. or 1/1000 sec. will freeze most of the activities we all pursue with precision, sharpness, and clarity—though any action worth freezing should also be a subject that you consider panning. (For more about panning, see page 162.)

Shutter Speed and Its Role in Dramatic, Emotion-Filled Imagery

Choosing the right shutter speed to capture all the movement of life is, for many shooters, a hit-or-miss proposition, but it doesn't have to be if you ask yourself the following three questions: 1) Do you want to freeze the action in crystal-clear sharpness? 2) Do you want to convey a heightened sense of speed or urgency? 3) Do you want to capture the ghostlike presence of people against an otherwise sharply focused scene?

Panning subjects is easily accomplished with shutter speeds between 1/60 sec. and 1/15 sec., depending on the speed of your subject. And if you want ghostlike figures in your scene, a shutter speed of 1/4 sec. will often do the trick.

No matter which shutter speed you use, don't forget to adjust your ISO for a well-balanced exposure. If you're freezing action with a fast shutter speed, your ISO will need to be high, perhaps 400. If you're panning, you'll want a lower ISO, around 100. And if you're using a very slow shutter speed to capture ghostlike figures, your ISO will need to be as low as possible, either 50 or L1.0 as is often indicated, perhaps even with the addition of a 3-stop ND (neutral-density) filter.

↑

So, this guy sees me with my camera at the edge of Lake Michigan in Oshkosh, Wisconsin. He asks, "Are you a photographer?" I say, "Do you want me to be a photographer?" and he replies, "Yeah, I do!" So I say, "Okay, then, I'm a photographer!" And then he tells me that he is going to get up on the pier, take a short running start, and launch himself out over the sand while doing a full body flip in midair, landing upright. My job, simply enough, was to freeze him mid-flight.

After a practice jump, I told him that if we timed it just right, I should be able to capture a "portrait" of him looking as if he were traveling through space on an invisible magic carpet. Well, we succeeded! I'm still toying with the idea of Photoshopping a carpet under him.

NIKON D500, NIKKOR 18–300MM LENS AT 100MM, F/8 FOR 1/1600 SEC., ISO 400, DAYLIGHT/SUNNY WB

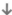

Most of us are familiar with the phrase "like shooting fish in a barrel." Along the White Salmon River, just up the road from the tiny town of Husum, Washington, the perfect shooting location awaits anyone who wishes to look like the world's greatest sports action photographer. On any given summer weekend morning, a number of people in large rubber rafts will launch over a waterfall that almost guarantees a minor wipeout. On this particular day—a hot August Saturday morning—a fully loaded raft came over the waterfall about every two minutes over the course of an hour.

Although this is clearly a freezing-action shot, my first concern was not setting an action-stopping shutter speed but dealing with what would surely be a whole lot of dark exposures thanks to all of the bright white water. If I had let the light meter do its thing, it would have, of course, recorded *gray* white water, simply because when anything white comes along, the meter reacts and says, "Okay, buster, you are much brighter than what I have been told about the world being gray, so it's my job to reel you in and make you conform to this gray world!" It then insists on a setting that *under*exposes the white to make it gray. Instead, I had to intervene. With my shutter speed set to 1/1000 sec., I merely pointed my camera into the whitewater rapids and adjusted my aperture until a +1⅓ *over*exposure was indicated. When the first raft passed through, I fired away and quickly confirmed that my hunch was correct.

NIKON D500, NIKKOR 18–300MM LENS, *F/11* FOR 1/1000 SEC., ISO 1600, DAYLIGHT/SUNNY WB

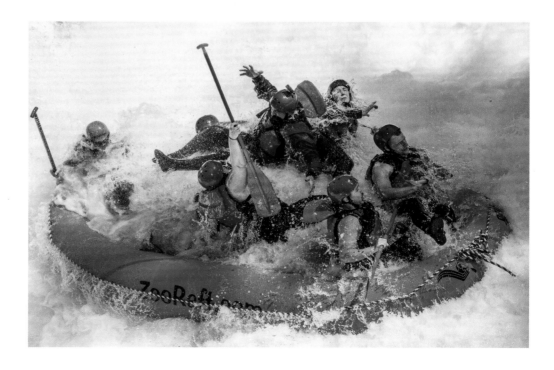

Panning: Conveying a Sense of Urgency

Motion-filled photo ops are present at every action-oriented event, and when you use slow shutter speeds of 1/20 sec. to 1/30 sec. to record them, dramatic effects often result. Handholding your camera at such slow shutter speeds might seem almost ridiculous, but it is indeed necessary if you're going to successfully pan with the action of your subject.

Panning is the act of moving the camera parallel with the action. So if your subject enters the frame from left to right, you move the camera left to right along with the action while depressing the shutter-release button. This ensures that your moving subject remains relatively "stationary" in relation to a particular spot in the frame and records relatively crisp, while all of the actual stationary objects that surround the moving subject record as blurry horizontal streaks. Many shooters embrace panning with zeal since they don't have to use tripods—the last thing you want to do is use a tripod when panning. Panning is all about handholding the camera and moving it in the same direction of your moving subject while you fire off any number of exposures.

When you pan a subject, keep in mind that you must have an appropriate background in order to be successful. Panned backgrounds are rendered as blurred, horizontal streaks of color. If you were to paint colored horizontal streaks onto a canvas, using a single color would result in nothing more than a solid color with no evidence of streaking. But if you were to use several colors, you'd be able to distinguish the streaks. In much the same way, panning a jogger against a solid blue wall will show little, if any, evidence of this technique because of a lack of tonal shift or contrast. But a wall covered with posters will provide an electrifying background when panned.

Simply put, the greater the color variety and contrast in the background, the more exciting the resulting panned image will be. So, rather than concentrating on choosing the right shutter speed when you pan a subject, you should make seeking out an appropriate background a priority. This will greatly improve your panned images.

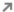

With more than three million motorbikes on the roads, Myanmar is a people-panning paradise! On this early morning, I captured a sidelit woman motoring away from the flower market, the busy background creating welcome contrast. With my ISO set to only 50 and an aperture of ƒ/20, I was easily able to shoot at 1/20 sec. shutter speed. I moved right to left and fired away. Expect more frustration than achievement when panning—it makes the successful exposures that much more rewarding.

NIKON D500, NIKKOR 18–300MM LENS, *F/20 FOR 1/20 SEC.*, ISO 50, DAYLIGHT/SUNNY WB

If you have mastered the art of panning on city streets, consider this next challenge: panning in the forest with a person moving. This time, ask your subject to move and up and down, with you, of course, moving your camera up and down with them. Trust me, a *ton* of images will end up on the cutting-room floor, but in addition to finally getting that one image that worked, you and your model will be much fitter after doing all those squats! Yes, it's a double win!

NIKON D500, NIKKOR 18–300MM LENS AT 40MM, *F/14 FOR 1/15 SEC.*, ISO 100, DAYLIGHT/SUNNY WB

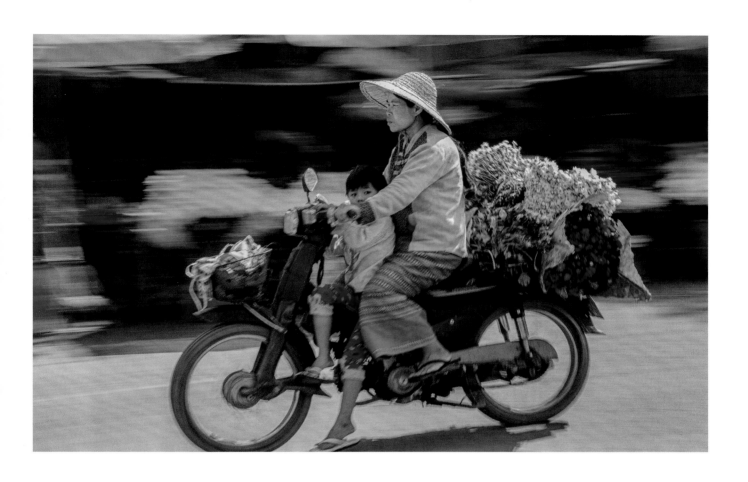

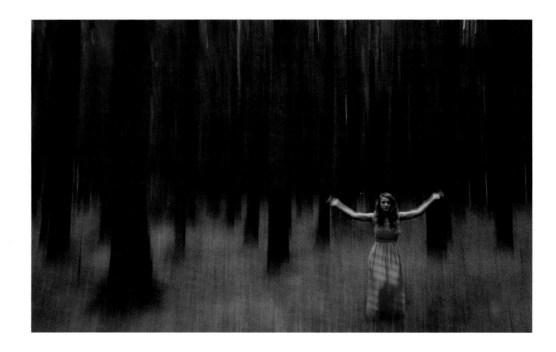

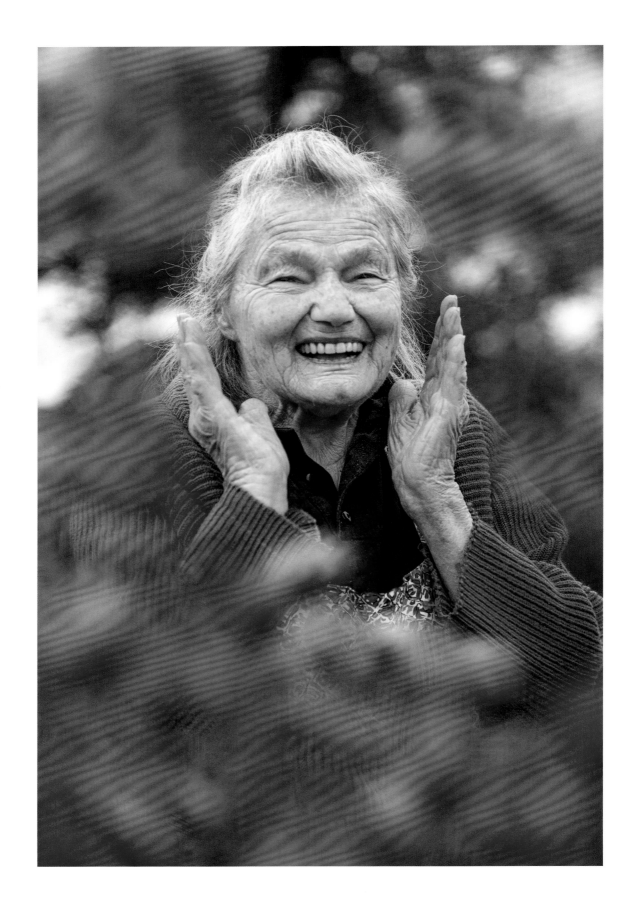

Choosing the Right Aperture

You may be wondering why I've used *f*/5.6 for some images, *f*/8 for others, and *f*/16 for still others. After all, as many of my beginning students say, "An aperture is an aperture, and apertures are simply there to help you make the exposure." This is true—up to a point. If all you're concerned about is getting the right exposure, then you can use any aperture you want, but getting successful images will always be a hit-or-miss proposition.

Apertures have many functions. The most obvious role they play is to control the volume of light that passes through the lens and onto the film or digital sensor. An aperture is merely a hole in your lens where light enters. When you release the shutter, light comes down this hole and is exposed to the digital sensor or onto the waiting film, thus forming an image. Turning the aperture ring on your lens or wheel on your camera body changes the size of the aperture. Conventional thought suggests that you make the aperture hole smaller when shooting subjects in bright light (snow and sandy beaches) and larger when shooting subjects in low light levels (church interiors).

But truth be told, the aperture plays a far more important role than just determining how much or how little light travels down the lens and onto the awaiting digital sensor or film. It is your choice of aperture that determines just

In almost every picture-making situation (if we are steady and choose the right spot to focus on), we should, in fact, see our subject in sharp focus. But when you combine a singular in-focus subject with a large lens opening (an aperture of *f*/2.8, *f*/4, or *f*/6.3) and the narrow angle of view of a telephoto lens (i.e., 200–300mm), you *can* create colorful foregrounds and backgrounds of out-of-focus colors and tones, as long as your focused subject is placed behind foreground color and in front of background color.

During my Bavaria Germany workshop several years ago, one of the backroads took us down a narrow lane where we met Frieda Müller. Frieda was not only willing to be photographed but she proved to be extremely gracious to nine complete strangers who stumbled onto her dairy farm completely unexpected.

A large lilac-like bush is all I needed to "build" a frame of out-of-focus color around Frieda. To make certain that this frame of out-of-focus color did in fact remain out of focus, I called upon a large lens opening, *f*/5.6, and while moving in a bit closer to the bush, I made certain to move a bit left, right, up, and down—small, almost precise moves, so the out-of-focus color did not block any of Frieda's face but simply framed her. In addition and this is so important when choosing to selectively focus through a foreground subject: Use manual focus! If not, your camera's auto-focus mechanism will be forever confused as you move around, not certain where you wish it to focus.

NIKON D500, NIKKOR 18-300MM LENS, *F*/5.6 FOR 1/400 SEC., ISO 200, DAYLIGHT/ SUNNY WB

↑

Her business is not much wider than a single kitchen cupboard and when she opens her doors, she sits cross-legged atop a soft red pillow and serves up a small glass of fresh cold water; not tea, not coffee, not snacks, no food at all, in fact, just a small glass of fresh, cold water—a very popular glass of water, too, as I bore witness to her steady stream of customers. With a bit of patience, I was able to create this simple portrait of a woman providing a popular service, tucked away in a local neighborhood beyond the main gates of the Pink City: Jaipur, India.

I want to add that it was imperative for me to open up the shadows in postprocessing. The interior where this woman sat was about 3 stops darker than the exterior, so I set an exposure of –1 for the exterior, knowing that it would render a 2-stop underexposure of the woman, but I could live with that knowing that I could open up the still-dark area where she sat by using the Shadows slider in Adobe Camera Raw (or Bridge).

NIKON D500, NIKKOR 18–300MM LENS AT 35MM, *F*/16 FOR 1/50 SEC., ISO 400, DAYLIGHT/SUNNY WB

how much more of the scene behind and in front of your point of focus appears sharp. (This area of focus from back to front in an image is called *depth of field*; if only a shallow area is in focus, that's smaller depth of field and if a deeper area is in focus, that's greater depth of field.) So, simply put, the wrong aperture can spoil a picture just as quickly as the right aperture can be responsible for a composition's success. Obviously, then, you should make choosing the right aperture a priority.

What do I mean by the *right* aperture? To understand this concept, simply think about the creative use of aperture in one of three ways: The right aperture can (1) tell a story, (2) isolate a subject, or (3) fall into what I call the "Who cares?" category. All photographs in which you choose to isolate a particular subject are also called *singular-theme compositions*.

Of these three aperture options, only the storytelling and isolation apertures really have any noticeable impact on your images. Storytelling apertures (*f*/16, *f*/22, and on some cameras *f*/32) render an area of sharpness well beyond the subject you focus on, and using a wide-angle lens at these settings is ideal for environmental compositions. For example, storytelling apertures allow you to record detail and sharpness in the background when your main subject is in the foreground. The reverse is also true. When the main subject is in the background, a storytelling aperture lets you render both the distant subject and the foreground sharp. Thus, storytelling apertures provide extensive depth of field, telling the whole story.

But when you want only the main subject to appear sharp and your working distance is between ten and thirty feet, you should choose an isolation or singular-theme aperture (*f*/2.8, *f*/4, or *f*/5.6). When you use these apertures with telephoto lens focal lengths from 100mm to 400mm, they always render any background or foreground colors or objects as out-of-focus tones and shapes.

Telephoto lenses, by their very design, limit the angle of view. And when they're used at singular-theme settings (again, *f*/2.8, *f*/4, and *f*/5.6), they reduce depth of field. As such, these out-of-focus backgrounds give the in-focus subjects in front of them even more visual weight, more importance. Simply put, when you look at a photograph, you quickly scan the image and assume that whatever is in focus is the most important element. Clearly, you should use an isolation aperture in combination with a telephoto lens when you want to focus all of the attention on the subject, not on the surroundings.

The third aperture option comes into play when the aperture choice isn't critical to an image's success, and it is for this reason that I have, for years, been referring to this as a "Who cares?" aperture (see page 172). For example, when you photograph your subject against a brick wall, does it really matter what aperture you use? No. The same principle holds true when you shoot your subject from a low point of view against a background of blue sky, as well as when you shoot straight down on your subject from above. In all these situations, and countless others, the aperture doesn't play a very important role since there are no real depth-of-field concerns. Although you can certainly select any aperture you want in such shooting situations, your best aperture choices are *f*/8 and *f*/11, because they often render the most sharpness and optical clarity possible in your photos. (Technically speaking, *f*/8 and *f*/11 aperture openings are called *critical apertures*; if a lens isn't critically sharp at these settings, it won't be tack sharp at any of the others, either.)

Ultimately, the right aperture will go a long way toward creating the perfect composition, and aperture choice is always yours to make. It's the right aperture that has the powerful ability to determine the visual weight of your composition, and more often than not, the visual weight of your composition will account for its ultimate success or failure.

Isolating the Subject

There is perhaps no better combination for shooting a portrait than the tele-photo lens and a large lens opening (a small aperture number). When we think of aperture's importance and its ability to render either a great deal of sharp-ness beyond what we focus on or no added sharpness beyond what we focus on, it of course becomes paramount that we choose the right aperture each and every time.

Storytelling

Storytelling images are compositions that have a beginning, a middle, and an end. More often than not, it is the storytelling composition that calls for aper-tures of *f*/22 when using a wide-angle lens and even up to *f*/32 when using the telephoto lens. Everything, from front to back, is definably sharp, thus making it obvious that this is a story and *not* simply an exclamation point.

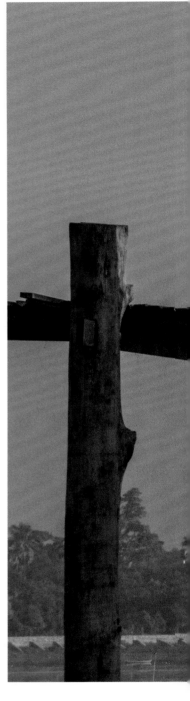

→

Stretching about 2,297 feet (700 meters) across the southern end of Taung Tha Man Lake in Mandalay, Myanmar, the teak Ubien Bridge has withstood the test of time. It has carried the weight of thousands of monks and hundreds of dogs and been witness to more than 73,000 sunrises and sunsets. On this early morning, a dog and a monk headed in opposite directions, each seemingly unaware of hav-ing just crossed paths only moments ago. I chose to use a storytelling aperture here, something I don't often do when shooting with a telephoto lens, because I wanted to also render the distant background in detail, bringing the white monas-tery into view.

NIKON D500, NIKKOR 18–300MM LENS AT 300MM, *F/22* FOR 1/200 SEC.,
ISO 400, DAYLIGHT/SUNNY WB

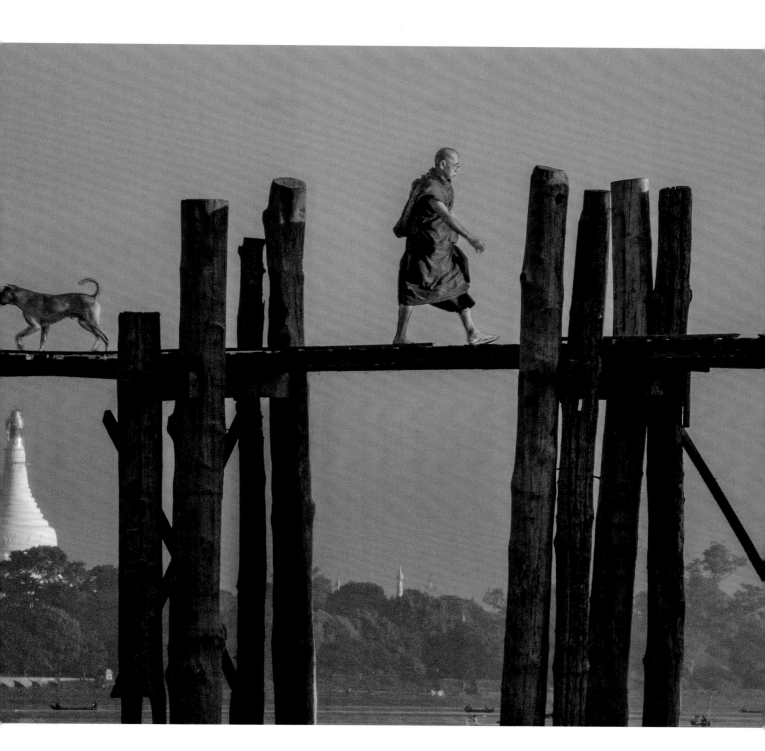

A Note about Handholding

There was a time when we used a rule to know when it was safe to handhold our cameras and lenses without fear of camera shake resulting in a blurred image. That rule was to never shoot at a shutter speed that was slower than the longest focal length of your lens. The trouble in following this formula today is that lenses are shorter in length than they were back then. For example, a 300mm lens back then might have been eleven inches but today might be only seven inches. Plus, with today's vibration reduction (VR) and image stabilization (IS) lenses, it is now possible to break this "rule" and handhold at shutter speeds that are 2 to 3 stops slower than the old rule of thumb would normally allow. So, as a new general rule of thumb, with VR or IS activated, I'm comfortable handholding at *1 stop* below the longest focal length of my telephoto and *2 stops* below the longest focal length of my wide-angle lens.

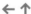

How do you bring much-needed water to your rice fields in and around Inle Lake, Myanmar? You make narrow channels from the lake to your farm, and while walking slowly in the narrow and shallow channels of water that lie between the elevated rows of rice, dip your one-quart stainless-steel bowl into the water. With a flip of the wrist, similar to the motion of releasing a bowling ball, you send the water cascading onto the awaiting young shoots of rice.

Two things of note here: First, a fast shutter speed of 1/1000 sec. was needed to freeze the cascading water. So with my shutter speed set to 1/1000 sec. and an ISO of 800, an aperture of $f/16$ indicated a correct exposure for the strong backlit field before me, but the sky was 3 stops brighter. Since I didn't have my 3-stop graduated neutral-density (GND) filter, I called upon the Graduated Filter in Adobe Camera Raw and "added" it in postprocessing. And second, I used an $f/16$ aperture because I wanted the background to be sharp, yet I did not want to use a wide-angle lens since it would "push" the young man way back into the overall composition, making him really small and distant. So I called up a moderate telephoto length of 100mm and composed the shot you see above, resulting in a storytelling composition yet shot with a lens that I often reserve for isolation/singular-theme concepts. It is possible, and sometimes necessary, to call upon the telephoto lens to tell a story.

Just for good measure, and because I'm a big believer in working the subject, you can see by the opposite photo that I did manage to extend the telephoto to a longer focal length, about 260mm, and was then able to also record a singular-theme image of the farmer, a working "portrait," if you will.

NIKON D500, NIKKOR 18–300MM LENS, *F*/16 FOR 1/1000 SEC., ISO 800, DAYLIGHT/SUNNY WB

Who Cares?

When almost everything in the scene before you is the same distance to the lens, does it matter what aperture you use? No … and yes. Let me explain. When there's no "depth" to the subject, meaning that there's nothing in front of or behind them, you can use *f*/4, *f*/11, or *f*/22, and the resulting depth of field will not be noticeably different, since the area of sharpness is limited to a given distance.

But actually, I do care, and here's why: Every lens has a *critical aperture*, referring to the aperture that renders both maximum sharpness and contrast, and critical aperture has everything to do with the design of a lens. Without getting too technical, on almost every lens for 35mm SLRs or DSLRs, the critical aperture is most often found around *f*/8 to *f*/11. So, when depth of field isn't a concern, your only concern should be using the critical aperture, since that will yield the greatest sharpness and contrast. So, when depth of field is not a concern—a "Who cares?" situation—my rule of thumb is to use *f*/8 or *f*/11.

Another day in the walled city of Harar, Ethiopia—one of my top five favorite locations in this, our very colorful world. This little girl had been following me around for most of the afternoon, and I had taught her a very important English phrase: "You keep shooting." It was at this moment, after I'd asked her to pose for me against this simple yet colorful wall, that she pointed at me and said, "You keep shooting!"

This is a classic example of a "Who cares?" aperture situation, since everything is at the same focused distance, so *f*/8 it was. Because it was a day of high overcast light, I chose to shoot in Aperture Priority Mode most of the day.

NIKON D500, NIKKOR 18–300MM LENS, *F/8* FOR 1/200 SEC., ISO 100, DAYLIGHT/SUNNY WB

↑

A quick shot, and the quick backstory: Natt and I were in a mansion in Delhi, which I had found on AirBnB. It was filled with art on almost every wall, some of which was haunting. "Damn…come quick, we got some great light, yes, sit there, on that stool, yes, perfect, now look at me and…. click, click, click …we got it, done!"

NIKON D810, NIKKOR 24-120MM, *F*/10, 1/320, 640 ISO, DAYLIGHT/SUNNY WB

Extremely Wide

It's not at all uncommon for photojournalists to use wide-angle focal lengths that offer any-where from 75- to 92-degree angles of view. For full-frame digital shooters, these focal lengths are the 14–24mm range, and for the DX crop sensor digital shooters, these focal lengths are in the 8–16mm range. Subject distortion is the norm when using these extreme wide-angle lenses, but in the hands of a gifted photojournalist, this distortion can be used to emphasize the joy or plight of a given subject.

It's not my style to use these wide-angle lengths all that much but, rather, to do so very selec-tively. In this instance, and taking a worm's-eye point of view, I chose to use the feet of one of the men from the Karo tribe in Ethiopia's Omo Valley to add both a sense of scale and depth to the composition of the women sitting in the background. This use of legs/feet also serves to arouse the viewer's sense of touch, since it is one of those "in your face" compositions.

NIKON D500, NIKKOR 10–24MM LENS AT 12MM, *F/22* FOR 1/200 SEC., ISO 400, DAYLIGHT/ SUNNY WB

Lens Choice

Just as aperture choice affects composition and the final success of an image, so does lens choice. Experienced photographers use, primarily, two lenses when photographing people: the telephoto lens (the more obvious choice) and the wide-angle lens. The telephoto lens is popular for several reasons. Most important, it frees photographers from having to work with camera-to-subject distances that might make them uncomfortable. This benefits their subjects as well, because everyone, to greater or lesser degrees, has a psychological boundary. Although this isn't clearly marked the way a parking space is, it does exist. You can quickly find out where a subject's boundary is by attempting to shoot an extreme close-up of the person's eyes with a macro lens. Chances are you won't get very far, especially if the individual is a complete stranger.

The telephoto lens is also popular because it renders subjects in correct proportions. When you use either a 50mm standard lens or a 35mm wide-angle lens and want to fill the same area in the frame that a telephoto lens does, you usually end up distorting the subject. For example, if you shoot a head-and-shoulders composition with a 35mm or 50mm lens, the subject's nose or chin might appear larger than it actually is. Shooting the same composition with a telephoto lens, on the other hand, would create the illusion that the eyes, ears, chin, nose, and shoulders are all the same distance from the camera.

Although there's no set rule about which telephoto lens is best, many seasoned professionals swear by the 100–200mm focal lengths. The popularity and quality of the tele-zooms (for example, 70/80–200mm, 70/80–400mm) mean that most, if not all, of these popular focal lengths are available to even the amateur photographer. Tele-zoom lenses are able to zoom in and out, so cropping in-camera is relatively simple. And in some situations, these zoom lenses free you from having to walk closer to, or move back from, the subject.

Additionally, all telephoto lenses have a much narrower angle of view than their wide-angle counterparts. For example, a 24mm wide-angle lens has an angle of view of 84 degrees, while the 100mm focal length lens has an angle of view of approximately 27 degrees and the 300mm lens has an angle of view of only 11 degrees. When using my 70–200mm F2.8 lens, I'm not restricted to photographing faces. At a country fair, for example, I can zero in on hands exchanging money, as well as a child's hands hanging on tight to that candy apple.

When photographing a group portrait, on the other hand, I often use a wide-angle lens. I would never use a wide-angle lens for a frame-filling portrait because it would distort the subject's face, but if I back off just a bit, I can shoot a portrait of the subject that, due to the angle of view of the wide-angle lens, also incorporates the surrounding environment. In fact, my other favorite lens is the Nikkor 17–55mm F2.8. This is what I often call my "street lens," meaning that if I want to travel light, I simply head out the door with my camera and this one lens and see what I can find as I walk the streets of the world. It's both a wide-angle and a short telephoto lens, so I can shoot environmental portraits as well as frame-filling head shots with just this one lens.

It was during a workshop in Las Vegas that I was asked to shoot a wedding photo of a bride and groom. I haven't shot a wedding since 1972, when I photographed what I swore would be my first and last, yet here I was doing something I never dreamed I'd ever do again. Okay, granted, this wasn't a wedding but more of a "walkabout" after the wedding, and after I'd agreed to shoot a couple of frames of the wedding couple, I realized there just might be something else that was more up my alley: I noticed everyone standing around in this small plaza, their long shadows mimicking the opposing lines of color. I suggested that we all gather around and make a bunch of lines—lines to support this couple's love and special day—to call attention to the joyous celebration. I switched to my Nikon 10–24mm lens and, using the widest angle of view (10mm), shot this storytelling image of that special color-filled day with friends.

NIKON D500, NIKKOR 10–24MM LENS AT 10MM, *F*/16 FOR 1/100 SEC., ISO 100, DAYLIGHT/SUNNY WB

176

The Personal Side of Lens Choice

If you haven't noticed, I've used, for the most part, two lenses for this book: the Nikkor 18–300mm F3.5–F6.3 DX lens, and the Nikkor 24–120mm F4 lens. With both lenses, most of the time I use the telephoto end (i.e., from 80–300mm). Although this might imply that these are the focal lengths that you should also embrace, I want to encourage you to try other focal lenses and their related focal lengths, such as a full-frame fish-eye and the super telephotos, including 500mm and 600mm. Understanding the "vision" of all of your lenses will go a long way toward not only flushing out what works and what doesn't in your photographic compositions, but also to developing your personal style. For example, I have several students who use nothing more than their 50mm F1.4 lenses for all of their people work.

Photography is one of the arts, and there are no hard-and-fast rules in art. A lens, just like a painter's brush, is a tool. You can use the brush to make strokes up, down, or from side to side. You can find a really narrow brush, a brush limited to just a few fine hairs and paint ultrafine lines, or grab a brush with lots of hairs, splay it out upon the canvas and create much wider lines. You can also throw the brush out and use a palette knife, your fingers, your nose, or even your cheeks to spread the paint around.

I believe that you can—and should—experiment with lenses in much the same way. Don't reserve wide-angle lenses for group portraits. These lenses have a much greater angle of view than telephoto lenses do, so they're a natural choice for environmental portraits. They gather up those elements that call attention to the subject's character. And when shooting indoors in a small, confined area, you'll have to use a wide-angle lens to show the subject from head to toe.

I've had a great deal of success shooting storytelling portraits of people all over the world with the Nikkor 18–300mm F3.6–F6.3, but again, it's a personal choice. A lot of users still like "fast glass," meaning the street and telephoto zoom lenses that offer an $f/2.8$ lens opening, but in light of today's high ISOs with low noise, and the extreme weight of $f/2.8$ lenses, I feel that fast glass is a thing of the past.

Ultimately, your end goal should be a powerful composition, an image with feeling, and of course, the use of the "right" lens combined with the "right" point of view is, in large measure, ultimately responsible for the strong or weak composition that you create. Whatever lenses you end up using to create powerful compositions, whether fast glass or "slow glass," were obviously the right choice!

The Role of Photoshop in People Photography

If you're hungry for photo-editing know-how as well as fun, you'll be pleased to know that I have a number of free video tutorials on expanding your creativity as it relates to the art of Photoshop and photographing people at www.youkeepshooting.com/photographingpeople. Once you enter your email address and answer a simple question (with the answer: "Rainbow"), you'll gain access to the videos.

Artificial Light

It seems that every week, if not every month, the world of photography is introducing some new must-have gadget, but no one change, at least in my mind, has had more impact on flash photography than the introduction of very small, compact yet powerful light sources made of LEDs. This is not to say the use of portable flash is dead, but more and more, at least in my workshops, I'm seeing students choosing to use the "fixed," or constant, LEDs over the portable flash, and when asked why, most reply that they can *see* and thus better control the light output, since the LED light remains *on*, versus a sudden, blazingly fast flash that lights up the subject at a ridiculous 1/2000 sec. or faster. Sure, one needs only to look at the camera's monitor to see if the portable flash did its job and, if not, to try again by moving a bit to the right or left or up or down. But again, in real time, one can see how the light is falling on the subject with these powerful and very portable LED lights.

Am I suggesting that using portable flash is no longer a good idea? Not at all! I am still a flash believer, as a few of the forthcoming examples will show, and as you may know, I wrote about the subject, too (*Understanding Flash Photography*), but what I am saying is that you should consider *adding* a small, lightweight, portable LED light to your camera bag as it will come in handy when you wish to light up a subject standing against the night sky or to create a small "fill light" when shooting a simple portrait. If the images and captions that follow inspire you to experiment further with artificial light, you might want to check out *Understanding Flash Photography* for technical instruction and explanations.

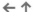

My love of photography and subsequent career began in the film days of the early 1970s, when 1/500 sec. was the fastest shutter speed, when ISO was called ASA, when if you wished to shoot color slide film, your ASA was either 25, 50, or 64, and—I stress this next point strongly—*there was no such thing as Photoshop.* Yes, there was a darkroom for black-and-white shooters, but us color shooters had no choice but to do it *all* in camera, thus inspiring many inventive in-camera discoveries, such as creating textured overlays as part of a single exposure, especially in portraiture, simply by draping various fabrics over the subject's face.

As you can see opposite, my subject, Natt, is draped in a sheer black fabric and holds a small LED light, which is sidelighting her face. All that remains is for me to move in close, filling the frame with both fabric and half of Natt's face.

You'll find numerous options for textures in every fabric store, and I highly recommend taking a look for yourself. You'll discover, as I did years ago, that using actual textures in the initial creation of an image is not only quick and easy but also feels remarkably creative and empowering, versus adding a texture later from some "suite" of textures you purchased and then applied via Photoshop.

NIKON D500, NIKKOR 18–300MM LENS, *F*/8 FOR 1/200 SEC., ISO 1600, DAYLIGHT/SUNNY WB

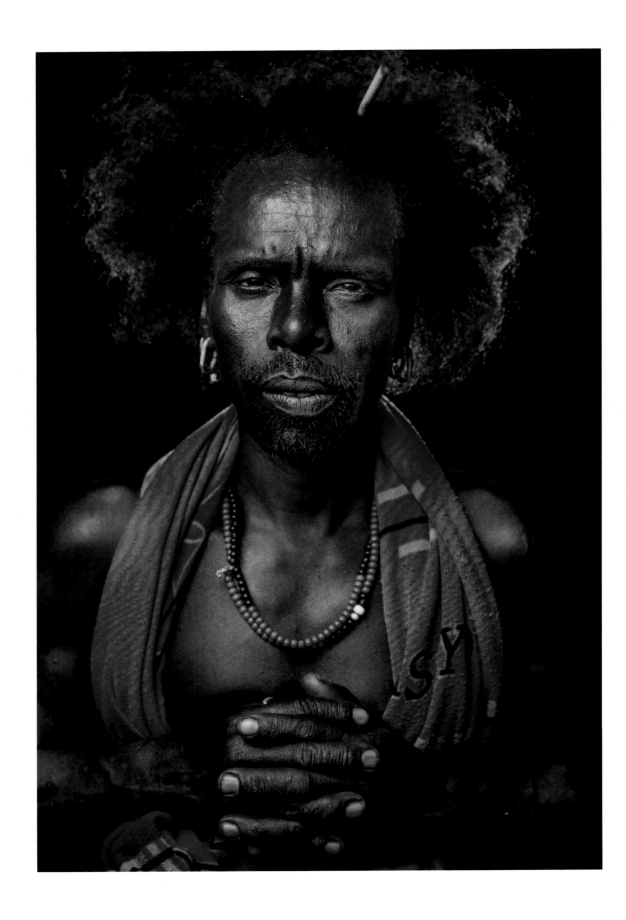

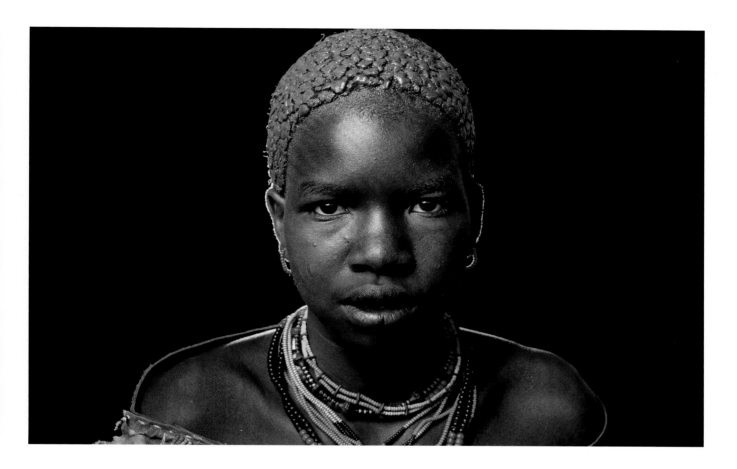

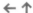

Over the course of three magical days, I set up camp with one of the local Hamar tribes of southeastern Ethiopia. We were well off the beaten path, and for this Hamar tribe, my presence was not the norm; however, as one who believes that a camera can be a great communicator, I proceeded to set up a "studio" inside an old schoolhouse, a schoolhouse that had but two standing walls and a partial roof. My studio consisted of two Nikon SB 900 flashes along with two light stands. The main light, the one that would light up the faces of my subjects, was inside a soft box, and the other light, complete with an amber gel, was set up behind the subject. Both flashes were hooked up to remote receivers and on my camera's hot shot was a remote trigger that would fire the portable flashes when I pressed the shutter.

Once I was all set up, I needed a willing subject. At first the reluctance was quite palpable, but after photographing one subject and sharing a print made with my HP Sprocket printer, I was soon inundated with willing subjects. In fact, I had to stop because I'd used up all seven packets of photo paper (that's seventy prints!) in only one afternoon. Two of my favorite photographs from that memorable after-noon are shown here.

NIKON D810, NIKKOR 24–120MM LENS AT 120MM, *F*/8 FOR 1/250 SEC., ISO 50, DAYLIGHT/SUNNY WB

In-Camera Double Exposures

Before closing the topic of photographing people, I wanted to call your attention to one more "tool" at your disposal, a tool that renders surprising and welcome results, time and time again. I'm talking about your camera's ability to create an in-camera double exposure. Most of you have this feature, unless you happen to own a Sony, such as the AR-7 model, which does not have double-exposure capability (for reasons that I cannot even fathom!). Shame on you, Sony, for denying your users the fun and massive creativity to be had when using the double-exposure feature. But enough venting; I'll let the following in-camera double exposure speak for itself, and perhaps Sony will understand and make amends in their future offerings of DSLR cameras.

When shooting a double exposure, you shoot each image as a correct exposure, and when the double-exposure feature is engaged, the camera automatically blends the two images together, creating a single histogram of the two exposures. Depending on which brand of camera you own, you'll see a setting called either Average or Auto Gain—you must choose one of these, since it will affect how the camera blends the two exposures.

Opportunities to combine textures such as stone, brick, tree bark, leaves, pebbles, broken glass, cracked windshields, or rusty metal with portraits are truly unlimited. In fact, I'm convinced one could make an entire career doing nothing but creating in-camera double exposures—and at the very least, it will double your photographic pleasures for the rest of your life!

For those of you looking for new approaches to create fresh and arguably compelling portraits, I remain convinced that the Multiple Exposure setting in the Shooting Menu and the Overlay feature in the Retouch Menu on Nikon and Canon cameras remain an unknown and unexplored visual mission! Let's begin with how I was able to create the strong portrait of the fiercely independent "Woman of Steel" opposite.

It's a simple idea to execute in-camera by calling upon the Multiple Exposure feature in the Shooting Menu of your Nikon or Canon and/or the Overlay feature in the Retouch Menu found on most Nikons. (For Sony, Fuji, Panasonic, and Olympus cameras, refer to your camera manual index.) For Nikon and Canon users:

1 Set your camera to shoot a double exposure (two shots).
2 For Nikon, choose the Auto Gain feature; for Canon, choose Average. (These are Blend modes that produce the best in-camera results.)
3 Find textured patterns, such as tree bark, rocks, a group of flowers, or, in my case, some crushed wire mesh sitting next to a dumpster in a Hong Kong alleyway. Shoot the texture for your first exposure.
4 Finally, take the second exposure—in this case a simple frame-filling portrait of Natt—and a surprising and unique portrait may result!

If creating fine art is your thing, consider adding double exposures to your arsenal of creative weapons. And no, this technique isn't limited to textures and portraits. Let your imagination run wild!

During a workshop in Venice, Italy, several years ago, I shot a simple portrait of the model Maja as the first of two exposures and then immediately turned to a nearby canal and photographed a reflection of color on the water's surface. As you can see, the resulting double exposure was both welcome and surprising.

NIKON D500, NIKKOR 18-300MM, SHOT AT F/11, WITH CAMERA IN APERTURE PRIORITY MODE, ISO 400

About the Author

Bryan Peterson is a professional photographer, internationally known instructor, and founder of two extremely popular photography instruction websites, The Bryan Peterson School of Photography at BPSOP.com and You Keep Shooting at youkeepshooting.com. He is also the best selling author of *Understanding Exposure*, *Learning to See Creatively*, *Understanding Color*, *Exposure Solutions*, *Understanding Shutter Speed*, *Bryan Peterson's Understanding Composition* and *Bryan Peterson's Understanding Photography Field Guide*. It was Bryan who introduced the Photographic Triangle, an exposure teaching tool that has helped millions understand and implement not just a correct exposure but the most "creative exposure" and his trademark use of use of color and strong graphic compositions have garnered him many photographic awards, including the New York Art Director Club's Gold Award and honors from *Communication Arts Photography Annual* and *Print* magazine.

Index

Text copyright © 2006, 2020 by Bryan Peterson
Photographs copyright © 2020 by Bryan Peterson

Published in the United States by Watson-Guptill Publications, an imprint of
Random House, a division of Penguin Random House LLC, New York.
www.watsonguptill.com

WATSON-GUPTILL and the HORSE HEAD colophon are registered trademarks
of Penguin Random House LLC.

Originally published in different form in the United States as *Beyond Portraiture*
 by Amphoto Books, an imprint of Random House, a division of Penguin Ran-
 dom House LLC in 2006.

Library of Congress Control Number: 2020932210

Trade Paperback ISBN: 978-0-7704-3313-0
eBook ISBN: 978-0-7704-3314-7

Printed in China

Design by Isabelle Gioffredi

10 9 8 7 6 5 4 3 2 1

Revised Edition